Copycat Television

Copycat Television

Globalisation, Program Formats and Cultural Identity

Albert Moran

UNIVERSITY *of*

LUTON PRESS

British Library Cataloguing in Publication Data

A catalogue record for this book is available from the British Library

ISBN: 1 86020 537 2

To Noela,
with love

Note: University of Luton Press has a policy of adopting the spelling regime of the culture within which an author works.

Published by
University of Luton Press
Faculty of Humanities
University of Luton
75 Castle Street
Luton
Bedfordshire LU1 3AJ
United Kingdom

Tel: +44 (0)1582 743297; Fax: +44 (0)1582 743298
e-mail: ulp@luton.ac.uk

Cover Design by Morgan Gravatt Design Consultants, England
Typeset in Perpetua and Helvetica
Printed by Bookcraft Ltd, Midsomer Norton

Contents

VINCENT:	But you know the funniest thing about Europe is?
JULES:	What?
VINCENT:	Little differences. I mean they got the same shit over there we got here but there it's a little different.
JULES:	Examples?
VINCENT:	Alright. Well you can walk into a movie theatre in Amsterdam and buy a beer. An' I don't mean just like no paper cup. I'm talking about a glass of beer. And in Paris, you can buy a beer at McDonalds. An' you know what they call a Quarter Pounder with Cheese in Paris?
JULES:	They don't call it a Quarter Pounder with Cheese?
VINCENT:	Naw. They got the Metric System. They wouldn't know what the fuck a Quarter Pounder is.
JULES:	What do they call it?
VINCENT:	They call it Royale with Cheese.
JULES:	Royale with Cheese!
VINCENT:	That's right.
JULES:	What they call a Big Mac?
VINCENT:	Big Mac's a Big Mac but they call it Le Big Mac.
JULES:	(Imitates French accent) Le Big Mac. (Laughs). What they call a Whopper?
VINCENT:	I don't know. I didn't go into Burger King. You know what they put on French Fries in Holland 'stead of ketchup?
JULES:	What?
VINCENT:	They put mayonnaise.
JULES:	(Laughs)
VINCENT:	I seen 'em do it man. They fuckin' drown them in that shit.

(Quentin Tarintino *Pulp Fiction* 1994)

Acknowledgements

My biggest debt in this book is to the Australian Research Council which, under its Large Grants Scheme, funded the project 'Media Globalisation and the Circulation of Australian Television Series' while a Senior Research Fellowship has given me the time to write up the results of that research. Two other institutions should also be thanked – first my employer, Griffith University, which has been highly supportive of the project, and secondly, the Australian Film Commission in London which provided access to various facilities. This research has been truly international and I have accumulated many debts to individuals and organisations in various parts of the world. For hospitality and encouragement while in foreign lands, I would like to thank Cynthia Wilde in London; Waddick Doyle and Deirdre Gilfedder in Paris; Horst and Paulette Tiessen in Dusseldorf and Michaela and Stephen Freeman in Amsterdam. I would also like to thank Denise Quinn in Frankfurt and Stefan Tiessen in Dusseldorf for additional favours. The investigation went forward through the efforts of a number of research assistants to whom I am enormously grateful, most especially Margaret Pullar in Brisbane; but also David Henry in Sydney and Munich, Emma Sandon and Gabriella Romano in London; and Rea Turner in Brisbane.

At the Grundy Organisation in Sydney, I would like to thank Katherina Ray who was invaluable in helping me to watch program material, gather information and photographs. I am also very grateful to Ian Holmes, Ray Kolle and Bill Mason who answered different questions. At Grundy Television in London, I am indebted to the staff of the Publicity Office, most especially Jeremy Cootman and Zoe Cartell. Grateful thanks also go to the following: Andrew Brooke, Jim Henry, Mike Murphy, Alan Boyd and Mark Callan. Senior Grundy figures in other offices were also most welcoming and helpful; I am especially indebted to the following: Lionel Baart in Paris; Jason Daniel and Jurg Bruckner in Cologne; Bob Crystal in Los Angeles; Peter Pinne in Santiago; and Tony Skinner in Singapore. Other television producers and broadcasters made time and effort to speak with me. My thanks go to the following:

In Aalsmeer, Thomas Notermans at JE Productions;

In Amsterdam, Jessica Haagmans and Koen Kriel at IDtv;

In Cologne, Peter Struss and Klaus Ruthrof at WDF and Christiane Ghosh and Catherina Heim at RTL;

In Hilversum, Stephan Warnig and Jo Bergen Henegouluensxat at RTL 4 and Kim Kronhout van der Meer at John de Mol Productions;

In Laren, Hedy van Bochove and Irene van Affelen at Endemol;

In Lisbon, Piet Hein Bakker at Endemol;

In London, Suzy Giblin at BRITE, Dinah Grey at All American Fremantle International, Charles Denman, Colin Jarvis and Chris Pye at the BBC, Richard Cox at London Weekend Television, Roger Hancock at Action Time, Paul Stiles at KP Peat Marwick, and John Woodward at the Producers' Alliance of Cinema and Television;

In Los Angeles, Stephen Freedman at King World;

In Paris, Christian Bidault at France 3, Simone Halberstadt Harari at Tele Images and Guilleman Guilleman at AB Productions;

In Sydney, Ian Hogg at Fremantle/Richard Becker and Associates;

In Wellington, Rod Cornelius at TVNZ.

One other body of professionals deserve mention and thanks. This research is very grateful to the following British legal experts in the area of television program formats and copyright: Stephen Edwards at Richards, Butler and Company; Shelley Lane at Queen Margaret Mary College at the University of London; Richard Dee McBride at Charles Russell and Company; and Alan Williams at Denton Hall and Company.

The project involved a significant amount of material that had to be translated and I am most grateful to the following who helped with this work: Nicki van Canon, Alexandra Frink, Tanya Frink, Tanya Sax, Simone Smala, Barbara Susec, Madelaine de Winde, Katarina Wrzesniewska and Sascha Zonncveld. Various academic colleagues also assisted in gathering research data – my sincere thanks to Michael Brun Andersen at the University of Oslo; Stefen Aufenanger at Universitat Hamburg, Jorg Becker at Solingen; Robert Burnett at the University of Karlstad; Huub Evers at Hogeschool Katoleke in Tilborg; Romy Frolich at the Institut fuer Journalistik und Kommunikationsforschung in Hanover; Christina Holtz-Bacha at the Johannes Gutenberg University in Mainz; Hans Kleinstauber at Universtit Hamburg; Inger Lindstedt at Goteborg University; Jochen Walter in Cologne; and Liesbet van Zoonen at the University of Amsterdam. Special thanks for other assistance goes to Paul Attallah at Carleton University and Errol Vieth at the University of Central Queensland. I would also like to thank Manuel Alvarado, Ann Simmonds and Keith Marr at University of Luton Press for seeing this into print. Finally, I would particularly like to thank Noela, James and Kate for putting up with the long hours I have spent away from more pleasant family experiences.

For permission to reproduce copyright material, I would like to thank the BBC; Faber and Faber; Grundy Television; and JE Productions.

Preface

When pressed, almost everyone can name instances of television format translation or adaptation. In the early days of the new medium in the 1950s, many radio programs were remade for television; the game show, *What's My Line?*, originated in the US but was adapted by the BBC where it became a popular success on radio and then television; the British sit-com *'Till Death Us Do Part* crossed the Atlantic and became a big success in the US as *All In The Family*; the US game show *Wheel Of Fortune* has been adapted in over 25 countries across the world. Very many other examples of format adaptation might be cited although the point is clear. Format adaptation is a constantly recurring feature of international television. Given the frequency of program format adaptation, it is surprising that the phenomenon has received little critical attention. There is one book on the subject – a legal handbook written in Dutch which is unlikely to be translated into English (van Manen 1994). There is no entry on the subject in the *New York Times Encyclopedia of Television* (Brown 1977) while a more recent reference guide to television, the *Museum of Broadcast Communications Encyclopedia of Television* (Newcomb 1997) contains only a short entry (Fiddy 1997). Unfortunately, the latter is content to confine itself to notable instances of format transfer such as some of those cited above rather than develop a more analytic outline of the practice. However, it does make two valuable points – first, that the practice is not new and can be traced back to radio; second, format adaptation in international television appears to be on the increase.

Copycat Television goes some way towards filling this gap. In particular, I am interested in exploring the phenomenon of format translation and its wider cultural significance. The book is therefore divided into four parts. The 1980s and 1990s has seen a multiplication in broadcast hours of television throughout the world and this has fuelled a dramatic increase in the practice of format adaptation. However, this practice of national translation appears to fly in the face of arguments about globalisation, according to which national cultural production is dying if it is not already dead. Chapter 1 therefore examines the globalisation thesis and suggests its modification in the light of the continued viability of national television systems. Chapters 2 to 5 – Part One

of *Copycat Television* – is concerned with the industrial parameters of trade in television program formats. As we shall see, no goods change hands in this kind of exchange. Instead, what does occur is a process of licensing or franchising, whereby the owner of a television program format contracts with another party to allow that party legal access to the format for the purpose of producing an adaptation. Even a simple description of this kind raises many questions – What exactly is a program format? Is a format constituted by one element or a group of elements? Are formats undifferentiated or are there particular types? When a format is licensed, what activities and outcomes are being afforded legal sanction? What legal mechanisms exist or might be used by format owners in order to protect their formats from infringement? How much infringement occurs and how successful have format owners been in legal actions? Why should a producer want to adapt a format rather than develop an original concept themselves? Is the licensing of formats on the increase in international television industries? How much trade is there in international adaptation of television program formats ? Who are the major international companies involved in the format trade and how did they become major? Such a list is by no means exhaustive yet it suggests that the process of format adaptation subsumes many issues. Chapter 2 examines the industrial context of television program format adaptation. An important issue that is beyond the scope of the present study concerns contemporary levels of trade in international format adaptations. How much trade is there in television program formats? Where are the key centres for the export and the import of formats? What is the current value of this trade?

There is clearly scope for an international inventory, along the lines of earlier studies of aspects of trade in international communications such as those to do with traffic in television programs and video hardware and software (cf Nordenstreng and Varis 1974; Alvarado 1988). In the meantime however, Chapters 3 to 5 go some distance towards filling this gap. Chapter 3 offers a survey of some of the more important players in the international format trade while 4 and 5, by way of a case study, pay particular attention to the development of one of the 'Big Three' in international formatting.

These chapters bracket out issues concerning the national translation of television texts. Part Two reinstates this concern. What is translation? What occurs when a program format is adapted from one national television system to another? Clearly, the production of national adaptations is a complexly mediated process and is not one whose textual results can be read off from the industrial circumstances of its conception. In this Part of the book, we examine several national adaptations. Because game show format adaptation is the kind most often cited by commentators, it has given rise to a perception of adaptation as a mechanical and one-dimensional process. To redress this impression, Part Two consists of several case studies of national format adaptations of both game shows and soap operas. Neither genre has a great deal of cultural legitimacy although certainly recent years have seen a considerable rise in the critical reputation of the latter. Nevertheless, as

against more nationally prestigious television forms such as the documentary special or the drama mini-series, the game show and the soap opera are more commonplace forms whose individual programs are mostly oriented to a domestic rather than an international audience. The encoding of particular nationalities is therefore likely to be casual and incidental rather than self-conscious, deliberate and explicit.

In examining particular texts in terms of their national elements, we are always aware of the social construction of textual meaning. Reading always implies particular readers and this is most directly registered in those instances below where we draw upon the response of particular translators. However, the analyses do not attempt to confine themselves to ethnographic materials but also draw upon the written comments of others. It goes without saying that implicit in the research method adopted in these chapters is the view that there is no single 'right' way to read a text although equally we reject the view of absolute relativism that has recently been advanced (cf Jenkins 1992).

Part Three is concerned with particular segments of national television audiences. The role of the audience is obviously crucial for, in a very real sense, it is the audience that 'nationalises' an adaptation. However, audiences are composed of subjects who are more than and often other than national readers of television program format adaptations. They are part of larger historical and social formations and have their own biographical trajectories. Chapters 10 and 11 examines several segments of the German and Dutch television audience, stressing the variety of ways in which particular social groups do and do not emphasise their sense of national belonging and the role that television format adaptations can play in these processes. Finally, the last Part consists of a single chapter that returns us to larger conceptual issues of the significance of adaptation and notions of the nation and nationality. Concluding the exploration, it suggests some theoretical touchstones for format adaptation and notions of national identity.

Theoretical Bearings

There is no doubt that the past 25 years have seen dramatic and significant changes in the economic, social and political lives of populations, such that the world shaped by two world wars and their aftermath is well and truly gone. Starting with the two international oil crises of 1973 and 1979, there has occurred a series of profound political and economic events that have helped bring about a different world order to that of earlier this century. Among the most public signs of this change have been the rise of unemployment in the advanced economies of the west and inflation in the Third World, the advent of trade liberalisation, the formation of new international trading blocks, and the end of the Cold War (Galtung 1993). War and physical disasters, changing labour markets and tourism has led to an ever increasing mobility of populations both within and between nation states (Castles and Miller 1993). At the cultural level, there has been equally significant albeit less visible developments, not least in the areas of transportation and communications. Airline travel is now considerably cheaper and more efficient than it was in the mid century. Private car usage has increased while road building has multiplied to keep pace with extra traffic. New technologies for the production and distribution of information and communication have appeared, including fax machines and the mobile telephone, the personal computer and the Internet, broadcasting satellites, cellular and fibre optic cable, digital compression, the videorecorder and the videocassette, CDs and the laser disc (Anderson 1992). How do we make sense of these changes? What are the most important forces at work in the present? What kind of world awaits us in the early years of the next millennium?

Globalisation

Where once terms such as modernity or internationalisation were favourite labels for summarising and understanding these changes, now 'globalisation' has become the favourite ephitet,

one of the most persistent buzz words of the past 20 years. Simply put, the notion of globalisation is the assertion that a world wide system of economic, cultural and political interdependence has come into being or is in the process of formation. Older systems that organised the distribution of political, economic, and cultural power, generally on a national basis, are now being superseded by a more international system or set of forces that span the planet (cf Lasch and Usury 1987). According to theorists of globalisation, one of the major casualties of these profound changes of the late twentieth century is the nation state which is variously described as dying or indeed already dead (cf Horsman and Marshall 1994). Like many other announcements of demise such as the death of the novel, the End of Ideology, the eclipse of Hollywood, the extinction of reading, the passing of colonialism and the death of Communism, to mention just a few recent disclosures of endings, so too the age of nation states seems increasingly to be a thing of the past. According to the economic globalisation thesis, the world economy appears to have recently undergone a profound and qualitative change so that people everywhere live in a time in which the bulk of social life is shaped by world wide mechanisms in which national cultures, national economies and national borders are disappearing (cf Ohmae 1990). The claim is that a fundamental economic reordering is at work which is determining this change: the change is a structural one involving not an evolution but a profound break with the international economic system of the past, a transformation where a global economy, a global culture and a world without frontiers is coming into being. Pointing to a group of external signs ranging from the deregulation of the international currency market and the banking industry to the advent of the Internet, proponents of this view assert that more and more of the internal economic management of nation states is beyond the control of those actors. The external economy in which these states exist has 'globalised' in its basic dynamics and is dominated by uncontrollable market forces (cf Lasch and Usury 1987). Nation states are no longer the major players so far as the economy of the late twentieth century is concerned (Julius 1990; Ohmae 1990). Instead transnational corporations, often with incomes that surpass the incomes of nation states, that have the capacity to locate wherever market advantage dictates and an international reach that make them accountable to no national government are now the principal economic actors on this global stage (cf Aksoy and Robins 1992). The power of nation states has shrunk considerably and they are mostly powerless to influence this globalised economy (Camilleri and Falk 1992). Instead their place is now like that of local or municipal authorities, providing the infrastructure and public goods that the transnational corporations need at the lowest possible cos (Julius 1990; Reich 1992).

However, such claims seem exaggerated and premature, to say the least. (cf Held 1989; Dahrendorf 1990). Although the 'globalisation' thesis is extremely fashionable with many commentators treating it as fact, nevertheless, there would appear to be strong grounds for believing in the persistence

and the continuing pivotal role of nation states, both internationally and domestically. As two British economists have recently argued:

> There is no doubt that the salience and role of nation states has changed markedly since the Keynesian era. States are less autonomous, they have less exclusive economic and social processes within their territories, and they are less able to maintain national distinctiveness and cultural homogeneity. The question, however, is whether such a global economy exists or is coming into being. There is a vast difference between a strictly global economy and a highly internationalised economy in which most companies trade from their bases in distinct national economies. In the former national policies are futile, since economic outcomes are wholly determined by world market forces and by the internal decisions of transnational companies. In the latter, national policies remain viable, indeed they are essential in order to preserve the distinct styles and strengths of the national economic base and the companies that trade from it. A world economy with a high and growing degree of international trade and investment is not necessarily a globalised economy in the former sense. In it nation states, and forms of international regulation created and sustained by nation states, still have a fundamental role in providing governance of the economy. (Hirst and Thompson 1995 177-185)

The cultural corollary of the globalisation thesis is the claim of the advent of a global culture driven by the globalisation of the media of mass communications. Proponents of the thesis of cultural globalisation adopt either a negative or a positive perspective on the brave new world they see as coming into being. Since the late 1960s, theorists of the media such as Guback (1969;1984), Schiller (1969;1976), Wells (1972), and Nordenstreng and Varis (1974) have argued that the increasing tendency for television programs and films from the advanced countries of the west, most especially the US, to dominate national audio-visual systems, is leading to the breakdown of indigenous or national cultures. If the tone here is one of profound regret and mourning, then the supplanting of national culture by a global culture is more a cause for celebration in the writings of a post-modernist tradition that begins with McLuhan (1962; McLuhan and Fiore 1968), continues through Baudrillard (1985), Jameson (1984;1986), Featherstone (1990), Robertson (1992) and Kahn (1995). If, in the argument about economic globalisation, the nation state is being surpassed as an agency of economic management, so in the latter argument, national culture is more and more eclipsed by a consumer culture that is now to be found everywhere. Increasingly, everyone lives in a world where difference is disappearing, McLuhan's global village, where world populations are more and more subject to the same universal culture, transmitted by what is now seen to be a global media. In the words of a recent proponent of such a view:

Mediascapes refer(s) both to the distribution of the electronic capabilities to produce and disseminate information (newspapers, magazines, television stations, film production studios etc.), which are now available to a growing number of private and public interests throughout the world; and to the images of the world created by these media. These images of the world involve many complicated inflections, depending on their mode) documentary or entertainment), their hardware (electronic or pre-electronic), their audiences (local, national or transnational) and the interests of those who own and control them. What is most important about these mediascapes is that they provide (especially in television, film and cassette forms) large and complex repertoires of images, narratives and ethnoscapes to viewers throughout the world, in which the world of commodities and the world of news and politics are profoundly mixed. What this means is that many audiences throughout the world experience the media themselves as a complicated and interconnected repertoire of print, celluloid, electronic screens and billboards. The lines between the realistic and the fictional landscapes they see are blurred so that the further away these audiences are from direct experiences of metropolitan life, the more likely they are to construct 'imaginary worlds' which are chimerical, aesthetic, even fantastic objects, particularly if assessed by the criteria of some other perspective. (Appadurai 1990 p 298)

Again, this kind of view seems exaggerated and premature. First, it ignores the historical dimensions of this process of the internationalisation of communications. This system is not new; its origins can be traced back, not only to the spread of Hollywood films in the years during and immediately after the First World War (Thompson 1985) but even to the development of the international submarine telegraphic cables and news agencies in the nineteenth century (cf Noam 1991; Tunstall 1970). In addition, such a view of a homogenised global culture in which populations on a world wide scale view the same programs and derive much the same meanings from them seems excessively determinist. Using the apparent global circulation of films, television programs, music and other cultural goods and practices as evidence, an argument that has been described as 'the distribution fallacy' (Schlesinger 1987 p 239), a multicausality is inferred between this availability and a process of cultural homogenisation. On the one hand, the consumption of these cultural goods are assumed to bring about this homogenisation; on the other hand, the consumption becomes evidence that this homogenisation has already taken place. If the logic of this argument is flawed, so too are other kinds of evidence of globalisation. Certainly as Appadarai and others have noticed, there is an international system that facilitates a large scale distribution of film, television, music advertising and so on. However, as Ferguson notes, despite the claims of global circulation, these cultural artefacts would

at most only reach approximately one third of the 5.3 billion people living on earth with a heavy bias towards the OECD and G7 nations (Ferguson 1993 p 73). Moreover, if there is skewed access due to population size, domestic wealth and geography, there is also structured inequality of access due to the cultural background of individuals. As Ferguson puts it:

> ... despite this more visible world of 'the distant other' and a more interconnected world political and cultural economy, we cannot infer from this an homogenised global metaculture. To do so would be to ignore the historical role of stratification systems based on caste, class or party, on ethnic cultures defended by bloodshed or kinship traditions linked to religious proscriptions stronger than any claims that might be made for the reductionist power of global media. (Ferguson 1993 p 72)

Finally and even more importantly for present purposes, there is the fact that international trade in television programs while impressive in terms of its value, is, nevertheless, dwarfed by the overall volume of television programs that only receive domestic circulation. The fact is that most of the world's television programs are produced and broadcast in national television systems and do not receive international distribution. Criticising the all-too-ready recourse to metaphors of 'globalisation', one author has recently pointed out:

> Such research generally fails to accord an integral place to 'local and regional' production and the 'indigenising' of international product within the resulting market mix. In short, the tendency is to focus only upon what is internationally traded to the exclusion of what is locally traded. To be sure the US accounted for 71 per cent of the international trade in 1989 ($1.7 billion out of an estimated total of $2.4 billion in television exports) But this dominance needs to be understood with reference to the very much larger sum of estimated world television production that never leaves its nation of origin. This nationally destined programming accounted for an estimated $US 70 billion in 1989 – 29 times greater than the amount spent in international audio-visual exchange. (O'Regan 1992 p 87)

Of course this kind of figure must be treated with caution. After all such a figure will include low- cost domestically produced programming which will often attract small audiences. Nevertheless such an observation gives pause to the claims of the cultural globalists. While the international circulation of television programmes is important, nevertheless nationally produced television programs are far more significant for both local producers and local audiences. Such an axiom would seem obvious and even redundant were it not for the omnipresence of the globalisation argument. This same unsurprising fact finds support from yet another quarter. Recently a series of national researchers working independently in countries such as Australia, Brazil, Germany and Quebec have shown that, where national audiences have

a choice, they usually prefer television programs produced nationally or in the national language as against imported programs. (Becker and Shoenbeck 1989; de la Garde 1994: Ferguson 1993; Katz and Wedell 1977; Larsen 1990; Moran 1985; and Silj 1988,1992)

National Television Systems

Up to this point, we have concentrated on the claims of globalisation and some of the problems of argument and evidence associated with that position. Our particular subject is international television, the extent to which it is globalised and the extent to which it remains national. As against the claims of the globalists, we can identify several mechanisms that have worked both singly and in concert to create and sustain world television as a series of mostly national systems. By the term national here, I mean a system whose geographic and cultural reach is more or less coterminous with the borders of a nation state. Of course in both the past and the present, there have been important exceptions in terms of services that have been oriented towards serving both larger and smaller populations: geography, nation and television often do not coincide. Generally speaking though, television systems have been and continue to be national. This is not surprising for there are several factors working to bring about such an outcome.

First, in reflecting on the link between the nation state and communication systems, it is worth recalling that the present international system of wire and wireless communication, including television broadcasting, is based not on the recent activities of transnational media corporations, no matter how powerful or wealthy, but rather on agreements reached between nation states in the nineteenth and twentieth centuries (Nowell-Smith 1991). In fact, this system of agreements is rooted in a tradition that dates back to the sixteenth century and the establishment of highly profitable state postal monopolies (Noam 1991). These early international agreements between the postal authorities in nation states were extended to include telecommunications when it was realised that radio waves did not respect political boundaries (Head and Sterling 1987). Nation states co-operated in regulating use of the electro-magnetic spectrum, internally through their telecommunication authorities and internationally through the International Telecommunications Union. This body is an agency of the United Nations with headquarters in Geneva, Switzerland. Nation states are admitted as members by means of treaties, after which they meet regularly to agree on ITU regulations. The ITU adopts frequency and other technical rules, standardises terminology and procedures for international information exchange. Member states, no matter how small, are recognised as having a right to the airwaves. In turn, it is the telecommunication authorities of the particular nation states who decide which groups might be allocated broadcasting frequencies and under what conditions. (Head and Sterling 1987) Although the particular arrangements in different nation states have differed historically, varying from the licensing of private commercial broadcasters in

the US, the mixed or dual systems of public service and private commercial broadcasters to be found in Australia, Canada and many parts of South America, to the former monopoly situations of many European countries, whether the monopoly was held by a public service broadcaster or one that was more completely under the control of the state, nevertheless the fact remains that it is nation states that are the final arbiters of the airwaves.

In other words, despite recent changes that have seen many countries move from a monopoly to a dual system and the phenomenon of satellite-delivered cross-border broadcasting, national television broadcasting structures persist as the constituent elements of the international television sector. World television continues to be determined through a complex system of external and internal governance of nation states rather than the international activities of transnational media conglomerates. In turn, nation states have made crucial choices when it comes to organising the domestic details of their television systems. Two examples – having to do with technology and program content – can be cited. One significant technology of television among many has been the scanning system for the recording, transmission and reception of a television image. With monochrome (black-and-white) television, at least 12 systems existed, known as the A to M Systems, the systems being based on a series of technical variables including the number of horizontal lines in a picture, band and channel widths and vision and sound modulation. Thus, broadcasts transmitted on one system could not be received on television sets manufactured for a different system. This was the situation that had obtained historically between regions such as the US, UK, France, Western and Eastern Europe (Paulu 1970). European nation states hoped to overcome these differences with the introduction of a single colour system in the 1960s (Dizard 1966). However with colour, there were again several systems available – the US NTSC, the German PAL and the French SECAM – and once again these were incompatible so far as standards were concerned. A study of the French decision to adopt the SECAM system demonstrates clearly that a nation state's technical choice can be a deliberate means both of protecting domestic industries and controlling broadcasts transmitted across national airways. (Crane 1979) Nor was this incompatibility confined to Europe but has also existed elsewhere. In South America, for example, Argentina uses the PAL system while neighbouring Chile is on the NTSC system while in Asia, North Korea is on SECAM although South Korea is on NTSC.

If nation states have made technical decisions about their television systems, they have also had to develop regulations concerning such issues as who will broadcast and what will they put to air. One determining factor affecting this issue has been state policies to do with the volume of nationally produced and imported television content shown in a national television system. Obviously, such regulations are significant factors in determining the national character of a television system. Thus, for example, the UK has in the past insisted that as much as 84 per cent of programming be originated in that part of the world, the BBC itself only being allowed to import 14 per cent of

its programming while France has set a level of 60 per cent for local programming (Alvarado 1997; Balio 1995; Emmanuel 1997). In addition, quota regulations in national television systems can also stipulate the sources of imported programming – the most significant recent decision at this level being the 1989 directive of the European Community that: 'Member States should ensure, where practicable, and by appropriate means, that broadcasters reserve for European works a majority proportion of their transmission time, excluding time appointed to news, sports events, games, advertising and teletext services'. (European Communities 1989 p 27)

Clearly this last consideration highlights yet another general feature of national television systems. Such systems exist legally, economically, and geographically within the boundaries of nation-states which licence and regulate the activities of individual broadcasters. Although these may not have a specific cultural mandate, nevertheless the national television system will inevitably have cultural effects, by subjecting everyone within a given territory to the same type of service, thereby producing notions of equality and commonality, by instituting the expectation of rhythms of service, subjecting everyone to the same flow of content. This is part of a process of enculturation that promotes a sense of community among a particular group of viewers within a national territory. However if a national television system accomplishes the task of identity formation, then it does so only in very differential ways. With this caveat in mind, we might examine three further ways in which national television systems have cultural consequences.

We have already touched on the first of these. Language, together with religion, is the most important component of a particular culture and it literally defines the world view of its linguistic community. The preceding section has mentioned several examples where particular national communities prefer indigenously produced programs to imported programs. Such domestically produced programs will of course be in the national language or, in the case of a bilingual or multilingual nation state, in one of those national languages. Television programs in these languages are invariably preferred to imported programs. As one European commentator has put it:

> … (language is) the irreducible impediment to transborder television programmes In spite of all the changes, mass media are still organised on a national basis or function on a sub-national entities, corresponding to language communities in multilingual countries such as Belgium and Switzerland. This fact reinforces the point that language is really the key cultural factor when it comes to mass media. Smith (1990 p 175) emphasises this, in writing that 'communication networks make possible a denser, more intense interaction between members of communities who share common cultural characteristics, notably language. (Heinderyckx 1994)

Overlapping the element of language is another, a more diffused one that might be called the national television culture. This infrastructure includes a

variety of interlocking practices and procedures that help make a national television system distinctive and include program scheduling, promotion and marketing, advertising, and subtitling and dubbing of programs that have been produced in a 'foreign' language. Collectively, these practices work to overcome some of the otherness of imported programs so far as domestic audiences are concerned; in various ways, they help create equivalences between imported programs and ones produced inside the national broadcasting system. Scheduling, for example, is important in synchronising the broadcast time of a program with the domestic routines and rituals of the nation. (cf Williams 1974) There is no universal pattern that dictates how long an instalment of a particular program will run or where it should appear in the daily television schedule. Thus, even in advanced capitalist nation states such as France and the US, there are different perceptions about matters such as the duration and timing of such programming zones as prime time access and the broadcast length of programs in prime time. (Jazequel and Pineau 1992; Saenz 1997) Scheduling also concerns itself with both the placing and timing of commercial advertisements, during and between the transmission of programs and here too practices differ from one national television system to another. (cf Tulloch 1989) In any case, commercials carry their own messages about the range of goods and services which, although often produced by international companies, circulate in a particular national territory and are very often produced within the same geographic space. Subtitling and dubbing further elaborates this effect of domestication by partially translating the text that is the imported program into a language, written or spoken, that is, in the case of monolingual nation states, the national language or, in the case of multilingual states, one of the national languages. (Kilborn 1993)

Yet another mechanism that helps secure the local character of a national television system is domestic production. Domestic production can be generated from three different sources – locally originated concepts and projects, program ideas that serve co-production arrangements and those based on format adaptations. Government policies have very often had much to say about the first two of these sources, frequently suggesting formulas or criteria for deciding on the nationality of a content depending on the nationality of the originating creative or industrial source. On the other hand, little attention has been given to the subject of program formats and their national adaptation and it is to this subject that we now turn.

Part One

The International Format Trade

The Pie And The Crust: Television Program Formats

<div style="text-align: right">**2**</div>

What Is A Format?

How then do we define a format? The term had its origin in the printing industry where it is a particular page size in a book. My word processor's thesaurus lists 13 different synonyms for the term, ranging from 'blueprint', through 'pattern' and 'design', to 'model' and 'shape'. However, where these terms suggest an aesthetic dimension in designating an object that can be copied, the term format in the phrase – television format – carries a particular industrial set of implications. In radio first and then in television, the term has been intimately linked to the principal of serial program production. A format can be used as the basis of a new program, the program manifesting itself as a series of episodes, the episodes being sufficiently similar to seem like instalments of the same program and sufficiently distinct to seem like different episodes. Similarly, behind industrial/legal moves to protect formats, lies a complementary notion that formats are generative or organisational. Thus, from one point of view, a television format is that set of invariable elements in a program out of which the variable elements of an individual episode are produced. Equally, a format can be seen as a means of organising individual episodes. Van Manin quotes a television producer who offers a more colloquial summary of this latter point: 'The "crust" is the same from week to week but the filling changes'.

Several elements constitute a format (Dawley 1994). From an industrial perspective, television programs can be divided into two types: those to do with 'reality' programs, such as news, talk and game shows; and those to do with drama, including situation

<div style="text-align: right">13</div>

comedy. In turn, van Manin identifies a series of material components of each of these types. A game show's elements, for example, include a written description of the game and its rules, a list of catch-phrases used in the program, information on how prizes are to be assembled, copies of artwork and decor designs and blueprints, and software for computer graphics. In the case of situation comedies and drama series, the concept will typically include an outline of the narrative situation of the series, perhaps with projected storylines, together with a detailed outline of the characters. In addition, the package may also contain further elements useful in subsequent productions such as computer software, scripts and footage. The software may facilitate the production of graphics and program titles; the filmed footage can be included in both a program such as a game show and in an anthology-type program such as *Funniest Home Videos*; while the scripts can be used directly in a new version of a program, can be modified or adapted to a new setting, performers or production circumstances, or may simply be available as background material.

There are two other elements that may be in a format package and although they are not formally a part of a format, nevertheless their inclusion signifies the actual nature of the exchange taking place under the name of the licensing of a format. The first element is the Bible – a compilation of information about the scheduling, target audience, ratings and audience demographics of the program for its broadcast in its original national territory. Needless to say, it is only programs that have been successful in gathering large audiences in one territory that will be attractive for licensing purposes in other territories. The second element is a consultancy service provided by the company owning the format. The consultancy will generally take the form of a senior producer from the original production overseeing and advising the early production of the adaptation.

At this point, by way of illustration, we can briefly examine a television format package that has recently become available for licensing.

Room 101 was a light entertainment series broadcast on BBC2 in the UK in 1994. The program was described as a chat based comedy show that each week featured a celebrity guest star. Subsequently, in 1995, the program was formatted, an operation whereby the precise production elements and their organisation, including the steps of production, were documented in a booklet known as the Format Guide, itself part of BBC Programme Format and Production Kits series ('The cost-effective way to originate your own successful series'). Like a cooking recipe, the Guide identifies both the ingredients and the sequence and manner of their combination that will produce an adaptation of *Room 101*. The booklet, prepared by the BBC, includes general notes on the host, the guest, the 'rules' of the show, the set and the individuals that constitute the production team. A second section deals with the organisation of time in the production process and includes descriptions of how an episode is researched, how choices are finalised, scripting, timetabling the studio day. Yet another part of the Guide deals with the bud-

get and an audience profile based on audience research on the UK production. Finally the package also contains a sample post-production script based on a UK episode together with detailed studio and set plans. A note on the cover of the Guide indicates further elements of the overall package: the Format, whose rights are jointly owned by an independent production company, Hat Trick, and the BBC; Consultancy ('Advice and guidance throughout the production process'); Design ('Studio plans and set design'); and, Video Cassette ('BBC programmes for reference and inspiration'). The front page summarises the benefits of the package, most especially the format: 'Repeat the winning formula – Create your own successful series of *Room 101* with BBC World Wide Television's format package. Minimise the risks – formats offer tried and tested creative ideas for reliable quality programming. Grasp the essentials – each package contains many elements you need to make an individual series tailor-made to your own particular requirements'.

However, the analogy between a television program format and a cooking recipe breaks down when we consider the legal and industrial dimensions of television program formats. For if part of a format package consists of a list of ingredients and an outline of how these are to be combined, this act of documentation carries its own industrial and legal significance. Many of the elements already described exist as intellectual properties so that formatting involves not only the documenting of constituent features of a format but also involves obtaining legal clearance for their use in format adaptations. In other words, as well as having an aesthetic component, television program formats also have an important legal dimension.

The Legal Context

Adopting a broad historical perspective, we can suggest that, coincident with the international television industry's elaboration of the elements of the format has been the attempt to secure legal protection for the creator and owner of a format. This has been sought through three legal instruments – copyright, breach of confidence and passing-off (Mummery 1966a, 1966b; Lane and Bridge 1990). Copyright appears to be the most important of the three: certainly, it is the first area to which van Manen attends in his legal handbook on formats and it is the one that receives most attention (pp25-68). van Manen cites a number of cases of legal action in countries such as the Netherlands, France, Germany and the US which were based on the perceived copyright infringement of television program formats. However, what is revealing is the fact that all these actions were lost, a view that has been corroborated several times. (cf Fuller 1993a) To paraphrase van Manen:

> The extent or magnitude of protection by the copyright act is not large: a new production can be created by changing characters or other elements in a format; the combination of the elements may be protected by copyright but such protection exists in limited degree for the individual elements; excessive imitations can be

fought with the Copyright Act but the imitator who makes some minimal changes is likely to succeed. Often the strength of the format lies in the idea which forms the basis of the format and it is this which has been shown to be least protected. In any case, there are doubts as to whether program formats can be copyrighted. (1994 pp25-6, paraphrase by van Canon/Moran)

This point has been reinforced by other writers (Rubinstein 1957, Burnett 1988; Kean 1991; 1957). For present purposes, it can be underlined by a brief examination of two cases where legal action was initiated on the grounds of copyright infringement. The first occurred in the US and concerned the situation comedy, *The Cosby Show*, which starred popular black comedian Bill Cosby. The matter began in 1980 when Hwesu Murray, following preliminary discussions with an NBC official, submitted short written proposals for five new shows to the network (Levine 1989). One of these was a situation comedy, *Father's Day*, which concerned a black middle-class family where the father was a lawyer. At NBC's request, Murray expanded several of these proposals. *Father's Day* subsequently grew to two pages and included the casting suggestion that actor Bill Cosby play the lead role. Late that year, NBC returned the material and indicated that it was not interested in the proposal.

In 1984, NBC aired *The Cosby Show*, a situation comedy about an upper middle class family where the father is a doctor and the wife is a lawyer. The series starred Bill Cosby. Murray took legal action against NBC and the packaging company that produced the series for the network. The grounds included infringement on the format of *Father's Day* and breach of implied contract. In 1987, the defendants moved successfully in a district court in New York to have the complaint dismissed on the grounds that Murray's 'ideas'(format) lacked sufficient novelty to sustain a misappropriation action. An appeal in the following year upheld this decision.

There are various anomalies in the case, most especially in the court's decision that have been discussed elsewhere (Levine 1989 pp139-51). For our purposes though, it is worth noting two features of the case. The first is the fact that since the US Copyright Act of 1976, the US Copyright Office has recognised television program formats as copyrightable (Libott 1968; Fine 1988). Nevertheless, the court in this case decided that the format for *Father's Day* was not sufficiently novel as to attract legal protection. The second detail is the fact that the format existed only as a series of verbal ideas communicated by Murray to NBC and as a two page written outline. Van Manen makes the general point that the more concrete a format is the more chance it has of attracting copyright protection (1994 pp69-71). The third feature is a set of specific facts associated with the case. The original format for *Father's Day* existed only as a written outline and not in the form of a finished program which might have been tendered as evidence. In addition, the circumstance that the alleged offence occurred in the same country where the original had been developed meant that legal action also occurred there.

The second case concerns a much more concrete format that was imitated in another national territory so that initial court action, following the Berne Convention, occurred in the country where the alleged infringement took place. In 1978, Hughie Green, who created, produced and compered the long running British television talent game show, *Opportunity Knocks*, was contacted by the British Inland Revenue for an account of royalty payments for a version of his program being produced by the Broadcasting Corporation of New Zealand. Green had never been approached by the BCNZ for permission to use his format nor had the Corporation offered him payment for its use. On checking the unauthorised version of the format being produced by BCNZ, Green found that it imitated all the important aspects of his format with the obvious exception of not using him as the host. Negotiations between the parties broke down and Green sued in the New Zealand courts on the grounds of passing off and copyright infringement. The action failed. Subsequently he decided to appeal the decision. Because New Zealand is a member of the British Commonwealth, the appeal was heard at the Privy Council in London. In 1980, the latter upheld the New Zealand decision on the basis that the format of *Opportunity Knocks* had little or no dramatic value and therefore no copyright could exist (Lane and Bright 1990; Lane 1992). In turn, that decision has led to debate about whether the new UK Broadcasting Act needed amendment (Lane and Bright 1990a, 1990b; Lane 1992; Martino and Miskin 1991; Smith 1991).

These two cases – the *Father's Day / The Bill Cosby Show* and *Opportunity Knocks* – highlight the uncertainty concerning copyright protection of television formats. In addition, the two plagiarised formats had no more legal protection under the other two grounds of breach of confidence and passing off. Not surprisingly, van Manen's legal handbook on formats urges producers to include in their contracts every possible means of legal protection in the area of intellectual property, including patent law, brand names and trade marks, a call that is echoed elsewhere. (van Manen 1994 pp 69-121; Battersby and Grimes 1986; Freedman and Harris 1990; Kurtz 1990) In other words, a closer examination of the legal context of television program formats discloses that finally they may have little protection in law. That does not however prevent an elaborate legal machinery playing its part in the international format business. Formats are registered for copyright purposes, format libraries are bought and sold, licence fees are paid, legal threats are continually made and court actions launched. In fact, for the most part, format owners, producers and others behave as though formats have solid legal protection. If we turn to an examination of the industrial context of program format adaptation, then it becomes clear as to why the arena needs to appear as though it is ordered and bound by legal rules rather than chaotic.

The Industrial Context

In a real sense, to ask the question 'What is a format?' is to ask the wrong kind of question. Such a question implies that a format has some core or

essence. As our discussion has suggested, 'format' is a loose term that covers a range of items that may be included in a format licensing agreement. The term has meaning not so much because of what it is, but rather because of what it permits or facilitates. The format is a technology of exchange in the television industry which has meaning not because of a principle but because of a function or effect. A relevant analogy is with another regulatory function in the broadcasting industry, namely the system of program ratings. Television program ratings have often been criticised both for errors in their calculation and on the grounds that they are not accurate indicators of how audiences actually listen to radio or watch television. In fact though, such criticisms are beside the point. For finally the function of ratings is more important than their accuracy. Ratings are a mechanism of exchange between broadcasters and advertisers where what is exchanged is the 'audience'. Ratings 'work' not because they are valid indicators of what real viewers do when they watch television but because they quantify an object that broadcasters can sell to advertisers, namely a market (Ang 1991).

Similarly, the concept of a television format is meaningful in the television industry because it helps to organise and regulate the exchange of program ideas between program producers. In the past, before the formalisation of the format, the exchange of such ideas was improvised and *ad hoc*. Plagiarism – borrowing of ideas without sanction or payment – was rife. In particular, program producers from European countries such as the Netherlands, from Australia and from South America regularly adapted program ideas from US radio and later television. Early payments for the use of program ideas were *ad hoc* and more in the nature of a courtesy to the original producer or owner. Brunt, for example, notes that the BBC in 1951 paid Goodson-Todman, the US devisors of the radio game show *What's My Line?*, a total of 25 guineas an episode for the use of the format (Brunt 1985 p 28). Clearly with the cost of development of a format (if indeed it might be said to have a cost – the cost of devising a format being amortised in a program's original production), a licence fee had to be set according to what a licensee could pay. While the originator was anxious to extract as much payment as possible, there was also a *de facto* ceiling on the level of payment; an exorbitant licensing fee for the use of a format can lead to borrowing without payment. By the late 1970s, as part of a larger formalisation of the exchange of program ideas, a regular licence fee system seems to have emerged in the international television industry (Mason 1996). In turn, this formalisation seems to have helped stimulate international trade in formats in the 1980s and the 1990s.

However, the expansion of the format market in this period can also be linked to other, more salient factors. The period has seen a dramatic change in national television systems in many parts of the world with de-regulation, privatisation and the advent of new distribution technologies. This has led to a multiplication of television channels available within national boundaries. The increase in channel choice, in turn, has the potential to fragment televi-

sion audiences and, as a consequent, the ever-present industry imperative to try to ensure audience popularity for new programs is exacerbated. Obviously, the import of low-cost, foreign programs is one way to fill the expanded number of time slots in the new television environment. However, such a strategy does not necessarily ensure good ratings and, ultimately, does not expand or even guarantee existing advertising revenues. In surveying the particular significance of formats from the point of view of national television producers and broadcasters, we can note constraints relating to program imports on the one hand and national program productions on the other. In other words, why do countries such as Germany and France produce their own versions of a television program such as *Wheel of Fortune* when other countries such as the Philippines and Columbia prefer the more economical option of importing the US version? The answer is a mixed one. For some producers and broadcasters in some national territories, the overwhelming consideration will be financial and the US version will be imported and screened. However such a version will always be 'foreign': American-English will not be the language of the national population and the program may have to be subtitled or dubbed; the version will feature American contestants and host; the game in this version will draw on cultural knowledges and abilities most available to Americans; prizes will be in the form of goods and services deemed desirable by Americans but not necessarily by other national populations. However, financial considerations have also to be reckoned against ratings success. A locally-produced version of *Wheel* will be more expensive than the imported version but, with local contestants, host, questions and references, prizes and so on, is likely to have more national appeal and is therefore likely to achieve better ratings. Certainly, as was noted in Chapter 1, that seems to be borne out by some long term studies of the process of import-substitution of television programs. As a UK-based market analyst put it:

> ... there is an interesting counter-phenomenon occurring, which is the increasing domestic level of demand in peak time in television schedules. So, for example, American dominance of key terrestrial broadcasters around the world is dropping. In the peak 6 pm to 11 pm slots, it is very difficult now to get a major American series to work on the main channels here – BBC1 or the ITV Network. So big hit, syndicated shows like *The X Files*, *Emergency Room* and *NYPD Blue* are actually working as cults here on Channel 4 and BBC2 with a half or even a third of the audience reach that they would get in comparable markets. What we notice around the EC is this domestication of prime time means that there are some local vitality in those markets. I do believe that, long term, the domestication issue will spread. There is a classic S curve at work here. When a new channel enters the market, whether by cable or satellite subscriptions or advertising, it has very little earnings. It is therefore in a position where it has to import low-cost program-

ming. I helped the launch of a satellite channel in the UK called *UK Living*. It was targeted to women. And the buy-ins were 95 per cent. But it was already noticeable on this minor channel that in any 15 minute day part had only 30,000 viewers (although its cumulative audience for the week is high) that the domestic element – a couple of hours of chat and life style which we originated – were already very popular. Within 18 months ... (this program) ... had been extended to three hours. The second thing that has occurred is that a couple of American shows have been licensed to be re-made with British components. So you can already see the domestication of this minor channel. We have predicted that within five years over 50 per cent of its prime time content will be original, although, in many cases, it will have been licensed from American formats.' (Stiles 1995)

If there is a general commercial logic at work that leads to a preference for the more expensive domestically-produced program over the lower cost imported program, then the same logic will tend to favour a format-adaptation over an original concept. An original concept is exactly that; it is untried, untested and therefore offers a broadcaster little in the way of insurance against possible ratings failure. Even if a broadcaster commissions a development, there is no guarantee that the would-be program will survive the trialling process and will go into production. And even if it does, the producer and broadcaster have no security that the program will be a popular success. Formats, on the other hand, are almost invariably based on programs which were a popular success in another national territory. In other words, formats come equipped to survive the trialling process of being tried and tested. The ratings Bible is a kind of guarantee that the format is a successful one: an adaptation of the format is therefore likely to repeat the program's original success. In addition, a video episode of the program from the other territory, recorded off-air, can be offered as an equivalent of a pilot episode for the new series (D'Alesandro 1997). Thus, for example, Reg Grundy Productions contracted to produce an American version of the game show, *Sale of the Century*, for the NBC Network on the basis of an episode of the Australian version. This kind of practice represents a significant cost saving and will help offset part of the licence fee for a format adaptation. In other words, there are significant savings in the area of program development to be achieved through using a format from another territory rather than developing an original concept. Of course, previous success does not absolutely guarantee future success. Adaptations frequently fail with audiences. However the point is that the format-adaptation offers some insurance and security to broadcasters and, in an industry so beset with uncertainty, such a promise is worth having.

Of course, there still remains the question: why pay a licence fee for using the format, why not simply borrow the program idea without paying a fee? The answer is reasonably obvious. Unauthorised infringement may lead to

costly legal action. Paying a licence fee is, therefore, a means of offsetting the cost of defending the action. In addition, the unlicensed use of a format will damage a producer's business reputation and may lead other format owners in the future not to deal with that producer. However, as the *Father's Day / The Cosby Show* and the *Opportunity Knocks* cases demonstrate, borrowings without payment continue to take place (cf Fuller 1993a; Driscoll 1994). Thus, the capacity of format owners to protect formats would seem to be directly related to their commercial strength and ability to bring legal pressure on others. The more positive reason, though, why licence fees are paid is because it appears to give access to the format's previous success in another national territory.

However – and this is an important point – in licensing a format, a producer is allowed a good deal of flexibility so far as the choice and arrangement of elements in the adaptation is concerned. There is a recognition that the original set of ingredients and their organisation may have to be varied to fit production resources, channel image, buyer preference and so on. The original formula does not have to be slavishly imitated but rather serves as a general framework or guide within which it is possible to introduce various changes to the original formula. In other words there is variation within repetition. Thus, for example, as we shall see in more detail in Chapter 6, the German-originated game show format *Mann O Mann* was adapted for an Italian version: the title was changed to *Beato Tra Le Donne*; the set, decor and costumes were varied; the number of contestants increased ; and the program was elongated from an original length of about 55 minutes per episode to 140 minutes per episode. And indeed in the case of drama adaptations, the new version may move a considerable distance away from the original with new characters, situations and storylines, new settings, and new sounds. Thus, for example, the BBC's *EastEnders* is set in a working class part of London, the characters who have British names, such as Pete Beale and Gillian Tayleforth, speak English with Cockney and other accents. An adaptation of that program's format, *Het Oude Noorden* (The Old North), produced by IDtv in the Netherlands, is, by contrast, set in Rotterdam and the characters, who have mostly Dutch names such as Jozefien Otteveanger and Ismael en Van Ozcan, and speak Dutch with regional accents, including that of Freisland.

Significantly, under standard format licensing agreement, the variations to a television format developed through these types of adaptation become a further part of the format with ownership vested in the original owner. Clearly, under this type of permitted variation, there is no veneration of originality; rather, the format is seen as a loose and expanding set of program possibilities. There is, on the part of the owner, the overriding imperative to gain maximum commercial advantage from everything generated from the initial set of elements. In turn, the new elements introduced as variations in the adaptation will be equally as available as the original should a further adaptation of the program be required. Thus, for example, a South American version of *Man O Man*, prepared for broadcasters in Argentina, Uruguay and

Paraguay in 1996/7, drew as much on the Italian version of the format, *Beato tra le donne*, as it did on the German original. This flexibility contained in format adaptation underlines an important general point. Among the few media researchers who have noticed the phenomenon of television format adaptation, there is a tendency to assume that adaptations are a mechanical repetition of the initial format (cf Strover 1994; Lull 1995: Sinclair 1996). Such accounts tend to assume that formats are invariably those of game shows, a genre that is held in low critical esteem, such that adaptation is no more than a simple repetition of the ingredients in the original version of the program. Aside from a High Culture snobbery around notions of originality, this line ignores the extent to which an adaptation of a format for a particular national territory will involve considerable amounts of skill and experience in adapting, varying, amending, improvising, creating and so on using the initial format as a source. In other words, the process of nationalising a television program format is undoubtedly a more subtle and complex process than some commentary would have one believe. After all, as has already been suggested, a television format is actually a regulatory mechanism in the international television industry. The written concept of a particular format may be brief indeed so that a producer, in adapting such a concept for a particular national territory, may have the task ahead of her or him.

Finally, we should note that besides commercial considerations, national television producers and broadcasters have to consider the political implications of importing a program or adapting a format. It was noticed above, for example, that some countries import the US version of *Wheel of Fortune* while others produce their own versions under licence. Aside from cultural considerations, program imports have little in the way of a domestic financial spin-off. A national adaptation of a format, on the other hand, provides employment in the national territory and may lead to international sales of the adaptation. It will also provoke fewer complaints and less unrest among production workers, cultural critics and politicians than will imports or co-productions. And aside from employment arguments, there are also cultural arguments in favour of what is nationally produced. Here one runs into an interesting situation in that there appears to be a general reluctance on the part of national cultural critics and policy makers to make any distinction between programs wholly originated in the national territory and those that are adaptations of international formats. In practice, these two different kinds of program are regarded by media regulators and governments alike as domestic or national. Such a classification has not been the outcome of debate or enquiry: indeed, there is a general policy vacuum surrounding this aspect of format adaptation. While the classification may seem like an obvious and sensible response to the situation – after all, audiences make no distinction between the two types – nevertheless what is interesting is the lack of political debate, the fact that television program format adaptation usually does not appear on the political or cultural agenda. And yet, there are often

relevant precedents and policies at work in related areas. Thus, for example, the regulation of Australian content in commercial television has never involved a consideration of the national origins of a program that is locally produced. Quite the contrary. Programs that are Australian adaptations of overseas programs are equated with programs that are based on locally derived ideas, both qualifying as Australian (Moran 1985). On the other hand, what constitutes Australian content so far as government support for Australian film production is concerned has often been more closely defined. In 1983 the Federal Minister for Home Affairs issued guidelines for film producers on the criteria that should be taken into consideration in deciding on the Australian content of a project for tax-relief purposes. The guidelines specified that the source of the script be Australian. They went on:

> ...where the source is non-Australian, the scriptwriter would be expected to be Australian and the subject-matter should be demonstrated to be in accordance with the above criteria (viz. the 'concept of a film can be expected not to be alien to the Australian multi-cultural experience'). *'Australianised' versions of foreign scripts would not normally be acceptable.* (Quoted in Dermody and Jacka 1987 pp 149-150; my emphasis)

The argument then is that 'formats' are a relatively recent development in the international television industry that has led to both a formalisation and a regulation of the movement of program ideas from one place to another. A format is a cultural technology which governs the flow of program ideas across time and space. The elaboration of what is being transferred together with its embedding in a legal framework has been a powerful means both of codifying and stimulating trade in this area. By turning to an examination of the role played by program formats in international television, we can strengthen this argument about the relational meaning of formats.

The International Format Market: Players and Trade

This chapter offers profiles of some of the major industrial players in the international television program format marketplace. In order to grasp how the field is structured, it is worth noting the relationship between three different types of international trade in television, namely program sales, co-productions and program format adaptation. If a company has a program format that it has made available for licensing in foreign territories then it also inevitably has a successful, finished home version of the program. In other words, its overall activities as a company or organisation is not restricted to format licensing. It is inevitably a program producer in its home territory; in turn, it will also seek international distribution of finished programs, looking to sell these programs into other national markets; and, finally, it has program formats that it can licence. Unless it is an international company with its own branches in different national television markets, then it must - so far as the licensing is concerned - enter into negotiation with national producers. This leads us to the notion of co-production although one that is significantly different to the usual sense provoked by that term. The most common model of a co-production is that which might arise on a feature film or television series production where companies from two or more different national territories come together as roughly equal partners in devising, funding and producing a film or series that will, because of casting, subject matter, story or some other textual factor, have equal market appeal in two or more national audio-visual markets (cf Porter 1985; Strover 1994; Jackel 1995). However such a model of co-production is by no means universal. In particular, it does not apply to some of the production arrangements that are

engendered through the process of format adaptation across national boundaries. As we shall see, in this and the next two chapters, some of the larger international television program producers with extensive format catalogues often enter into co-production arrangements with national producers with the intention of producing a national adaptation of a program format that is designed for that particular national market only. In other words, the international program sales divisions of large production companies, including several of the organisations discussed here, are in direct competition with their formatting licensing divisions.

In turn, these three elements of foreign program sales, co-production arrangements and format licensing help us to sort the field into different types of players. It is by no means the case that one program formatter is the same as another (cf Akyuz 1992; Fuller 1992). What follows is not exhaustive but it does serve to identify the major players, their market position and strategy. The first group are companies with strong production track records in their domestic market. Accumulating an extensive library of programs, they have sought to expand through foreign sales of programs. In turn, program distribution tends to also take on the ancillary function of format licensing in other national territories. However, these companies' resources are mostly oriented to domestic production so that the only extra value they can realise from format licensing is through the provision of consultancy services. The second group involved in format adaptation do so as an extension of their activities as brokers or agents of program owners and producers. Here the company neither originates or owns the format nor is it involved in the domestic production of the program. Instead it becomes the agent of the producer in relation to domestic syndication sales and also for the program's international distribution. As an extension of its agency role in foreign territories, the company also licences foreign adaptations and will often become involved in the production of these adaptations, either as sole producer in a particular foreign territory or else in a co-production arrangement with a foreign broadcaster or producer. The last group function as producers, adapting formats that they have devised, purchased or themselves licensed as the bases of program adaptations in the various countries in which they operate. Thus they come to broadcasters not only with a catalogue of program formats but also with the production expertise to produce adaptations of these formats, either directly through their own company or else indirectly as a co-production with a local producer. In practice of course, we find that companies often overlap between these three categories as they seek to gain market advantage. Nevertheless, the tripartite division is a useful means of identifying the format players.

1 The Format Licensors

The BBC

The British Broadcasting Corporation is a television broadcaster and producer. Its primary area of responsibility as a national public service

broadcasting organisation is to provide a television service, consisting of two channels, in the United Kingdom. As a broadcaster, the BBC produces approximately 50 per cent of its programs in-house and buys the other 50 per cent of its British content from UK based packagers. Through both its own productions and through its buy-ins, the BBC as a broadcaster finds itself using formats developed elsewhere. Thus, for example, Action Time produced the game show, *Do The Right Thing* for the BBC, the latter adaptation was licensed from TV Globo and was based on the Brazilian format *Voce Decide* (You Decide).

The BBC's marketing operation is designed to gain further revenues from the sale of programs and other services internationally. Over the years, the BBC has seen many of its program ideas imitated by broadcasters, especially public-service channels, in many parts of the world. In Australia, for example, the ABC has borrowed formats for many programs since 1956 when it went on the air and these have included *Panorama*, *24 Hours*, and *Tomorrow's World*. While, no doubt, these borrowings were flattering to the BBC, they did not involve any payment for the use of the ideas. Thus, as formatting - including licensing developed, the BBC began to set fees for the use of its program ideas. The BBC's Format Licensing division was established in 1993 as a unit of BBC Worldwide Television, the marketing arm of the corporation with sales offices in New York, London, Paris, Cologne, Sydney and Hong Kong (Wood 1994). Before 1994, the BBC had licensed program formats through its sales offices. However format licensing needed a central base for the preparation of format packages and the overseeing of licensing so it was decided to set up a separate formatting unit (Frean 1994).

Format licensing continues to be far outweighed in importance and value by the sale of programs. In 1993, for example, the BBC had approximately 1,750 titles in its program sales catalogue and 83 titles in its formats catalogue. Up to a point, these two units are in competition and certain ground rules have had to be established. Thus, in the areas of situation comedy and drama, the BBC will only format a title once its sales life is close to an end. This affects the format of a situation comedy such as *Absolutely Fabulous* which the BBC has decided not to licence for the time being although it has varied the decision by licensing a US version (Jarvis 1995). This same disposition is evident in the Format catalogue released by BBC Format Licensing. Of the 83 titles on offer, only 30 are dramas and situation comedies and some of these, such as *The Brothers*, were produced as long ago as 1972. Besides the perceived shelf-life of titles, 'translatability' is another factor in whether a title will or will not be included. Thus, some situation comedies such as *Keeping Up Appearances* with its class comedy was considered to be too parochial and was therefore not included in the Format catalogue. However several other genres included in the catalogue are more current. These include light entertainment, quiz, children and factual, suggesting that these, usually unscripted and 'live', programs are seen to have less sales potential in foreign markets and therefore are more quickly formatted. The consumer-

affairs series, *That's Life*, is the BBC's most successful format package, selling in several European territories including Germany, Norway, Spain and Belgium. In terms of volume of formats licensed, the Netherlands and Belgium are the most important of the BBC's national markets. In terms of income, Germany followed by France and Spain are the most valuable.

As a player in the international format trade, the BBC is primarily a licensor of formats. Unlike many of the other formatting organisations discussed here, it does not have the personnel necessary to help supervise the adaptation of BBC formats in other territories. For the moment, all it can offer foreign producers is the opportunity to observe the UK versions of the formats in production and liaise with the British producers. The main clients for BBC formats are the new channels in Europe that have come into existence following both the ending of public-service monopoly and the advent of satellite and cable broadcasting. Several of these do not have studio facilities and are forced to go to independent producers. However, both because it prefers to deal directly with broadcasters and because of gaining a production as well as a licensing fee, the BBC hopes, in the future, to be involved in the production of these overseas adaptations of its formats (Jarvis 1995; Woods 1994).

BRITE (Granada / London / Yorkshire)

BRITE shares many of the features of the BBC and therefore this profile can be brief. BRITE is a relatively new creation and is the sales and marketing arm of three of the companies involved as broadcasters/producers in the British ITV Network (Granada Television, London Weekend and Yorkshire Tyne Tees). The organisation is a co-venture arrangement which is 50 per cent owned by Yorkshire Television and 50 per cent owned by the Granada Media Group which owns London Weekend. With the exception of Carlton Communications, this group constitutes the most prolific and wealthiest group of broadcasters/producers in the ITV Network (Alvarado 1997). Like the BBC, these independent commercial broadcasters owe their first allegiance to the British television market. However, they are not constrained by this allegiance and are making a determined attempt to become major international suppliers of programs and services. To that end, BRITE was set up as the marketing arm of the group with the hope that, in the long run, it would represent all broadcasters/producers in the ITV Network. For the moment though, BRITE is still, especially by the standard of the BBC, a relatively small organisation. It has offices only in London and its program sales catalogue lists approximately 750 titles available for rental by foreign broadcasters (BRITE nd).

Like their counterparts in the BBC, those in ITV have been aware for some time of the international licensing possibilities of program formats. In the past, there have been borrowings, both authorised and unauthorised. *Lindenstrasse*, (Linden Street), for example, on Germany's ARD is a loose imitation of *Coronation Street* while the sitcom *Man About The House* was

reversioned in the US as *Three's Company*. In establishing BRITE, the ITV companies intended to not only offer finished programs for rent but also formats for licensing. However, no separate format division exists within BRITE. Indeed it was only in 1996 that this group issued its first format catalogue, offering some 76 titles for licensing. Again, like the BBC's format catalogue, that of BRITE offers a spread of popular genres encompassing entertainment, game shows, drama and children's shows. There are 21 situation comedies including *The Two Of Us*. Six factual/entertainment series including *Surprise Surprise*, 20 game shows including *The Krypton Factor*, 10 drama series including soaps such as *Coronation Street* and *Emmerdale Farm* and series such as *Within theseWalls* and *Stay Lucky*. There is also an anthology comedy drama set of formats for one-off fictions. In the area of children's programs, there are 11 formats offered, three of which are game shows. Finally, in the adult/factual area, four formats are available for adaptation (BRITE 1996). At present, again like the BBC, BRITE is only able to offer a consultancy service (Giblin 1996). However, aware of the extra value to be gained in another production of a format, BRITE hopes that a company like Granada would actually produce the national version of a program such as *Surprise, Surprise* in a foreign territory in the not too distant future (Giblin 1996).

Globo TV

Although it is the largest television producer of drama in Latin America, the Brazilian Globo is, like the BBC, Granada/London Weekend and many other companies, a national media organisation which achieves significant revenue from the international sales of its drama serials, especially its telenovelas. (Mattelart and Mattelart 1990; McAnany 1984; Staubhaar 1997). Besides headquarters in Rio de Janeiro, the company has program sales offices in London and Paris. In the past 10 years, Globo has achieved significant sales of telenovelas in Europe, especially to broadcasters in Spain, Portugal and Italy, where they have enjoyed popular success (Mattelart and Mattelart 1990). In 1993, on the heels of this trade, Globo began marketing formats. Its first program format offered for licensing has been that of an interactive game show *Voce Decide* (You Decide), whose format had been devised by Globo for the Brazilian market. Like Action Time's *Cluedo*, *Voce Decide* is a hybrid, an amalgamation of a game show with a fictional situation and story: a moral dilemma is presented in the form of a drama and the audience is invited to vote on one of two possible courses of action, both of which are dramatised. By 1996, *Voce Decide* had given rise to an astonishing 37 adaptations in different parts of the world. What was so impressive about this international licensing was the transcontinental spread of the format with Spanish-language versions in 12 countries including the US and 11 countries in South America, 18 productions in Western and Eastern Europe (including Russia), 6 in the Middle East, and one each in China and Angola. On the other hand, what was frustrating for the format owners was the fact that Globo only received licence fees from these productions. For the future

then, it would seem likely that the company will not only format more of its Brazilian successes but will also establish international production resources that will enable it to gain production fees for adaptations of its formats.

2 The Broker/Producers

AAFI (All American Fremantle International)

AAFI is the oldest and most established of international formatting companies. It is also by far the largest formatter and producer of television game shows in the world (Cooper-Chen 1994). Its base lies in the international distribution of US television programs, an area that founder Paul Talbot pioneered in 1952. In the later 1950s and 1960s, Talbot's company developed several international relations. These included the Becker group in Australia (Hogg 1995). By the early 1970s, Fremantle (as the distributing company was then known) began handling the overseas distribution of US television program formats, principally those of game shows. In 1978, the most important and successful US game show devisor/producer, Goodson Todman (later Mark Goodson Productions), contracted with Fremantle for the latter to represent its formats in Europe (Graham 1988; McDermott 1997). Over the years, Fremantle was also involved in television co-productions. In 1988 in the US, in partnership with All American Television, it co-produced the serial *Baywatch*, with Fremantle handling international sales of this and other AAT drama series. Finally, in 1994, All American Fremantle International Inc. was formed after All American bought out Talbot (Gray 1996).

The main business of AAFI is production. Rather than restricting itself to format licensing, as an agent acting for US format owners in other parts of the world, the company felt that it had to add value to those formats and therefore moved into international production. Thus its service extends to full production packaging and includes the provision of format, producers, studio, set design, music, host, audience, prizes and so on. AAFI owns few formats in its own right. Rather its business as a formatter is one of representing US format owners in foreign television markets. Like competitors such as Endemol and Grundy, it secures a licence for a format and then sets about producing adaptations in foreign territories. AAFI has its own production companies in the more lucrative national television markets in different parts of the world: the UK, Germany, Spain, Portugal, Greece, Turkey, India, and Australia. In addition, it has on-going affiliations with local production companies in the Netherlands, Russia and South America (Gray 1996: Hogg 1995). Indeed, AAFI was particularly quick to move into the Soviet block following the end of the Cold War. In 1992, it signed a co-production contract with the Russian State Television and Radio Network for a game show, *Ustamy Mladentsa* (Child's Play) (Anon. n.d.). Currently the company is producing game shows in six of the former Eastern Block countries. In other smaller territories, such as those in the Scandinavian countries, co-production arrangements are made for particular programs with local companies. Altogether in 1996, AAFI had some 86 programs on the air in 26 different

countries, most especially in Western Europe but also in the Middle East, Eastern Europe, Southern and South East Asia and South America.

AAFI's business is founded on the production of adaptations of US game shows. The acquisition of the Goodson format library was an important step in solidifying its market position. By early 1996, AAFI's catalogue also included game show formats from other US deviser/producers including Stewart Television and Hatos/Hall Productions. There are approximately 60 titles in the company's catalogue and over 95 per cent of these are game shows. *The Price Is Right*, *Let's Make A Deal*, *The Pyramid Game*, and *Family Feud* are among the most popular titles in the catalogue. In 1996, for example, AAFI was producing or co-producing the latter in 9 different national territories. Besides game shows, the company has several other formats on its books including the 'reality' program *Divorce Court*, the situation comedy *The Honeymooners* and the drama serial *Loving*. However the adapting of game show seem set to continue as the core of AAFI's activities. Finally late in 1997, Pearson plc., the UK based media conglomerate, bought AAFI for US $373, an amount that coincidentally - as we shall see in the next chapter was very close to what Pearson paid for Grundy some two and a half years earlier. The move was a protective one, designed to prevent the producer/distributor falling into the hands of a rival. AAFI's international involvement in the licensing and production of domestic versions of US game show formats bore directly on Grundy World Wide's global efforts in the same field and the acquisition meant that the two companies would dominate the market for game shows everywhere outside the US.

KingWorld

Where most US owners/producers of game shows have turned to AAFI to both distribute the US versions of their game shows and produce national adaptations elsewhere, Sony Columbia Tri Star have used the distributor King World. Although a very much smaller group compared to AAFI, King World is important because it handles two game shows, *Wheel of Fortune* and *Jeopardy*, that are among the most successful ever devised (Cooper-Chen 1994). King World was founded in 1974 and, although now a public company, is controlled by the King family. The company began life as a distributor and its big break came in 1983 when it gained the syndication rights to *Wheel of Fortune* (Schlieir 1986). Currently it distributes not only the two game shows already mentioned but also *The Oprah Winfrey Show*. It also produces three news magazine programs for the US syndication market — *Inside Edition*, *American Journal* and *Rolonda* (Anon 1994). The company has offices in New York and Los Angeles but no offices elsewhere (Freedman 1996). As domestic and international distributor of the US versions of *Wheel of Fortune* and *Jeopardy*. King World also licenses and produces adaptations of these two game shows in national territories outside the US. *Wheel of Fortune*, in particular, is the most successful game show ever with an estimated audience, both domestically and internationally, of over 100 million (Gerard 1990). This success has enabled King World to retain the services of one

consultant-producer whose brief is to specialise in setting up foreign productions of *Wheel*. In late 1996, the game show was being produced in approximately 27 different national territories across the world. Adaptations of *Jeopardy* were in production in 12 countries outside the US.

3 The Devisor/Producers

Action Time

Action Time began life in 1978 as a UK based broker of US game shows for the different British broadcasting groups, most especially Granada. Among its early US clients were Paramount and Ralph Edwards Productions. (Silverman 1987) However, the US companies always had a preference for being represented abroad by US brokers so that, over time, the supply of US game shows dwindled. In 1987, the company was sold to Zenith, a division of Carlton Communications, and Paramount. Four years later, to facilitate Carlton's bid for an ITV franchise, Zenith put the company up for sale and a management buy out occurred. The management group ended up with 70 per cent of the shares and Carlton and Paramount took 15 per cent each (Fry 1995; Hancock 1995). In keeping with its early role as a broker of game show formats, Action Time initially had little in the way of production facilities for the UK market. However, the introduction of independent program production that began in 1980 with the arrival of Channel 4, led Action Time to become a producer. The company now produces all its own programs which it supplies to both the commercial and the public service broadcasters for transmission on both terrestrial and satellite and cable systems from its headquarters in Manchester (Fry 1995). But the company also has a strong format-development side. Action Time lists some 37 titles for adaptation in its 1995 catalogue and a little less than half of these were devised in-house. A few formats continue to be licensed from smaller US originating producers. A third source of formats is European devisors/producers who are associates of the company (Anon 1995). Of the game show formats developed by Action Time, several of these including *Cluedo*, *Body Heat* and *Seat On The Board* are hybrids. This is not only an indication of Action Time's innovativeness but also of the dominant position of competitors, holding more traditional game show formats. The company's most popular format in both the UK and elsewhere is a variant of the dating/romance game show *Love At First Sight* which it originated and produced for BSkyB. The series was licensed to Endemol in the Netherlands, Action Games in Germany, Gestmusic in Spain and Wegelius in Sweden for production in those territories. In addition the format was also licensed to local producers in New Zealand and Russia (Hancock 1995).

Action Time's main source of income is the licensing and production of game shows for the domestic market. In 1995 the company was reported as working on 29 productions for UK-based broadcasters, about two thirds were productions while the rest were licence deals (Fry 1995). But the company's strategy is also to develop internationally. In 1993 it linked up with several

international partners to form Action Group. The Group is a loose association with five other independent European-based television production companies such as Endemol in the Netherlands, Gestmusic in Spain and La Italiana Produzioni in Italy. With a common alignment towards television game shows and light entertainment, Action Group guarantees members access to each others original formats and production consultancy services and thus helps ensure the long-term survival and growth of members of the Group. In 1996, Action Time was working on 41 other productions across Europe and Asia. As a long term goal, Action Time also intended to extend its licensing and consultancy activities to Asia, having already been involved in productions in India and Japan (Fry 1995). However, late in 1996, there were industry rumours that Endemol was interested in buying the company.

Endemol

Endemol was created in 1993 through the merger of two Dutch television production companies, JE Productions and John de Mol Productions (Fuller 1993b; Bell 1994). The merger was the formal linking of the two companys' international operations although, for the present at least, the Dutch components of the two continue as separate entities. Thus, the following profile is divided into three sections that treat the two companies separately before considering the merged operation.

(i) JE Productions

Joop van den Ende, a Dutch theatrical entrepreneur, formed JE Entertainment in 1969 as a special events organisation and theatre production company. Even today the theatrical, circus and public concerts division represents approximately 25 per cent of the company's business, the other 75 per cent of income coming from television (Notermans 1996). By the early 1970s, JE was involved in arrangements for the televising of some of its special theatrical and entertainment events by the Dutch public broadcasters and, in 1978/9, sold its first drama series, *Dagboek Van Een Herdershond* (Diary of a Sheep Dog). The latter was an adaptation of a popular Dutch novel but this strategy of domestic program development was not to be one subsequently pursued by JE. Rather, because of its background in commercial theatre where it would routinely produce Dutch versions of popular American and British theatrical successes such as *Sweet Charity* and *Cabaret*, the company has mostly acquired successful television formats from elsewhere (JE 1995). In 1983, JE signalled its television production ambitions by constructing a sizeable television studio, Studio Aalsmeer, to produce large-scale light entertainment and dramas. The company enjoyed good relations with the public broadcasters and continued to grow over the next five years. By 1988, JE was the largest independent television producer in the Netherlands. By then, the company had ambitions to become a broadcaster in its own right. That year, it set up a Dutch satellite television channel TV10 (The Station of the Stars). However, because the channel did not meet a foreign-ownership

requirement, TV10 had to discontinue broadcasting (Noam 1992). The move earned the producer the wrath of the Dutch public broadcasters (Notermans 1996). These saw the likelihood that, had the channel gone ahead as a broadcasting rival, JE might have withdrawn its stars and programs from the public sector in favour of its own channel. In retaliation, the public broadcasters boycotted JE which, for almost a year, sold no new programs. Indeed to this day, some of the Dutch public broadcasters have continued to boycott JE.

Ironically, it was a new commercial television broadcaster which saved the company. The Compagnie Luxembourgeoie de Telediffusion (CLT) with its new channel RTL4, met the legal requirements that JE had failed to meet and introduced private commercial television to the Netherlands in 1989. The advent of the new broadcaster broke the financial drought for JE Productions. That year, Joop van den Ende Productions signed a three year contract with RTL4 worth more than US $75 million and extended it in 1992 for an additional three years for a package worth more than US $100 million. (Anon 1995). In turn, the relationship with CTL led to the setting up of a German subsidiary, JE Entertainment Productions, established in Cologne in 1991, which entered into a three year US $160 million output deal with Germany's RTL Television (Anon 1995; Anon 1996). Nor by then was the public service broadcasting sectors entirely closed to JE programs with the companies selling to Tros and Vara in the Netherlands and WDR in Germany.

By the time of the formation of Endemol, JE's catalogue contained an impressive number of successful formats. The company's main source of income was prime time game shows. These included several 90 minute variety hybrids that it had devised in-house such as *The Honeymoon Quiz*, *The Soundmix Show* and *The Playback Show*. These had all found ready markets in territories such as Germany, Spain, Portugal and Belgium as well as spinning off other more occasional adaptations in markets such as the UK, Italy, Greece and Australia. The company was just as active in its licensing of formats from other territories including the UK (*Surprise Surprise*, *The Bill*, *Casualty* and *The Two Of Us*), the US (*Ryan's Hope*, *Who's The Boss* and *Married With Children*) and Australia (*The Restless Years*). In turn, the international adaptation of its formats fuelled the spectacular growth of JE Productions. Between 1989 and early 1994, JE's profits tripled from $34 million to $104 million, making it a significant group in both the Netherlands and across Europe although still far from being the largest European producer of television programs. (Bell 1994)

(ii) John de Mol Productions

The second partner in Endemol is the principal of John de Mol Productions. During the 1970s, John de Mol had worked in Dutch television production for the public broadcaster TROS as a director. In 1979 he set up his own production company. Initially producing specials for Dutch broadcasters, the company in 1984 sold its first weekly program, *Pop Formulae*, a pop music magazine program which was to run until 1991. The same year saw a second

major boost when Sky Channel in the UK signed a three year contract for a daily music program, *Euro Chart Top 30*. In 1985, Sky contracted to broadcast *DJ Catshow*. The latter was presented by de Mol's sister who, in effect, became the company's first star. (Anon 1995) However it was the TV 10 affair involving its much larger rival, JE Productions that created the opportunity for the spectacular growth of John de Mol Productions. After JE's signalling of its ambition to become a broadcaster, the existing Dutch public broadcasters saw it in their long-term interests to give their new business to other domestic producers such as John de Mol Productions (Notermans 1996). In addition, once RTL came on the air, the company also picked up program commissions from the new broadcaster. Nor was de Mol confined to music programs; instead it had expanded into game shows, drama, and comedy (van der Meer 1996). The company acquired the Dutch licence for several of the most successful US game show formats and produced local versions of programs such as *Wheel of Fortune*, *The Price Is Right* and *The Dating Game*. It also created the entertainment show, *Love Letters*. One of the company's biggest successes, also devised in-house, was the drama series *Medical Centre West*, which ran from 1989 to 1994.

In 1992, the company finalised a three year output deal with RTL 4, covering all areas of programming and worth US $65 million. (Anon 1995; Anon 1996). That same year, encouraged by CTL, it opened an office in Germany to provide programs for RTL Plus. The need to supply new programs to the Dutch and German markets led to the expansion of the company's format library. New formats included *The 100,000 Guilder Show* and *Will They Or Won't They* in the variety/game show genre, the drama serial *Foreign Affairs* and, most especially, the creation of 'reality' entertainments such as *Forgive Me* and *All You Need Is Love* (Fuller 1992). By 1994, John de Mol Productions had become a European company from its base in the Netherlands and Germany. Through either its own foreign company or co-venture partners, the company had various productions in western and central Europe including *Love Letters* (The Netherlands, Germany, Belgium, Greece and Sweden), *All You Need Is Love* and *Forgive Me* (The Netherlands, Germany, Italy, Spain, Portugal and Sweden), *Medical Centre West* (The Netherlands, Germany, Hungary and Poland) and *Foreign Affairs* (The Netherlands, Germany, Hungary, Poland, the US, Denmark and Russia) (Anon 1995). The company's dramatic development in the period 1989 to early 1994 was reflected in the quadrupling of revenue from US $18 million to US $75 million. It was now about three quarters of the size of its principal competitor in the Netherlands, JE Productions. Yet the two had much in common. Both had a strong commercial orientation, both produced much the same range of popular television programs, both saw the opportunities for international expansion created by formatting, both counted RTL 4 in the Netherlands as their best domestic customer and both had opened German offices at the invitation of CTL. Merger talks began between the two in the second half of 1993 and Endemol came into existence early in 1994.

(iii) Endemol

For the time being, the two companies continue to operate as separate entities in the Dutch television market. Internationally, their merged operation, Endemol Entertainment, is Europe's largest independent television production company with a projected turnover of US$535 million in 1996/7. At the time of the merger, Endemol had subsidiaries in the US, Germany, and Luxenburg and, in the past three years, it has established its own production companies in Portugal, Belgium and Scandinavia. It has also bought significant minority shareholdings in existing production companies in France and Spain, establishing Tele Images Endemol Divertissements and Gestmusic Endemol. The group maintains four different production outlets in the Netherlands. In late 1996 it was also seeking to buy ActionTime, a move that would give it an important presence in English-language markets. The company has also struck an international territorial agreement with its largest competitor, AAFI, whereby Endemol's Portugal office is an agent and producer for the latter's gameshows, an arrangement reciprocated by AAFI's office in Greece (Notermans 1996). Equally, in late 1996, it was also looking to have Grundy act as its representative in South America. Finally, we can note that, in 1996, Endemol Entertainment, which up until this point had little in the way of international sales of its finished programs, was also considering buying existing libraries of finished programs from other companies, a move that would make it a significant force in the area of distribution (Anon 1996).

In classic oligopolistic fashion, JE Productions and John de Mol Productions had seen clear market advantages in a merger. Two examples highlight some of these benefits. The first concerns the establishment of offices in smaller markets such as that of Portugal. Both companies had sold two game shows/entertainment programs each to SIC, the Portugese private commercial broadcaster, but these productions did not guarantee sufficient income to make a Portugese office viable for either JE or John de Mol Productions. The merger made it financially feasible to establish an Endemol production company and office in Portugal (Hein Bakker 1996). The second example concerns the strength of the combined format catalogue that has enabled the group in the Netherlands, Germany and Portugal to sign deals with broadcasters not for individual format adaptations from the catalogue but rather for a package of programs over a particular period of time (Anon 1996). During the Hollywood studio era, the major film companies had sufficient strength in distribution to force this kind of 'block' or 'blind' bookings on independent exhibitors. The merger gives Endemol a comparable market advantage.

Beyond expanding its production capacities, Endemol has also looked to expand into broadcasting, a clear sign that the ambition behind the TV10 venture is still alive. In late 1995 Endemol planned to take control of the former public broadcaster Veronica. Such an arrangement would have meant that Endemol/Veronica was a vertically integrated operation with interests

in the three key sectors of the Dutch television industry. RTL 4 also joined what was to be called the Dutch Media Group. The Group clearly threatened to become one of the very biggest broadcasting groups not only in the Netherlands but also in Europe (Westcott 1995). An appeal was made to the European Commission and the merger was blocked. Endemol subsequently sold its shares in the Group. A second move, the following year, saw Endemol enter into an agreement with other Dutch interests including the Dutch soccer association, KPN, the Dutch telecommunications company, and Phillips, the electronics giant, to start a sports satellite channel, Sports 7, late in 1996 (Kreyn 1996). And finally, Endemol's principals planned in late 1996 to list the company on the Dutch stock exchange (Notermans 1996). This will greatly expand the company's capital base and enhance the prospects of further international development.

ID TV

The import and export of program formats has been and still is a particularly common market strategy among Dutch television producers and the third company from the Netherlands to be discussed here is no exception. However unlike the two that joined to form Endemol, ID maintains a more 'quality' orientation in the marketplace, in line with both its own liberal left philosophy and the programming alignment of its principal clients, the Dutch public broadcasters. IDtv was founded in 1979 by a former Dutch disc jockey who was also briefly involved through his company, Inter Disc, in the importation of music recordings from the US. ID was engaged in the pan-European broadcasting of concerts of music stars such as Tina Turner and Pink Floyd (Haagmans 1996). Like JE and John de Mol Productions, ID's early television program sales were in entertainment and special events, particularly music and youth affairs. The company entered a format exchange arrangement with US game show producer Ralph Andrews, benefitting especially from the latter's format for *Lingo*.

Like several groups in the field such as Action Time, ID lacks a large international production operation and therefore licences the formats in its catalogue. The actual production is undertaken by the local group and ID only derives a format and consultancy fee (Haagmans 1996).

With headquarters in central Amsterdam, IDtv has no production studios of its own. Programs are shot on film on location or else use broadcaster facilities. Through a series of subsidiary companies, the group also maintains a management agency, a theatre business, music interests as well as a film documentary unit. A subsidiary company, IDRA, was established in 1989 to formalise the format link with Andrews, who was subsequently bought out. IDRA survives as the international format licensing arm of the company. Unlike JE and John de Mol Productions, ID has sold few programs to the Dutch private commercial broadcasters and thus has remained small compared to these other two. However, it has pursued a parallel path of international associations. IDTV has a small production branch in Belgium which

has produced adaptations of game shows such as *Lingo* and 'reality' programs such as *Taxi* for the Flemish commercial broadcasters. IDtv also has an agent in Spain in the shape of the production company Videozapping. Action Time was an early British associate. More recently though, the latter has developed links with Endemol and ID has established connections with the Chrysalis Group, especially Chrysalis Visual Entertainment. That company is one of the major British independent television and film producers with interests in smaller companies such as Cactus and Red Rooster. Chrysalis bought 49 per cent of ID in 1994. To further strengthen its national and international position, the Dutch company is currently seeking associates in Germany and France (Kleyn 1996).

Andrews sold ID the international rights to *Lingo* and this has proved to be the financial rock on which the company's format catalogue is founded (Kleyn 1996). It sold a Dutch version of *Lingo* to public broadcaster Vara which is still in production as are 9 other versions in countries such as Sweden, Italy and France. Altogether some 20 adaptations have been licensed including productions as far afield as Israel and Malaysia. On the other hand, another ID adaptation was less successful. In 1992/3, the company produced *Het Oude Norden* (The Old North) based on the BBC's *EastEnders* for public broadcaster Vara. The company took out an option on a Belgian version and also hoped to produce adaptations in Germany and France (Fuller 1992). However the Dutch ratings for the first season were disappointing and the broadcaster did not renew (Anon 1996b). Like Endemol, ID has also been attracted by the format possibilities of British situation comedies. The company has produced a Dutch version of *Till Death Us Do Part* and also has an option on *Steptoe and Son*. Id has approximately 27 formats available for licensing that have been devised in-house or acquired. Among the former are the game shows, *Trivial Pursuits* and *Boggle*, as well as several 'reality' formats such as *Taxi* and *A Matter of Life and Death*. Drama series include *Called To The Bar*.

★ ★ ★

This chapter has identified many of the groups at work in the field of international format adaptation and the particular market strategies that they adopt. It is not exhaustive for the details are constantly changing. National producers, most especially in Europe, such as AB Productions and Tele Images in France, have sought to become permanent international presences while other, more international groups such as the UK's Taffner have concentrated on niche market opportunities. In addition, existing arrangements also change. Columbia Tri Star, for example, used AAFI in the past as its international agent for its game shows, *Wheel of Fortune* and *Jeopardy*, but these are now handled by King World. Meantime Columbia Tri Star has set up an international production office in Cologne, initially to adapt and produce German versions of several of its popular US situation comedies for that market. Clearly Columbia Tri Star could be a significant international format player in the near future, not least because of the large number of first-run

Hollywood featrue films that it can supply or withold from broadcasters. Nevertheless, despite these other details, this summary serves to underline the dynamic nature of the field and the relative recency of the upsurge in format licensing. It should also be clear that western Europe is now an especially important hub of the format trade. Nor is this surprising, given the recent breakup of the public service broadcasting monopoly in that part of the world. It should be clear too from this chapter that there are big players as well as more minor players. Of the groups discussed above, AAFI and Endemol are the largest and the most powerful. As we have seen they both have a series of particular strengths although they differ in several ways. They have evolved from very different backgrounds in particular national settings even if they have had to develop production in other national territories to achieve their present strength and profitability. The next two chapters examines the structure and development of the third of the 'Big Three' format driven companies, onc that emerges in yet another national market and acquires different strengths in different combinations to these two.

English Language Grundy

The Grundy company has its origins not in North America, like AAFI, nor in western Europe, like Endemol, but in the particular historical conditions of Australian television. This chapter therefore deals firstly with Grundy's Australian evolution. In addition, the chapter also examines its entry into three other national territories sharing a common language.

Australia

Companies with the name Grundy have operated in Australian broadcasting for over 40 years, much of that time as a business operations owned by founder, Reg Grundy. These have never been listed on the stock exchange and thus have never publicly disclosed the full range of activities or finances. Even as late as 1993, the Grundy Organisation, the current name of the Australian company, had 12 Australian Securities Commission exemptions which relieved it from reporting any financial data to the Commission (Anon 1993). Nevertheless, since its emergence in the early 1970s as the most successful and the largest production house in Australia, profiles of the company have appeared from time to time, especially in the financial pages of Australian newspapers and magazines but also in more critical contexts (cf Moran 1985;1993;1997; Cunningham and Jacka 1996). What follows is a summary of relevant developments in that 40 year span, especially as it bears on the international dimension of the company's activities. Overall, it is important to note the process whereby Grundy develops from being an importer of television program formats to being an exporter of formats. The chronicle can be broken into four periods as follows: (i) Early history, 1957–1969; (ii) Domestic dominance, 1969–1979; (iii) Internationalization, 1979–1995; (iv) After the Pearson buy out, 1995 to the present.

(i) Early History, 1957–1969

What was to become the Grundy Organisation and later Grundy World Wide began life in 1957 when Reg Grundy, then a Sydney radio sporting commentator and time salesman, started a daytime radio game show, *Wheel of Fortune*, that was aimed at a housewife audience. The program did well for 18 months but lost audience as the new Australian television service extended into daytime. In 1959 Grundy resigned from the station and took the concept of the program with him. He sold a television adaptation of *Wheel of Fortune* to TCN Channel 9 in Sydney. At the time, almost all programs produced for Australian television were made by long-term production employees of the television stations but, nevertheless, Grundy was able to reach an agreement with the channel whereby *Wheel of Fortune* would be 'packaged' by Grundy for the station using station facilities including labour. The station would absorb below-the-line costs while Grundy would be paid a fixed fee and be responsible for the above-the-line costs. As producer, Grundy would also own the format or concept of the program. *Wheel of Fortune* did reasonably well over the next year or so and the channel encouraged Grundy to take over another game show *Concentration* and run a new version of that show as a daytime program (O'Grady 1980). Since at least 1942, Australian commercial radio broadcasters, packagers and advertisers had been involved in 'borrowing' American radio program formats (cf Potts 1989; Lane 1994). In the late 1950s and early 1960s, the new television service was threading the same path at least as far as game shows was concerned. The first regular program broadcast on the first night of transmission, *Name That Tune*, was a format adaptation of an NBC/CBS game show devised by Harry Salter and so was another early game show produced at the same channel, *Concentration*, devised by Mark Goodson and Bill Todman, which Grundy began packaging for the channel in 1961. Grundy realised that the only way to insure that his new company, Reg Grundy Enterprises, always had at least one program in production was to ensure a steady supply of new formats. Accordingly he made the first of many trips to the US to gather information on the new game shows appearing on network television (O'Grady 1980; Moran 1985). By 1962, he had two further game shows on TCN Channel 9, *Tic Tac Dough* and *Say When*. In 1964, all of the company's programs were cancelled within a short space of time by the then dictatorial owner of the channel, Frank Packer (Whitington 1971). Grundy realised the folly of having all his programs with one channel and determined that he would never again be dependent on a single buyer. Fortunately, by that time, under the government's Frequency Assignment Plan, a series of regional television markets, around the state capital cities, had been created. The company managed to sell local versions of *Concentration* and *I've Got a Secret* to Brisbane's QTQ Channel 9, thereby surviving the crisis caused by the Packer cancellations.

Over the next four years, various changes occurred in Australian television and the company's pattern of operation became clearer. Although, there was still no such thing as national broadcasting, nevertheless three commercial

television networks came into being; the Nine Network, which consisted of the Packer-owned stations in Sydney and Melbourne together with Brisbane and Adelaide affiliates; the Australian Television Network, later known as the Seven Network, which consisted of independent affiliates in the four capital cities; and the 0–10 Network, which had common ownership in Melbourne and Brisbane together with affiliates in Sydney and Adelaide (Moran 1997). Inside this structure there were opportunities for the company for both regional and national sales. Thus, for example, Grundy's Brisbane version of *Concentration* was shown in the local market for a year and was syndicated nationally on the four Nine Network stations on the east coast, between 1965 and 1968. On the other hand, Grundy's Brisbane version of the Goodson-Todman format, *I've Got A Secret*, was not picked up, although the company did sell another regional adaptation of the format to Adelaide ADS Channel 7. In any case, Reg Grundy Enterprises had to extend its capacity for runaway productions even further: a national version of a game show often had to be produced in whatever studio of a network member, in whatever capital city, that was available. Thus, although the company's headquarters was in Sydney, it also opened small, regional production offices in cities such as Adelaide and Brisbane, closing these when production ceased. Meantime, the copying of US game show formats continued. By 1968, the company was growing, with Grundy recruiting experienced production and administrative personnel from the television stations. Still heavily involved in quality control of all his programs, the principal and owner was spending more time examining new US formats as these came on air with a view to their adaptation to Australian television. Among the programs produced at this time were *Split Personality*, *The Newlyweds Game*, *Play Your Hunch* and *Personality Squares*. Although US owner/producers were probably aware of the copying of formats that was occurring internationally, nevertheless they were mostly unconcerned: foreign markets, such as Australia, were not as lucrative as the domestic US market; US game show formats could not be registered with the Copyright Office for protection under the 1912 Copyright Act (Fine 1988); and, under the Berne Convention, legal action would have to be pursued in courts in foreign territories (van Manen 1994). Thus, Grundy could continue to act as a conduit for US game shows although, it was in the more long term interests of the company that it diversify.

(ii) Domestic dominance, 1969–1979

By 1970, the Australian television market for domestic production was booming. Game shows and light entertainment had been produced since the beginning of the service in 1956 while from 1964 the commercial stations were also commissioning drama series (Moran 1985). Although Grundy had suffered another downturn around 1968, when it briefly had no shows in production, nevertheless it had soon recovered. In 1970 it developed a loose adaptation of a US game show *Sale of the Century*, which it titled *Temptation*

and sold to the Seven Network. The program was very successful as a stripped daytime program and the company then developed a second adaptation, *Great Temptation*, which was stripped in prime time. The latter ran until 1974 and was an enormous success, giving the company a very lucrative cash flow. Grundy now sought to expand and it explored various possibilities. It established a documentary unit; it produced two feature films for international release; it set up a merchandising operation and a record label; it hired in three independent television producers, one of whom – Roger Mirams – was a specialist in children's drama series and who was later responsible for such Grundy series as *Secret Valley*, *Runaway Island* and *Mission Top Secret*. If many of the other initiatives were not followed up in the long run, there were two developments that were to be vital for the company's later expansion. The first was the move into drama serial production. As I have suggested elsewhere, Australian television was almost 20 years old before a market and an audience could be found for locally-produced soap opera (Moran 1985: 1989). After several abortive attempts at programming soaps, the breakthrough came in 1972 when the 0–10 Network commissioned the serial *Number 96* from a local production company and stripped it five evenings a week. The serial was an enormous success and the networks now looked for other drama serials. None of the other Australian packaging companies, with the exception of *Number 96*'s producers, could claim production experience in this genre and so all started equal so far as the market was concerned. However, Grundy was experienced in producing high volume programming, designed for strip scheduling. On the basis of its good relationship with the Seven Network after the success of *Temptation* and *Great Temptation*, Grundy succeeded in selling a serial to the Network for horizontal programming in the early evening time zone, which was now being defined as access. The serial was *Class of 73/4* and although it only ran for two years, it was sufficient proof that Reg Grundy Enterprises could produce drama as well as game shows and light entertainment. Over the next dozen years, the company produced at least 25 different drama series, soap operas, telemovies and children's series. Soaps included *The Young Doctors*, *The Restless Years*, *Prisoner*, *Sons and Daughters* and *Neighbours*, programs which were to be of enormous international significance to the company both in terms of sales and format adaptations. Nor did it neglect the production of game shows and light entertainment; indeed, it was here that the second important development for the company occurred. Around 1976, the company entered into a formal licence agreement with Goodson-Todman Productions in the US whereby Reg Grundy Enterprises had first option on Goodson-Todman formats outside the US and continental Europe. As already suggested, Goodson-Todman were the long-term genii of American game shows, having devised and produced successful game shows for network radio and television since 1946 (McDermott 1997). For the Goodson-Todman company, (renamed Mark Goodson Productions after the death of Todman in 1979), the arrangement with Grundy meant that licence fees were being generated from the

Australian adaptation of its game show formats. For Grundy, acquiring the option on this format catalogue not only secured its future in the Australian television market but also opened up the possibility of expansion into foreign territories.

(iii) Internationalisation, 1979-1995

Two key events in 1979 signal the shift to a new era in the company's history. The first was the purchase by the company of several game show formats, most especially the original American format for *Sale of the Century*. The initial version of *Sale of the Century* had been produced for NBC between 1969 and 1973 (Graham 1988). It had not been especially successful in the US market although, as we have already seen, it did provide part of the basis of Grundy's game show *Temptation*. Within a year of the purchase of the format, the company had sold an Australian adaptation to the Nine Network. *Sale of the Century* became enormously popular and has now been on air in the same time slot, five evenings a week, for almost 20 years, making it easily the most popular light entertainment program in the history of Australian television. In 1982, the company produced its first international adaptation of the format, *Dai Sou But*, for RTV in Hong Kong. More importantly, the company also sold a daytime US version back to NBC, using an episode of the Australian version as, in effect, a pilot (Mason 1996). The second significant development from a company point of view was the opening in 1979 of an office in Los Angeles to produce programs for the American market. By 1982 the company could report the beginning of a solid presence in this difficult market, both with program sales, especially of *Prisoner*, and the network sale of *Sale of the Century*.

Some of the seeds of this international expansion were planted earlier (cf Anon, 1973; Anon, 1977; Toohey 1973; Day 1980). After all, since the early 1960s, Grundy's production of game shows had always been closely tied to developments in that genre in US television. Since at least 1973 Grundy had planned to distribute its productions internationally, at first concentrating on feature films and documentaries but soon switching to drama series and serials. In 1977 the company had been reorganised; the parent body became the Grundy Organisation and the latter was structured to conform to American organisational norms (Moran 1985). By that time, the principal of the company, Reg Grundy, had recruited a former program manager of TEN Channel 10 Sydney, Ian Holmes, as President of the company. This allowed the owner to concentrate on program development, format acquisition and, soon, the establishment of a Los Angeles office.

As will become clearer in the remainder of this chapter and the next, there were several elements that contributed to the company's international expansion. The most important was the deregulation and privatisation of public service broadcasting as well as the dramatic increase in the number of television channels in different parts of the world, most especially Europe. Broadcasters look for some kind of insurance for the success of new programs and format

based adaptations promise to repeat successes across national borders. Like AAFI and Endemol, Grundy brought other advantages to the table. These included a sizeable catalogue of program formats, both owned and held under option. In addition, the company is remarkably expert in two key genres that form the backbone of the broadcast schedule, game shows/light entertainment and drama serials. Two other arms of Grundy have also facilitated international co-production agreements, especially in new territories. The first is program distribution. Initially, in the 1970s, this was handled by Paramount; in the 1980s, by representatives in different territories coordinated by a principal representative based in New York. These arrangements always involved substantial commission fees so that in 1989 Grundy set up its own distribution arm, which, in turn, in 1995, became a part of Pearson Television Distribution. This growth of distribution has meant that the company handles not only its own drama serials and game shows, most especially those produced in the English language, but also various US game shows based on Goodson formats as well as other programs such as the Australian ABC's legal drama series, *Janus/Criminal Justice*. Early contact between Grundy and particular national broadcasters has also occurred through various co-productions on drama series and, most especially, children's series. The combined effect of these elements was to ensure the rapid international development of Grundy in the 1980s and 1990s.

One other feature of this stage of Grundy's development involved a further change of title, structure and headquarters. In 1988 the company moved offshore: the new parent body was based in Bermuda, copyright ownership of the company's program formats was registered in nearby Antigua and legal and financial matters were handled in Monaco. The erstwhile parent, the Grundy Organisation, remained as the Australian branch of the company. Over 40 international Grundy companies were in existence in different parts of the world and Grundy offices were set up in key countries such as Britain and France and later in territories such as Singapore and Chile. The new parent body was Grundy World Wide.

(iv) After the Pearson buy out

In 1993, the owner of the company decided to sell. Private negotiations were conducted that year but a satisfactory price could not be achieved and the matter lapsed. However, early in 1995 the UK based Pearson group bought Grundy World Wide for US$279 million. The sale enabled the owner to concentrate on investment interests, using his private companies, including RG Capital. For Pearson, the purchase made a good deal of sense as it already had a television division that had broadcasting interests in companies such as BSkyB, UK Gold and UK Living in the UK, European Satellite Television and TVB in Hong Kong as well as owning another production company in the shape of Thames Television. In addition, Pearson Television was also part of the group that would turn out to be the successful bidder for the franchise on the new UK commercial broadcasting channel, Channel 5. The acquisition

of Grundy World Wide then made sense in terms of developing a vertically integrated television operation in the UK as well as a rapidly developing production company in Europe, Latin America and Asia (Moran 1997a).

After nearly three years in Pearson Television, new patterns are developing in the company, both internationally and in Australia. Grundy World Wide acquired a new head, who is permanently based in London. Grundy Distribution has been integrated with Thames program distribution and its head is now directly responsible to the head of Pearson Television. In addition, the board at Pearson Television now oversees all major expenditures. Frustrated at the new style at work in the company, several of the company's Australian executives have left. These resignations underline the relative stagnation of the Australian wing of the company. Although still producing over 10 hours a week of game shows for the Australian networks, the Grundy Organisation has sold no new drama serials since the cancellation of *Richmond Hill* in 1988. Where the Grundy Organisation in the past has often had up to three successful drama serials on air at the same time, now it has only one (*Neighbours*). In other words, although the parent of Grundy World Wide, Grundy Australia is now of only minor importance in the international group.

Further changes to Grundy can be expected in the wake of the Pearson acquisition of AAFI. For while Pearson has generally been content to allow new television production companies coming under its control to retain their own identity, nevertheless – as we have already noticed – AAFI and Grundy have shared some of the same game show and light entertainment formats across the world so that again some king of rationalisation and reorganisation will undoubtedly occur.

The United States

As early as 1977, the Grundy company was planning to establish productions in the United States (Anon 1977). In 1978/9 the group registered an American company, Reg Grundy Productions, Inc. In 1979, the company established an office in Los Angeles, its first foreign production office. The moment of this entry may or may not have been propitious. In 1979, US network television was on the brink of an era of crisis and transformation which has continued down to the present (Blumler 1991; Auletta 1992; Couzens 1997; Strover 1997). Three years earlier, the networks – NBC, CBS and ABC – which had dominated television broadcasting since the inception of networking in 1946, experienced a peak of broadcast television viewing on the part of the US public (Attallah 1991). Thereafter the total audience size began to contract such that, by 1992, it was estimated that the networks had lost about a third of the audience that they had in the halcyon year of 1976 (Arletta 1992). Many new competitors emerged in the 1980s and 1990s. For one thing in 1984 the FCC had liberalised the rules so far as ownership of television stations was concerned. Each of the networks changed ownership and new fledgling commercial networks attached to the major Hollywood

companies, such as Fox, Warner and Paramount, came into being (Balio 1995). However, it was the national satellite delivery of cable television, beginning with Turner's channel 17 in 1980, that had proved to be the main drain on the network television audience (Attallah 1991; Couzens 1997). By 1997, viewers in large urban markets such as Lower Manhatten in New York had a choice of some 75 channels, with this kind of proliferation causing a further fracturing of the mass television audience. Nor had the technological revolution, associated with the new delivery technologies that had begun with satellite, cable and videocassette, run its course. Quite the contrary. New sectors such as the computer hardware and software groups and the telephone companies eagerly eyed the television market (Arletta 1992; Strover 1997) and there were promises of viewers in large urban centres having a choice of 500 channels in the not too distant future (Levy 1995).

Clearly, in the medium to long term, these changes did create opportunities for newcomers such as Grundy. However, the US broadcasting market is an intensely competitive one and so too is the production sector. The latter is dominated by about two dozen production companies. In the area of game shows, the major groups include Mark Goodson Productions, Barry and Enright, Hatos-Hall, and Stewart Television (Cooper-Chen 1994). In drama production, the competition has included the motion picture studios such as Universal, Paramount and United Artists as well as independent producers such as Aaron Spelling, Tanden/TAT, and Lorrimer. These production companies are favoured program sources for the networks. Thanks both to personal contacts with the networks and past successes, they are, in Gitlin's phrase, on the 'inside track' and therefore continue to receive the majority of commissions (Gitlin 1985). In other words, it is difficult for a newcomer to break into the market. However, Grundy had one advantage, namely the library of programs and formats that it had developed in Australia. Over the two years after it opened its Los Angeles office, the company sold the serial *Prisoner* to independent station KTLA in Los Angeles and in 30 other markets. In 1980, it produced two pilots for new US drama serials, *Starting Over*, an adaptation of *The Restless Years* and *Willow B:Women in Prison*, a re-versioning of *Prisoner*. (Anon 1980). However, neither went to series. Instead, it was to be a further two years before Grundy was in full scale production, following the network sale of *Sale of the Century*.

Over nearly 20 years in the US market, the company has had its ups and downs. Grundy has had most success with the production of game shows, especially in the 1980s when it had programs such as *Sale of the Century* and *Scrabble* on air on the NBC Network. These were all daytime programs. Although clearly very profitable, none of them was sufficiently successful to catapult Grundy into the role of a production leader. In any case, daytime television in the US was in the 1980s profoundly transformed by the advent of talk shows such as *The Phil Donoghue Show* and *The Oprah Winfrey Show* (Munson 1993; Crystal 1996; Erler and Timberg 1997). By the early 1990s, the Los Angeles office found itself mostly unable to sell daytime game shows

although there was a slight revival in 1997 with a US special of *Man O Man* produced for station UTN and a season of *Small Talk* for the Family Channel.

In the meantime however, Grundy attempted a second concerted push to establish itself as a producer of drama. *Neighbours* was a hit program in the UK, Australia and New Zealand as well as reporting good sales in many other territories. In the US, two syndicated stations in key markets, KCOP in Los Angeles and WPIX in New York, made a thorough attempt in summer 1988 to promote the program, broadcasting it in good timeslots aimed at a young audience and providing plenty of marketing. However, the serial failed to attract a large audience and it was dropped by both stations (Crystal 1996; Cunningham and Jacka 1996). However Grundy was far from spent. In 1991, following the general success of *Prisoner* on syndication and cable stations, the company decided to proceed with an American adaptation, *Dangerous Women*. Working through a broker in New York, the company road-showed the serial, constituting a circuit of independent syndication stations in various urban markets. These included the Pineland Group's WPIX New York, KCOP Los Angeles, WPWP TV Chicago, the TVX Broadcast Group (which had several stations in Texas as well as one in Washington), Hubbard Broadcasting in Florida and the Chris Craft/United TV Station Group with stations on the Pacific seaboard as well as Minneapolis and Phoenix. Altogether, this 'network' reached approximately 30 per cent of the population. The serial was screened twice weekly starting in the fall of 1991 and continuing into 1992. However this home-grown serial fared no better than the imported *Neighbours*, leaving the company to wonder if it could ever become a substantial production presence in the US market so far as drama was concerned.

By the late 1990s, Grundy found that in the US market it is, for the moment at least, mostly unable to sell either local game shows or drama serials. Instead, over recent years, it has concentrated on another role as a developer of game show formats, a kind of industrial laboratory for R and D on game shows and light entertainment for the international operation (Crystal 1996; Mason 1996). This was very much an outcome of circumstances. Outside Australia, Grundy was restricted by territorial arrangements, in terms of the foreign formats it could use in particular markets. Thus, for over 10 years, Reg Grundy Productions Inc. produced a series of low-cost pilots of new formats that it devised in its Los Angeles office. Among game show formats developed and piloted there are *Going for Gold*, *Hot Streak* and *Keynotes*. Although first developed for the domestic market, none of these were picked up by US television broadcasters. Instead however, these and several other format/pilots were successfully adapted by the company for several national broadcasters in Western Europe.

Summarising then, we can note that Grundy has been operating in the US for nearly 20 years. Despite apparent affinities between the US and Australia (Bell and Bell 1993), including their television systems, the company has found progress there difficult. It has had most success with game shows in the

1980s but has not fared well since then. Grundy has made no lasting impression as a drama producer which is again not that surprising given the strength not only of native production talent but also network and syndication's lack of interest in other kinds of drama series. However, the Los Angeles office has made itself relevant to the international operation by providing original formats, a vital ingredient in the company maintaining and improving its position elsewhere.

The United Kingdom

By contrast with its situation in the US television market, Grundy has had more unequivocal success in the UK. Underlining the point that English is indeed the language of advantage so far as international television is concerned, the company's distribution arm has recorded solid sales of its Australian and New Zealand programs over more than 10 years (Collins 1989). The company has been accepted by UK broadcasters as a reliable supplier of popular entertainment; the London office has been a beachhead for entry into the different national markets of continental Western Europe. In 1995, Grundy was bought by the UK based Pearson group so that its 'Anglisisation' was complete (Moran 1997b). Altogether then, the company has had much more of a 'fit' with British broadcasting than with US television.

Despite perceptions that Australia has severed most of its ties with the UK in favour of closer economic and cultural links first with the US and then Asia, the fact is that Australia continues to be closely tied to what was once called the mother country (Scrivener 1987). In point of fact, many of the connections are still in place. Britain remains Australia's third largest trading partner and the second largest single source of direct foreign investment; the offspring also retains ties to the parent in areas such as education, religion, the media and sport as well as the legal, medical, defence and police systems (Scrivener 1987). Similarly, there has been a longstanding relationship between television industries in Britain and Australia. However, given the overall UK viewing population, GDP and financial strength of British television companies, it is not surprising that the relationship has mostly been a one way street from Europe to the Pacific (Alvarado 1995). Although the second half of the 1980s and the early 1990s saw a significant increase in Australian television program sales to British broadcasters (Solomon 1989), that moment has passed and trade between the two countries in the audio visual area appears to have reverted to more historical levels. Nevertheless the ties were and are striking. Since the 1950s, there has been a sustained history of British television production involvement and investment in Australia. The first television series to be made in Australia, *Long John Silver*, was filmed there and in the Pacific in 1954. The public service broadcaster, the ABC, founded in the likeness of the BBC in 1932, was an early borrower of formats from the British organisation and was involved in its first co-production venture on a one-off drama in 1966

(Inglis 1983). In addition, the Sydney television station, ATN Channel 7, was a co-production investor in the British/Australian western *Whiplash* produced in 1960 and indeed the Seven Network, which ATN later helped to constitute, has had a long association with British television (Tulloch and Moran 1986). All Australian television networks, most especially the ABC and the Seven Network, have bought large amounts of British programs over the years and indeed the early regulation of Australian content on commercial television between 1960 and 1974 further encouraged this by allowing broadcasters to count British programs as Australian content. Nor has the program flow been entirely one way. Rather there was a history of Australian black and white drama series such as *Homicide* and *Division Four*, being sold in the 1960s and early 1970s to UK regional stations, this trade being a forerunner to the brief wave of Australian drama serials on British screens in the 1980s. There are other signs of this congruence and one that concerns Grundy is worth mentioning. As I have already argued above, popular indigenous soap opera did not emerge as a viable programming form on Australian commercial television until 1972 with the success of *Number 96*. British television writers working in Australia had a good deal to do with the program's popularity (Hall 1976). In turn, Grundy established a drama serial production wing and, in 1976, enticed Australian-born Reg Watson to return from Britain to head it. Watson was a writer and producer who had devised the serial *Crossroads* for ATV in 1964 and was first executive producer of that serial (Gordon 1975). *Crossroads* is an important influence on the development of Grundy soap opera because it was the only British soap to be produced at the rate of five half hours episodes a week (Hobson 1982). In the person of Watson then, the Grundy Organisation had a figure with extensive knowledge of commercial television in the UK and who would later originate such serials as *Sons and Daughters* and *Neighbours*, programs that subsequently had a good deal of appeal to UK program buyers.

Following a pattern that is repeated in many other national territories, Grundy's entry into the British television market was through the sale of finished programs and the development of co-production ventures. In particular, its Australian drama serials were to constitute the company's 'calling card' so far as British broadcasters were concerned. In fact though, Grundy's involvement with the British audio-visual market was not recent, dating back to at least 1974. In that year, the company produced two feature films, *Barry McKenzie Holds His Own* and *ABBA: The Film*, with a clear eye to the possibilities of international distribution, most especially in the UK where the first feature film based on the *Private Eye* comic strip, *Barry McKenzie*, about a hapless Australian visitor to the UK, had been an enormous success (Anon 1973). In the late 1970s, Grundy drama series such as *Glenview High*, *Case for the Defence* and *Chopper Squad* were sold to regional stations in the UK. However it was its soap operas that was to make Grundy a household name. In 1984, Grundy sold a package of episodes of *The Young Doctors* to a regional station. By the end of 1985, it had hawked programs such as *Prisoner — Cell*

Block H, *The Restless Years* and *Sons and Daughters* in 11 of the 15 regional markets (Anon 1985). The real breakthrough occurred the following year when the BBC took *Neighbours*. At the time, the BBC and ITV were screening Australian soaps early on weekday afternoons. However *Neighbours* proved so popular that the BBC rebroadcast the program in an early evening time slot (Kingsley 1989). By 1988, *Neighbours* had become the most popular program on UK television, a cult so far as British teenagers were concerned. The program remained in the Top Ten for several more years. Even after 12 years on British television, the program is still popular and will run until at least 1998 when the BBC considers whether to renew its contract. Subsequently, two other Grundy soaps, the Australian *Richmond Hill* and the New Zealand *Shortland Street*, were sold to ITV. However, by the mid 1990s, it was clear that the highwater mark so far as the large sales of Australian series and serials, including those produced by Grundy, was over, not least because the financial crisis of Australian commercial television between 1987 and 1990 had led to a significant drop in the output of new serials in the 1990s (O'Regan 1991). Coincident with these sales, Grundy also entered into various co-production arrangements. In 1984, the company obtained investment in the children's series *Secret Valley* and British investment has continued in several subsequent children series. In 1987, Grundy and Central Television set up the mini-series co-production, *Tanamara – Lion of Singapore*, and followed this in 1992 with a second mini series, *The Other Side of Paradise*.

However, not withstanding this contact, Grundy was extremely lucky in the timing of its plans to enter the British television production market. Under the Conservative government of Margaret Thatcher economic rationalism was in full flight. In 1987 the government passed a declaration that 25 per cent of British programs on the BBC and ITV should come from outside independent producers, a measure that was later ratified in the 1990 Broadcasting Act (Goodwin 1992; Alvarado 1997b). That same year, Grundy set up its own British subsidiary, Reg Grundy Productions (GB) Ltd. As this name implies, Grundy felt that no nationalist prejudice would exist against the newcomer and therefore saw it as unnecessary to seek a co-venture production partnership as it would in several non English language television systems. It opened an office in London which was to serve as both a British and a European base. By 1990, Grundy had productions in progress not only in the UK but also in France, Germany, Belgium and the Netherlands and, as we shall see in the next chapter, had set up new companies and new offices in continental western Europe.

Over the past 10 years, Grundy's confidence in entering the UK television market has been well rewarded, especially in terms of its sale of game shows and light entertainments to the different British broadcasters. Unlike Australia, where the Grundy Organisation has, in a period of 40 years, only sold one series to the public broadcaster, the ABC, the British company has had a good deal of success selling to the BBC (cf Harris 1987). It's first sale was the daytime game show *Going for Gold* which ran from 1988 to 1996.

Subsequently Grundy has produced *The Main Event* (1993/4), *Small Talk* (1993 to the present), *Eureka!* (1994) and *How Do They Do That?* (1994 to the present for the BBC). Programs produced for ITV include *Keynotes*, *Jeopardy*, *Press Your Luck*, *Celebrity Squares* and *Pot of Gold* while *Sky Star Search* and *Sale of the Century* were made for Sky and the Challenge Channel. By 1994 Grundy was the seventh largest independent producer in the UK, a position based on the company's volume of annual production.

Until very recently, Grundy had less success with drama having developed several soaps and sit coms for public and private broadcasters, none of which went into production (Kolle 1995; Murphy 1995). No doubt the spectacular failures of the BBC's *Eldorado* in 1993 and ITV (Channel 3)'s *Albion Market* in 1994 made the networks extremely cautious of embarking on new soaps (Goldberg 1991). However the takeover of Grundy by Pearson and the advent of the new commercial broadcaster Channel 5 in 1996 changed this situation. As part of its successful licence bid, Pearson indicated that Grundy was to produce a strip daily drama serial, tentatively entitled *Lifeline*. Grundy was indeed in development of a daily soap for Channel 5 in 1995/6 and, finally, this went to air in 1997 under the title *Family Affairs* (subsequently Thames Television became producer of this serial). That sale reminds us of another sale that made Grundy a part of Pearson Television. And indeed, as a means of rounding out this account of Grundy's development in the UK, we can end by noting the increase in production commissions that the company is likely to achieve with the advent of Channel 5. Already by 1997, Grundy was contracted to produce four game shows/light entertainment programs for the new broadcaster as well as *Family Affair*. Altogether then, Grundy has had considerable success in the United Kingdom.

New Zealand

Before turning to the company's development in foreign-language markets, we can conclude this chapter by briefly examining Grundy's expansion into one other English-language market. Like the 'spill-over' of Dutch companies such as Endemol and IDTV into neighbouring Belgium, it was perhaps inevitable that Grundy would become a presence in New Zealand television. However, despite geographic proximity and the historical and institutional parallels between the societies of Australia and New Zealand as 'white settler societies' (cf Alexander 1979), there have been important differences between the two nation states in terms of politics, economy and culture. In fact, the opportunity for the Grundy expansion into the latter's television market only occurred in the late 1980s. Earlier, unlike the 'Americanised' system of broadcasting in Australia which had always had a strong independent, commercial sector, New Zealand's broadcasting system was more 'European' with a monopoly public-service broadcasting sector that had been set in place in 1936 (Bell 1995, Murdock 1997). In 1960 television broadcasting was introduced. The two islands were served by one television channel until 1975 when a second channel came on the air. The 1980s saw

the onset of economic neo-liberalism on the part of the state and this was felt in broadcasting. New Zealand television was already very dependent on the market-place, deriving some 87 per cent of its budget from advertising but the government's 1988 decision to allow private companies to become television broadcasters put further strain on TVNZ's two channels (Bell 1995). The first of the private, commercial broadcasters, TV3, went on the air in 1989 and has since been joined by several other private groups, operating as both broadcasters and narrowcasters, offering regional and national services (Murdock 1997).

Meantime under the 1989 Broadcasting Act, the BCNZ was restructured as a 'state owned enterprise forced to return a profit on all divisions' (Wilson 1991). This spelt the end of the 'studio-system', the system of in-house production, so far as TVNZ was concerned and encouraged the establishment of private production companies. Until the late 1980s, New Zealand's only involvement with Australian television producers had occurred through the former's import of the latter's programs. From the mid 1970s, Grundy had distributed many of its Australian-made drama programs across the Tasman including *Prisoner*, *The Young Doctors*, *Sons and Daughters* and *Neighbours*. It also distributed several American-produced game shows, which it represented internationally, and this paved the way for its entry into the local production market. In 1989, the company sold its first indigenous production *Sale of the Century* and soon followed with New Zealand versions of other game show formats such as *Wheel of Fortune*, *Perfect Match* and *Jeopardy*. *Neighbours* had already created a taste for stripped soaps in prime time access and in 1992 Grundy sold TV2 its own domestic daily soap, *Shortland Street*, which it co-produced with South Pacific Pictures, a production arm of the channel. In turn it distributed this serial internationally, securing a good sale to ITV in the UK (Moran 1996a). Even more important than the revenue generated by this sale was the fact that Grundy could achieve the economies of scale necessary to produce high-volume drama in a market of only 3.5 million, an achievement that might serve it well elsewhere (Murphy 1995). By this time, the company was rapidly expanding its operations in non-English language markets, most especially in Europe but also in other parts of the world.

Grundy World Wide

The focus in this chapter is on Europe, South America and Asia, although a full consideration of Grundy as an international format adaptor would involve national television markets elsewhere such as that in South Africa. Indeed, the discussion here is mostly restricted to continental western Europe. Grundy operations in South America and Asia are similarly restricted to particular markets. Overall, in terms of the international expansion covered in these two chapters, Grundy has been most fortunate in the timing of its move into Europe and the other regions. The late 1980s and 1990s have seen an increasing number of broadcasters coming on the air as well as an expansion of broadcast time. Where broadcasters, especially those in Europe, have been able to arrange their finances, they have preferred to schedule domestic rather than imported programs. These give the broadcasters the largest audiences (Silj 1992). As we have seen in Chapter 3, many producers and format owners – most especially AAFI and Endemol – have benefitted enormously from the practice of producing national adaptations based on international program formats. Grundy, too, has been an active player in this field. Not surprisingly, the paths of these three groups cross each other from time to time.

Western Europe

Although the company has made programs on the various rims of western Europe in countries such as Israel, Turkey, Greece, Belgium and Norway, nevertheless the discussion here is restricted to six countries with common borders. The first three are grouped on the northern European rim and consist of two neighbours, the Netherlands and Germany, as well as the largest of the Scandinavian countries. The other grouping consist of three Latin countries bordering on the Mediterranean in the south.

(i) The Netherlands

Overall, Grundy's development in the Netherlands might be described as stillborn. A country with a smaller population by general European standards, roughly the same size as that of Australia, the Netherlands has a television system which was established in 1951 and is founded on a public service model of sorts. The model was one in which, through a system of limited pluralism or 'pillarisation', a number of religious and political groupings in Dutch society were given a legitimated involvement in three television broadcasting channels (Browne 1989). However, in 1967, the system was modified to permit some advertising time to be sold and by the 1980s two of the broadcasting associations, TROS and VOO, had developed a distinctly commercial approach to their television service. In 1989, following the passing of the Media Law a year earlier, a first commercial television broadcaster came on the air (McQuail 1991; Noam 1992). By the mid 1990s the three public service channels (Nederlands 1, 2 and 3) were competing with six other commercial services - RTL 4, RTL 5, Veronica, SBS 6, TV 10 Gold and the Music Factory. Dutch television is now increasingly open to cross-border broadcasts and several of the dominant players in its system have strong international links (Servaes 1994).

For Grundy, the boom in selling stripped drama serials in the European market began in 1989. That year saw the launch in the Netherlands of a first fully commercial television channel, RTL 4 which was linked to the CTL group in Luxenburg (Nieuwenhuis 1992). RTL 4 wanted a strip drama as an anchor for its new evening programming and asked the Dutch production group, Joop van den Ende Productions, who would rapidly become its major supplier, to devise a serial. JE looked at several drama serial productions being made in other countries and, after visiting Grundy's production of *Neighbours* in Australia, asked that company to licence one of its soap formats (Holmes 1992; Kolle 1995). Grundy preferred a co-venture arrangement for the production of such an adaptation in the Netherlands. The result was that in 1990 the two companies signed a co-production agreement for *Goede Tijden, Slechte Tijden* (Good Times, Bad Times). The latter was an adaptation of the format of the Australian soap opera *The Restless Years* which had begun on air in 1977 and which had also given rise to a pilot for an American adaptation *Starting Out* in 1980. *Goede Tijden, Slechte Tijden* began on RTL 4 late in 1990 (Madsen 1994). The program soon built and maintained a strong audience making it the most popular daily drama serial in the Netherlands (cf Akyuuz 1994; Fuller 1994b). Its success also helped the sale of a further adaptation, *Gute Zeiten, Schlechte Zeiten* (Good Times, Bad Times) in Germany in 1992. However, by then, the cordial relationship between JE and Grundy had deteriorated although their co-venture agreement for the production of *Goede Tijden, Slechte Tijden* has continued. The cooling occurred in connection with RTL 4's commissioning of another serial concerning women in prison. Grundy offered RTL 4 an adaptation of *Prisoner*. However, this submission was passed over in favour of a similar concept, *Vrouwenvleugel* (Women's

Wing), which had been proposed by its erstwhile partner, JE. As a senior Grundy executive put it: 'We were too much alike to be partners. We are much more rivals' (Murphy 1995).

As JE and its international partner, John de Mol Productions, dominate independent production in the Netherlands (Edmunds 1994), Grundy has had little opportunity to sell other programs to the Dutch broadcasters and has concentrated its energies elsewhere. Since 1990 then, with the brief exception of a short season of a Dutch version of *Man O Man* in 1996, Grundy has sold no game shows or drama to Dutch television. Despite its success in other parts of Europe, most especially in neighbouring Germany, it has been unable to capitalise on the outstanding and continued success of *Goede Tijden, Slechte Tijden*, now approaching its ninth year of production. However as long as this program is still on air, it is visible proof to other European channels interested in commissioning daily soap that Grundy is the indisputable master of the form.

(ii) Germany

Like the other television structures of western Europe, Germany has historically had a public service system which has recently seen its monopoly come to an end. Although television broadcasting had begun in Germany as early as 1933, it was not until after the establishment of the German Republic in 1949, that the way was cleared for the setting up of a system of public service broadcasting. In 1952, what was to become the ARD, a loose network of regional television broadcasters, came on the air. In 1960 a second channel, ZDF, was established (Noam 1992). These two channels constituted the television service for the Federal Republic of Germany for the next 25 years, a public service structure that derived some income through the sale of advertising time. In 1985, two private television broadcasters, SAT-1 and RTL, went on the air, the first to use new satellite delivery systems. Over the past dozen years, there has been a marked expansion in the television service which now consists of two public-service channels(ARD and ZDF), together with four privately owned channels (RTL Plus, SAT-1, RTL 2 and PRO 7), delivered by both terrestrial and satellite links. RTL Plus is now the most popular channel followed by SAT-1. The multiplication of television channels has facilitated an increase in the advertising market although the public broadcasters struggle to maintain audience size and advertising revenues (Bleicher 1997). Like the German economy itself, the television market has been significantly boosted since 1990 with the absorption of the former German Democratic Republic into the Federal Republic (Kilborn 1994).

Germany has been identified as sharing a common cultural orientation of European countries along the north-west rim of the continent that has been labelled 'Germanic' to distinguish it from a 'Latin' cultural rim in the south (Galtung 1993; Heinderyckx 1993). This orientation gives Germany a loose common background not only with Britain but also with Britain's former colony, Australia (Cunningham and Jacka 1996). Such commonality helps

explain the long contact between Australian producers and German broadcasters that began as early as 1973 with *The Castaways*, a co-production between the ABC, Scottish Television and ZDF. Grundy also benefitted from these industry linkages with the sale of programs such as *Bellamy* and *Neighbours* to German broadcasters such as RTL and SAT-1 (Macken 1989). In 1991/2, the company was involved with the Kirch production group, owner of SAT-1, in a co-production of the crime series *Bony*, the latter providing two thirds of the finance while Grundy provided the remainder (Holmes 1992). Soon after 1987 and the establishment of the London office, Grundy set about building an infrastructure in Germany. Two companies were established. Grundy Television Productions was set up to produce light entertainment and game shows. The second company was Grundy/Ufa TV Productions, a co-venture arrangement with Ufa Film and TV Productions, itself a unit of the powerful Bertelsman media conglomerate which is also a part owner of RTL Plus (Hofmann 1992). Because Ufa was a film production company, the association with Grundy has proved to be a very stable and complementary relationship and is one reason among many why Grundy World Wide has been so successful in Germany (Murphy 1995).

As in other territories, the company had its earliest successes with game shows and these have remained an important source of cash flow. The series *Ruck Zuck*, an adaptation of the format Hot Streak was broadcast first on Tele 5 and then on RTL 2, running from 1989 to 1996. A children's version, *Kinder Ruck Zuck*, was also spun off and appeared between 1991 and 1992. An adaptation of *Sale of the Century*, *Hopp Oder Top*, ran from 1990 to 1993, at first on Tele 5 then DSP. In 1997 there were several new shows including *Muuh! Small Talk* and *Geder Jegen Geden* (Fifteen-to-One).

If the success with game show in Germany has been encouraging, the record with soap operas has been outstanding (Lewis 1994). The partnership with Ufa began slowly. Following the success in the Netherlands of the Dutch adaptation of *The Restless Years*, the German commercial broadcaster RTL commissioned a further adaptation *Gute Zeiten, Schlechte Zeiten* (Good Times, Bad Times) in 1992. Again this adaptation began by using the original Australian scripts but the production brought original German scripts on line after Episode 230. Unlike its Dutch counterpart, the German adaptation was slow to build an audience and RTL showed a good deal of faith in holding it on air. However, by 1994, it was proving very popular and later that year was the second most popular soap in Germany ((Fuller 1994b). In that same year, 1994, Grundy received two further commissions for strip drama. The first came from RTL which wanted an early evening daily drama serial that was strongly oriented towards a young demographic. Late that same year the new serial *Unter Uns* (Among Ourselves), based on an original concept, went to air. Meantime the company was also developing an adaptation of *Sons and Daughters, Verbotene Liebe* (Forbidden Love), for the public service broadcaster ARD and this began broadcasting early in 1995. Both serials were produced in separate studios in Cologne. Late the following year, came yet a

further commission for another daily soap, this time from RTL 2. *Alle Zusammen* (All Together) began on air in late 1996, a little over a month after the serial went into production at studios in Berlin. This serial which concerned the personal lives of five young doctors proved to be too expensive for the broadcaster which resolved not to renew the commission in 1997. Instead RTL 2 decided to purchase another serial *Hinter Gittern* (Behind Bars), an adaptation of *Prisoner – Cell Block H*. The latter which began on air later the same year was a prime time serial, designed for broadcasting as one hour a week drama and was the first Grundy serial scheduled for prime time transmission in Germany.

Between 1989 and 1995, these various productions were coordinated from the company's London office with Grundy personnel both on site and visiting. However after the company had established itself as a leading German television producer, it was clearly time to make more lasting arrangements. In 1995 Grundy established an administrative office for Germany as well as the headquarters of Grundy Television Productions. The office is now located in Leipzig and is a visible sign of Grundy's permanent presence in German television.

(iii) Sweden

Although one of the wealthier countries in Europe, Sweden nonetheless has a small population of 8.7 million, approximately 12 per cent of the population of Germany. Historically, the Swedish state has aimed to achieve a better society and the broadcasting media has been one instrument among many through which this goal has been pursued (Noam 1992). Until the 1980s, Swedish households had the choice of two public-service channels run by what is now SVT, the first coming on the air in 1958 and the second commencing operations in 1969. Advertising was not permitted. Instead, this remained the preserve of Sweden's powerful newspaper industry. However, the advent of cable television in the early 1980s destabilised the state monopoly by introducing first foreign then Swedish satellite-delivered channels. The foreign channels carried television advertising so that Swedish commercial channels became necessary to ensure that Swedish media groups were not disadvantaged by the foreign spillover. Swedish press owners had been opposed to the introduction of commercial television broadcasting because it would erode their advertising base. However, they swung in favour of such a service when they realised that it was an opportunity to enlarge their media interests (Petersen 1992). In 1987 a new commercial satellite-delivered channel ScanSat/TV3 was introduced while in 1990 a second commercial channel Nordisk Television/ TV4 came on the air. Currently there are four networks broadcasting in Sweden (Nielsen 1997). These consist of the two public-service channels (TV1 and TV2) and two private, commercial services (TV3 and TV4). TV3 is determinedly commercial and is the most popular of the networks while TV4 has adopted a profile more like that of a public broadcaster.

In the 1980s, even before the development of commercial television, Grundy's distribution agency sold several programs including *Neighbours* to the Swedish public broadcaster (Macken 1989). In 1994, the company developed a co-venture arrangement with Wegelius TV, a Scandinavian production house, and TV 3 to produce a pan – Scandinavian adaptation of *Man O Man*. The program was distributed to Sweden, Norway and Denmark in their respective languages. In addition, to develop particular national identifications inside this pan-Scandinavian emphasis, individual episodes featured different national hosts and contestants while the final was a Scandinavian affair. The program ran for three seasons from 1994 to 1996. In 1996, Grundy entered into a second co-venture arrangement with Swedish producer Jarowskij Productions to produce another game show, *Smapratarna*, an adaptation of the format of *Small Talk*, for TV 4. The game show is still on air. Late in 1996, the company began producing its first drama serial in Sweden. *Skilda Varlder* (Worlds Apart), stripped in a 7 pm weekday time slot, is yet another adaptation of *Sons and Daughters*. Ironically, one of the public service channels had screened a subtitled version of *Sons and Daughters* some years earlier. Altogether then, these commissions in Sweden, coming so soon after each other, were of a good deal of significance. For while the value of each was relatively small compared to sales in the UK and Germany, nevertheless, they were an important signal that Grundy could produce indigenous programs for smaller markets at viable prices. As we have already seen, the company had flagged this message with the New Zealand production of *Shortland Street* and the success of *Skilda Varlder* confirmed that this could be repeated in Europe.

(iv) France

Of all the European broadcasting systems, the French has been the most recalcitrant as far as Grundy is concerned. After the consolidation of the US office in the early 1980s and the establishment of the British office, Grundy decided to make a French base its next priority as part of a move into Western Europe. Again, like the timing of its establishment in several other European territories, the moment of the company's arrival in France was fortuitous. In 1986, private television broadcasting was introduced in France, thus ending a public service monopoly that had lasted 50 years (Emmanuel 1997). Over the next 10 years, there were various changes such that there are currently six major broadcasters constituting the principal components of the French television system. There are three public service broadcasters, two commercial television channels while the last is a cable channel based on subscription. However in practice, there is a good deal of overlap between the first and the second sectors, given that one of the present commercial channels, TF 1, came about through the privatisation of one of the public service channels while the remaining public service channels derive some of their revenues from advertising (Jezequel and Pineau 1992). The overall system is, then, composed of two sectors: a generally profitably

commercial sector and a weakened public sector that is short of resources and ridden with crisis. Grundy was not the only foreign production company to see the possibilities in the transformed French television market. In 1987, the American advertising agency Lintas was responsible for the importation and takeoff of French adaptations of *Wheel of Fortune*, *Family Feud* and *The Dating Game* on what became TF 1 (Fuller 1992b). In Grundy's case though, there was already a short history of contact between the company and France 3 and Canal J on children's series such as *Runaway Island*. Some Grundy English-language programs such as *The Young Doctors* and *Neighbours* were also purchased by French channels although the volume of sales was small and the programs were generally badly scheduled (Macken 1989; Cunningham and Jacka 1996). As early as 1985, Grundy planned to establish itself as a production presence in the French television market place. However, it was also aware that the market was a difficult one for a foreign company to enter. Following what was to become a familiar policy in continental western Europe, the company sought a co-venture partner. In 1987, it settled on Tele Image (Harris 1987). The latter was one of the most prolific producers of sit coms in France and Grundy was initially intent on making game shows and light entertainment. However the two found that they were in fact competing to sell broadcasters programs for the same time slots so that in 1993 the partnership was dissolved (Baart 1995). In 1989, Grundy also had a brief arrangement with Ellipse, a division of Canal Plus that concentrated on game shows but that too did not survive (Anon 1989). Finally in 1994, Grundy Worldwide, the parent group, set up its own indigenous company, Les Productiones Grundy, which has produced all subsequent Grundy programs (Baart 1995).

In France, Grundy has only had commissions for game shows but two of these have been enormously popular, giving it a schedule presence in daytime, prime time access and in prime time itself. The company's first commission was *Questions pour le champion*, an adaptation of *Going for Gold*, which began in 1988 for the regional public broadcaster France 3 and is still in production. A second game show, *Que le meilleur gagne*, based on the format of *Everybody's Equal*, was sold to La Cinq, one of the private networks, in 1991. Although that group went bankrupt in 1992, nevertheless France 2 picked up the program and it continued on air until 1996. Both of these were enormously popular and together they maintained Grundy as the third most successful independent producer in the French market (Cooper-Chen 1994). In addition to both the daytime and access versions of *Que le meilleur gagne*, both of which are 30 minutes in length, the latter has also given rise to a 90 minute 'special event' version, *Que le meilleur gagne plus*, which plays in prime time. Other programs have been more short-lived: *Le Jeu* (based on *The Main Event*), ran for two seasons as has *Mais comment font ils?* (based on the Time Warner format of *How do they do that?*) and *Cheri-cheries* (based on Grundy's format of *Man O Man*), while *Keynotes* ran for one season in 1994. All these game shows/light entertainment adaptations, with the exception of the last,

have been produced for public service networks. This same pattern of association between the company and public-service broadcasters, which has already been mentioned, is evident in a number of other countries including Germany, Italy and New Zealand. It underlines the point that, in systems where the public service monopoly has ended, the company has won as much if not more acceptance from the public broadcasters as it has from the new private, commercial operators.

However, if the situation with the production of game shows has been a relatively successful one, the same is not true of drama serials. As noted elsewhere, France has no tradition of producing and watching successful serial drama (Jazquel and Pineau 1992). In 1992, following the adaptations in the Netherlands and Germany, Grundy began developing a French adaptation of the serial *The Restless Years* in conjunction with Tele Image. However, no sales eventuated from this and other projects (Baart 1995; Kolle 1995). In this respect at least, Grundy's situation in France paralleled its situation in the UK where it had won enormous respect among broadcasters as a producer of game shows and light entertainment. Until 1997, in the UK, however, it was unable to sell a drama serial. The tide turned there when *Family Affairs* was commissioned by the new Channel 5. This together with the success with drama serials in other national markets may yet make an impact in France.

(v) Italy

Of all the national public service broadcasting bodies in western Europe, none saw their monopoly end as dramatically and even as spectacularly as did Italy's RAI (Richeri 1985). RAI was established in 1944 as a counteroperation to the Mussolini government's broadcasting organisation and became the exclusive Italian broadcaster after 1945. In 1954 television began with one channel while in 1961 RAI 2 went on the air. In turn, a third state channel with a regional orientation, RAI 3, began broadcasting in 1979. The networks were supported by licence fee and advertising. However various political, community and commercial groups resented the monopoly that RAI held over broadcasting. Following a 1973 ruling in the Italian Constitutional Court in favour of a small private cable television company in Biella near Turin, a new Italian law of 1975 introduced extraordinary liberal laws on local or regional television and radio broadcasting such that any Italian individual or group could go on the air (Noam 1992). Over the next few years there was an explosion in the number of television and radio stations. Although these were mostly local, nevertheless *de facto* national networking emerged with the three most popular networks controlled by the Berlusconi group. Currently, most of Italy is served by three public-service television channels (RAI 1, RAI 2 and RAI 3), which are legally the only national broadcasters, and 5 commercial channels (Mediaset Spa which operates three channels – Italia 1, Rete 4 and Canale 5 as well as TMC and Tele Lombardia) (Bechelloni 1997).

With this multiplication in broadcast hours, Australian producers in the 1980s and the 1990s have had good sales of their programs to Italian televi-

sion (Macken 1989). Grundy's first contact with the Italian television market took place at this time through the sale of drama series such as *Bellamy* and *The Young Doctors*.

Further contact came about through the establishment of a Grundy regional office for the Mediterranean area. Since 1987, northern Europe has been serviced from the London office. To extend its marketing operations, Grundy, in 1993, decided on a parallel arrangement for southern Europe. There was already an office in Monaco to handle legal and financial matters and this became a hub for program sales and format licensing for national territories along the southern rim of Europe. The markets serviced from this office are Portugal, Spain, Italy, Switzerland, Greece, Israel and Turkey. The decision was a sound one for while several of the companies discussed in Chapter 3 have been wary of the Italian market, Grundy has establish a firm footing there after a difficult start (Anon 1994b).

In 1994, Grundy, in conjunction with RAI, produced a local adaptation of the format *Man O Man* entitled *Beato Tra Le Donne* (Happy Among Women). The program was a 'live' entertainment which was broadcast by RAI 1 in its summer season. The series did enormously well, generally capturing more than half the viewing audience and has lead to repeat seasons over the past three years. Meantime, the company was also engaged in discussions about a strip drama serial and, although protracted, nevertheless, in late 1996 Grundy's first soap opera in Italy went on the air on RAI 3. *Un Posto Al Sole* (A Place in the Sun) was an original format devised for RAI (Lewis 1994). In addition, in 1997, Grundy also produced an Italian version of *Everybody's Equal*, *Vinca il Migliore*, as well as a new format *Per Tutta La Vita* (For Life) for RAI. Altogether, this body of programs, produced in four years, constitutes an impressive beginning in the Italian market on which the company plans further expansion.

(vi) Spain

Grundy set up its first production in Spain in 1991, a year after private national broadcasters had come on the air. Television broadcasting had begun in Spain in 1956 as a system of public state monopoly under the government of General Franco (Noam 1992). Following Franco's death and the introduction of democratic government, the state monopoly was reorganised in 1980 as RTVE. The latter is a public service broadcaster that derives its income not from licence fees but from advertising revenue. RTVE had a monopoly over the airwaves and over advertising until 1987 when six regional television channels were launched that were supported by regional governments and advertisers (Maxwell 1997). In turn, this paved the way for privately owned television broadcasting which began in 1990 (Villa Grasia, J.M. 1992).

Spain's television system consists of five national networks, two are public service operated by RTVE (TVE 1 and TVE2) as well as two private commercial services (Antena 3 and Tele 5), while Canal Plus is a pay-TV service.

In addition several of the countries 17 regions or nations have at least one if not two local channels, frequently dedicated to fostering national identity in their particular region. (Vila Gracia 1992). Many of these regional broadcasters have come together to form FORTA, a *de facto* network for the purposes of acquiring and producing programs (Widdicombe 1994). There has also been pressure on RTVE to make TVE 2 a regional channel. One other feature worth mentioning is the presence of foreign business groups in Spanish television which has included the Berlusconi group, Canal Plus and News Limited (Vila Gracia 1992).

With the onset of commercial broadcasting in 1990, television programrs in both the public sector and the private were faced by the prospect of limited revenues. Broadcasters were forced to rely on imported programs, most especially telenovelas from South America, and low cost Spanish productions such as talk and game shows (Moore 1992; Anon 1992). By 1994, Antena 3 had succeeded in capturing 26 per cent of the audience, Tele 5 had 19 per cent while the public broadcasters TVE 1 had 28 per cent and TVE 2 had 9 per cent (Burnett 1994). With RTVE suffering from financial crisis, it would only appear to be a matter of time before Antena 3 became the most popular network in Spain.

When Grundy turned its production attention on Spain, it already had a trail to follow. The company had early contact with Spanish broadcasters both through co-productions and program sales. The Australian Grundy Organisation's children's drama unit co-productions with RTVE have included the telemovie *The Rogue Stallion*, episodes of *Mission Top Secret* and the upcoming series *Return to Treasure Island*. In addition *Neighbours* was sold in Spain although it was broadcast well outside prime time. To generate national production in this new market, Grundy drew on the same catalogue of formats for adaptation that it was using elsewhere in Europe. Since 1991, Grundy game show productions for Spanish broadcasters have included the following: *Txandaka* (Kids Are Funny Too) for Basque TV in 1991; *Cuestionario Millonario* (Going for Gold) for TV Madrid in 1991-2; *Aqui Jugamos Todos* (Everybody's Equal) for TVE in 1997; and *Vore Qui Guanva* (Let's See Who Wins) for TVV-Canal 9 also in 1997. In addition in 1994 Grundy signed a co-venture arrangement with a Spanish production company, Zepelin, and their first co-venture was *Elles I Ells*. The latter was an adaptation of *Man O Man* for TVV-Canal 9, produced from 1993 to 1995, whereupon it was sold to Telechino as *Uno Para Todas* for national broadcasting in 1996 and 1997.

However the game shows have not as yet opened the door to selling drama serials. In this second area of expertise, Grundy inevitably runs up against the fact that Spain is part of what has been called the Latin audio-visual space. (Mattelart, Delacourt and Mattelart 1984; Sinclair 1996). South American broadcasters have beamed satellite programs into Spain and the South American telenovela has also had a major impact on schedules in that country. Thus in a 1994 international survey of drama serials on European television screens, three countries – France, Italy and Spain – reported that

imported South American telenovelas were extremely popular with national audiences. In Spain, seven of the top ten programs, including the top three, were telenovelas. (Ironically the most popular US drama serial was Grundy's *Dangerous Women*), (Akyuuz 1994). In other words, the company faces the same uphill struggle against the market dominance of the telenovela form as it does in South America. However although the South American telenovelas originating in countries such as Venezuela and Argentina share the same language with programs produced in Spain, nevertheless they are not indigenous productions. If the experience of Italy is any kind of guide, then, sooner or later, Grundy must stand a reasonable chance of securing a commission to produce local drama serials for the Spanish market.

Central Europe

Where countries in Western Europe have been moving over the past 20 years from systems of public-service monopoly to duopolistic mixes of public-service and independent commercial sectors, the change in broadcasting structures in Central Europe has been both more recent and different. With the exception of Austria, countries in this region have, until recently, been ruled by Communist governments and the operation of television has been directly under the control of the state. Since 1989 and the collapse of Communist rule in the region, the former Eastern bloc countries have sought to admit multi-political parties and to move their economics in the direction of the free market.

After the expansion and subsequent consolidation of its presence in the more important markets of Western Europe, Grundy has more recently increased its involvement in the former Communist bloc of Central Europe. In particular it has focussed on the eastern neighbours of Germany, most especially Poland, Hungary and the Czech Republic. Companies have been established in these three national territories and the first commissions occurred in Hungary in 1997. This was partly a matter of timing. It was also an outcome of Grundy's business affiliations in Europe and points to a new, powerful factor that now benefits its entry into new national markets. Hungary had experienced a relatively peaceful transition from a Communist state when in 1989 its Communist government decided to hold elections the following year that could be contested by all political parties. The move signalled the end of Communist domination and the first half of the 1990's saw Hungary moving towards a market economy. Parallel developments occurred in the area of broadcasting where state control was increasingly superseded. Magyar TV (MTV) is the former state broadcaster, operating two television channels, which since the end of communism has vigorously expanded its advertising base which was recently reported as being worth $128 million annually (*Life* 1997). In early 1997, the Hungarian government decided to allocate two commercial licences for a seven year period and these were awarded to operators calling themselves TV2 and RTL/Klub which were required to be on the air by late in the same year. TV2 has links to SBS (Scandinavian Broadcasting System).

Concentrating on both Hungary and the Czech Republic, which it designates as new territories, Grundy was already, in late 1997, working on productions for the former market. It sold its first programs to the new commercial channel, RTL/Klub, which has links to broadcaster CTL and the production company Ufa. Grundy's first game show *Szazbol Egy*(Everybody's Equal) began on air in late 1997. In addition, Grundy was also developing a daily strip drama serial that was scheduled to begin on air in 1998. This serial was not a reversioning of an existing format but was rather based on an original concept. The serial concerned a group of five friends, living in Budapest in a post-Communism world and had the working title of *Best Friends* or *Circle of Friends*. The intention was that the serial would be produced initially by the German drama arm of the company, Grundy/Ufa.

The Arab World

As we have seen, the Grundy office in Monaco has been responsible for licensing formats and producing programs along the Mediterranean rim of Europe. However, like the recent moves beyond Western Europe into Central Europe from the London office, Grundy has in the past four years made parallel moves from the Monaco office and now includes the Levantine shores of the Mediterranean in its sphere of operation. Like broadcasters in other regions, some of the television operators in this part of the world are under the same commercial pressures that would privatise state controlled and public service television broadcasting and introduce independently owned commercial channels and such a climate creates opportunities for this kind of company. Grundy owned formats have to date appeared in two countries of the region. An adaptation of *Hot Streak*, *Hamesh Hamesh*, ran for two years on Israeli television in 1993 to 1994 while a second game show, *Kids Are Funny Too* also appeared in 1994. More recently yet another adaptation of *Man O Man, Ah Kizlar Vah Erkekler*, appeared on Kanal D in Turkey 1996. Two of these three were produced by local producers under licence arrangement with Grundy so the entry at this stage is a modest one. However given the resources both of Grundy English-language program sales and the number of format titles on offer not only in its own catalogue but also in that of AAFI, the company is likely to become a more important presence in this region in the future.

South America

Of all the companies discussed in the past three chapters (with the exception of Brazil's Globo TV), Grundy is the only international formatter to establish a permanent presence in South America. As in other territories, the company had initial contact with this region through program sales. From Europe, the distribution arm had sold small packages of various Grundy programs, including *Bellamy* and *Prisoner*, to countries in the region (Ray 1997). Generally though, the company was not known to South American broadcasters. In 1992, the Australian wing obtained a sale for a

game show, *Desafio Familiar* (Family Feud), to the national channel, Channel 7, in Chile. A production office was established in Santiago for the duration of the program (Brooke 1995). Meantime as production bases in countries such as the UK and Germany reached maturity, Grundy began to look at new territories. In 1993, as part of a further wave of expansion, it decided to establish permanent offices in both South America and Asia. In South America, the temporary Chilean office became the permanent office for the whole region (Pinne 1996). There were several reasons for the choice of Chile. First, although *Desafio Familiar* only had a short run, the production of such a program by the *gringos*, as they came to be known, meant that Grundy had the beginnings of a production track record in Chile. Secondly, of all the Latin American economies, Chile's appeared to be the most stable so far as inflation was concerned (Lindsay and Milichip 1994). Moreover, in countries such as Brazil and Mexico, Grundy would immediately be competing against production giants such as Globo TV and Televisa (Sinclair 1996).

The present period for the company's operation in South America is very much one of early development and can be contrasted with similar intervals for the group in other regions. Besides characteristic difficulties due to the economic instability of some of the countries in the region and the complex involvement of politics and government in the various national television industries, factors that affect any production group operating in this region (cf Fox 1988), Grundy finds itself facing other difficulties. As we have seen in the last two chapters, Grundy's strength in entering a new territory lies in its catalogue of successful formats of game shows, light entertainment and drama serials that it owns or licences. The first two programs that the company sold in the region, *Desafio Familiar* and *Blockbusters*, were both adaptations of formats developed in the US by the Goodson group. Although Grundy has had a long term licensing arrangement for the Goodson formats, for regions outside the US and Europe, the sale of this catalogue, following the death of the principal in 1992, created doubt as to Grundy's continued access. However Pearson's purchase of AAFI, including the Goodson catalogue, removed this difficulty. In any case, many of these US formats had already been pirated by South American game show producers (Pinne 1996). However, the company has its own format catalogue and these have not been seen or copied in this region. It is not surprising then that Grundy's most recent productions have been based on formats in its own catalogue. A South American adaptation of *Sale of the Century*, *La Venta del Siglo* began in 1995 on Paraguay's SNT Canal 9 under a barter arrangement and is now in its third year. In addition, as in Scandinavia in 1994, Grundy produced a supra-national version of *Man O Man* early in 1997. This version drew inspiration from the Italian summer version and was produced during the southern region's summer season in early 1997 and broadcast in three of the countries in the Mercosur group – Argentina (ARTER Channel 13),

Uruguay (Channel 10) and Paraguay (SNT Channel 9). However the Goodson catalogue is still of value to the company and has given rise to two series of *Blockbusters*, in Chile in 1994 and in Uruguay in 1997.

In the area of drama, the company also faces difficulties in South America (Pinne 1996). Unlike Europe, where locally produced daily drama serials had not been broadcast before 1990, South America has a continent-wide expertise in the production of the telenovela and this in turn has shaped both television schedules and audience expectations (Fadul 1993; Martin-Barbero 1995). Grundy has made several attempts to adjust to the telenovela. In 1993/4, it developed an outline for an adaptation of *Sons and Daughters*, *Amore Prohibido* (Forbidden Love) for one of the Chilean broadcasters but production did not go ahead while in 1996 Grundy was reported to be co-developing a Spanish/English telenovela with Televisa of Mexico (Millichip 1996). Meantime, the company sees other market opportunities in drama series and situation comedy (Pinne 1996). In 1995, it licensed the Australian ABC's sit com *Mother and Son* and produced a Chilean version *Madre e Hijo*, now in its third season. In turn this adaptation has inspired two further adaptations of the sit com format which are presently in development in Germany and Sweden. Meantime Grundy also holds an option on a second sit com format, *Hey Dad*, which was produced in Australia by a commercial competitor. Overall then, the sales and projects in development constitutes a modest but positive beginning for the company in this continent, especially in the southern region. As might be expected, given the location of the South American office in Santiago, Grundy has had a successful start in Chile. It is also well established in the small television market of Paraguay and becoming well known in neighbouring Argentina and Uruguay although the more populated and lucrative markets to the north such as Brazil and Mexico still remain untouched.

Asia

Unlike the establishment of its South American office, Grundy had more advantages in place when it came to developing a production presence in Asia. Despite the very large social and political differences of religion, language and culture between Australia and the countries of Asia, nevertheless Grundy had a longer and a more extensive history of program sales there than in South America (Macken 1989). It also had previous contact on past productions. Moreover, it does not encounter the dominance of certain regional cultural forms as it does in South America.

Even before the establishment of a permanent office in Singapore in 1994, there had been contact between Grundy and Asian broadcasters. In 1982 the company produced two game shows *Dai Sou But* (Sale of the Century) and *Dai Pai* (Card Sharks) for a new broadcaster, RTV, in Hong Kong. Between 1983 and 1986 it produced *Matchmates* for Brunei TV (Robinson 1986). However, these were 'spillover' productions from the company's

operation in Australia. At the time, most of the company's energy was directed to the establishment of offices in the US and, later, the UK so that the Asian involvement lapsed. However the link was not completely severed. Several drama co-productions involved Asian investment and Asian location filming. The series in question included *Tanamara – Lion of Singapore*, *Embassy* and *The Other Side of Paradise* (Moran 1993). In addition, in 1992/3, the company co-produced a telefilm episode of the children's series *Mission Top Secret* with the Japanese broadcaster NHK. A third form of contact with Asia involved the sale of programs either handled or owned by Grundy. Game show sales included the US and Australian versions of *Family Feud* sold to Indonesia while drama serials such as *Neighbours* and *Prisoner* were sold to Hong Kong, Thailand and the Philippines. (Macken 1989; Anon 1994c). Following the decision to open a permanent office in the region, a branch of the company was established in Singapore in 1993. There were several reasons for the choice of this location. At the time, Grundy was planning a drama serial that was to be produced in Singapore. In addition, the South East area was the heartland of many of the 'Asian tiger' economies and appeared to offer more immediate opportunities than did Japan and China to the north or India, Burma and Pakistan to the west (Hamilton 1992; Grantham 1992; Atkinson 1994). Finally, as in South America, the host country needed to be politically stable and Singapore appeared to be a good choice.

Ironically, the company has had most production success to date outside of Singapore. As already noted, Grundy has access to US formats such as those of Goodson and King World that are also available to it in Australia, the Pacific and in South America but denied it in Europe. In 1995, an Indonesian adaptation of the Goodson-owned format *Family Feud*, *Famili Seratus*, went to air on the ANteve channel where it continues. In addition, the company also produced a celebrity version of the format, *Bintang Bintang Famili Seratus*. A third Indonesian game show, *Kata Si Kecil*, an adaptation of *Child's Play*, began broadcasting in 1997. All three were broadcast by ANteve. Meantime a second Indonesian network, TPI, began screening national versions of *Sale of the Century* and *Take Your Pick* in late 1997. The same year also saw a first game show, *Corporate Raiders*, being screened on ABN in Singapore. A sports-based light entertainment show, *Kricket!*, based on a format devised by Grundy, was produced in 1995 in partnership with United Television of Bombay for broadcast on the Star Plus channel of Star TV. Outside of Indonesia, Grundy sees its best opportunities for new productions in neighbouring Thailand and Malaysia. However there are certain difficulties in the way of these ambitions. Other game show producers, most especially AAFI, are active in the region with the latter using its Australian affiliate, the Becker group, as a production source for programs that it sells (Hogg 1995). In addition, television game shows in Asia often run into legislative restrictions on the size of prizes and the nature of the game (Atkinson 1994). Thus, for example, Grundy

was denied a production licence by Indonesian authorities for an Indonesian version of *Wheel of Fortune* because government officials considered the game element in the program to be based on chance. Finally, with drama, the company is pinning its hopes on the fact that soap opera in a contemporary setting will prove attractive to broadcasters in the region, both because of economies of scale and the lack of production competition.

The decision to locate the central office in Singapore has already been mentioned. More recently, an embryonic system of Grundy offices and agents in the whole Asian region has begun to emerge (Skinner 1996). Following its initial success in Indonesia, Grundy in late 1996 made new arrangements there that effectively saw a branch office open in much the same way that the company opened French and later German branch offices within its European operation. Complying with an Indonesian law that all broadcasting companies operating in the national television market be Indonesian, Grundy made arrangements so that the Indonesian company is fully owned by nationals. Operating as a nominee company, this company uses the Grundy logo, is financed and managed by Grundy and has full access to the latter's formats and skill (Skinner 1996). However, although this office is rapidly developing local expertise that can be drawn upon for new productions in other territories, the Singapore office remains the hub for the Asian region as a whole. This office continues to be the focal point for the distribution of Grundy English-language programs throughout Asia. From 1993 to 1995, Grundy had its own sales representative working out of this office, covering the region as a whole (Anon 1994c). However, the Pearson takeover and the coincidental resignation of the officer in charge of Asian distribution led to a reorganisation of marketing. In 1997, a new officer was appointed to handle the Pearson catalogue, including the Grundy programs. In addition to this arrangement, Grundy has an agent in Japan who is involved both in sales and co-productions. And, finally, the company also has a small office in Hong Kong with two agents concentrating on Korea, Taiwan and Hong Kong.

★　★　★

Stepping back from the detail of the past four chapters, we can see the international dimensions of trade in television program format adaptations. Clearly, this kind of program translation is a regular component of national television systems across the world with a ceaseless flow of imports and exports between these systems. Game shows are the television genre most often cited as an example of format adaptation but, as the outline developed in these chapters has suggested, this is only one part of international format trade. And if there is asymmetry between national television systems so far as the import and export of formats is concerned, so too there is often asymmetry between genres. Thus, a national

television system may be a strong exporter of formats in one genre but turns out to be an importer of formats so far as other genres are concerned. Obviously, a systematic international inventory of format traffic is urgently required although such a task is beyond the scope of the present volume. Instead, pursuing an interest in nationalisation, we now turn to an extended examination of specific examples of program translation.

Part Two

Program Adaptations and Cultural Identity

Contests of Knowledge and Beauty: Game Shows, *Sale of the Century* and *Man O Man*

Text and Nation

This chapter and the next three are concerned with specific national adaptations of television program formats in the areas of game shows and soap opera. We are interested not only in what is different between different adaptations but, especially, in just how these adaptations might contribute to a sense of particular national belonging. Such a concern with the complex relationships between text and nation is far from new. One need only recall Sir Joshua Reynold's essays on English painting and the art of the Low Countries and John Ruskins' essays such as 'The Stones of Venice' to realise that there is a well established tradition of inquiry into the relationship of text and nation. However, it is probably the links between literary texts and nation that have received the most sustained attention and the late twentieth century has seen this area of inquiry alive and well with recent studies by Porter (1981), Franco (1986) and Bhabha (1990) among others. Equally, this kind of inquiry has also included the interrogation of national elements in popular literary texts such as those by Sommer (1991), Turner (1994) and Kibberd (1996). Although cinema is essentially a product of the twentieth-century, nevertheless this same preoccupation with the national character of its output is also evident on the part of film scholars. Recent inquiries that focus on cinema and nation have

included Hill (1986) and Murphy (1989) on British cinema, Rockett, Gibbons and Hill (1988) on Irish cinema, Elsaesser (1975) and Bordwell, Thompson and Staiger (1985) on American cinema, McArthur on Scottish cinema (1982) and Berton (1975) and Harcourt (1980) on Canadian film.

Cross National Adaptation Studies

Much of the research on text and nation alluded to in the previous paragraph includes a concern with textual translation, the transfer and adaptation of textual materials from one national textual institution to another, with the researcher particularly interested in the national colouring acquired by the translation. Where there is resemblance or likeness between two texts in two different national textual systems, then their differences may contain clues about different national identities. Thus, for example, one might compare the novel *The Portrait of a Lady* by Henry James with the relevant sections of *Middlemarch* by George Eliot in order to discover not only differences between the two authors but also to trace the American and British colourings of the two novels. However a text can include not only individual works, sometimes characterised with the name of an author, but also larger textual collections containing many individual units including genre or some other series principle. Thus we can see the strategy of contrastive national textual analysis at work in the individual case in a recent study of Jean Luc Godard's *A Bout de Souffle* and Jim McBride's *Breathless* that finds these two films representative of their time and place of origin, France in the 1950's and the US in the 1980's (Gripsrud 1992). Equally, at the level of generic adaptation across nations, we might cite the opportunities for comparison between the Italian Spaghetti western and the Hollywood western (Frayling 1981). National adaptation analysis is also evident in television studies and three recent examples give some general indication of the field.

The first study occurred in Belgium in 1991 at the Université Libre de Bruxelles when a team of researchers undertook a comparison of news programs broadcast in 8 countries of western Europe on 17 different television channels. The countries in question were Belgium, France, Germany, Italy, the Netherlands, Spain, Switzerland and the United Kingdom. Although the report of the study and its findings does not mention 'formats' or 'adaptation', nevertheless it is clear that the purpose of the contrast is in fact a cross-national format adaptation study. Certainly the news programs had sufficient in common for the researchers to recognise the presence of a common format (Heinderyckx 1993). The report specifies not only recurring stylistic features but also common matters of substance including the issue of European unity, the emergence of a cross-border culture, the levelling of public opinion and the dwindling number of sources of information. The research analysed over 300 different news programs from the different sources and, on the basis of a correlation of significant elements, suggested the presence of two groups. A *Germanic-Culture* group consisting of German, British, Dutch and Dutch-speaking Belgians, and a *Romance-Culture* group,

comprising Spain, Italy, France, and French-speaking Belgium and Switzerland. On average, the latter's news programs are longer than the former although the *Germanic-Culture* group devotes less time to its items. This had the net effect that the time devoted to items in the programs of the two groups was exactly equal. In addition there was a sharp difference in style with the *Germanic-Culture*'s news items comparable with the headlines and introductory paragraph of a newspaper story while the *Romance-Culture*'s items corresponded to the more extended treatment of a topic that is found in an editorial. In the report's conclusion, Heinderyckx cautiously suggests some of the possible cultural significance of the national variations of the format:

> ... significant nuances exist between the various channels. These differences could hardly be explained by simple cultural peculiarities. Only time slots could be explained that way, as newscasts are aired around meal times. Some discrepancies in terms of substance can also be accounted for if we take into consideration the type of programs that immediately precede or follow the news. The position that a given station occupies in the market and its target audience are clearly factors that influence TV news producers However, to extrapolate any of the analysis of the various viewerships' divergent sensibilities from the results of this study would be to acknowledge that the programs meet a genuine public demand and this, no doubt, would not meet the requirements of scientific rigour. (Heinderyckz 1993 p 448)

The second study concerns the national adaptations of the format of the game show, *Wheel of Fortune*. A Danish investigation whose results were published in 1992, this research concerned the analysis of episodes of four different translations of the format, consisting of the US version, the Danish *Lyckohjulet*, the German *Glucksrad* and the Swedish/Scandinavian *Lyckohjulet* (Skovmand 1992). Adopting a structural approach to the analysis of these different versions, Skovmand is able to note variations within an overall pattern of similarity. The versions turn out to exhibit a range of differences which the researcher treats as nationally representative:

> *Wheel of Fortune* is a game show in which popular participatory and consumerist modes of address compete. A popular/participatory game show requires a genuine sense of constituency for the show to work. There is that sense of constituency in both the US and Danish versions. In the case of *Glucksrad*, there does not seem to be such a sense, and consequently the show relies on its consumerist address and appears primarily as a vehicle for advertising. In the case of the pan-Scandinavian *Lyckohjulet* there is an attempt to create a 'Scandinavian' sense of constituency and mode of address, but given the lack of cohesiveness of its actual satellite audience, the game show comes across as simply a slightly more up-market edition of *Glucksrad*. (Skovmand 1992 p 98-99)

The third cross-national adaptation study is the *East of Dallas* research project, conducted between 1984 and 1987. Admittedly this research had a wider focus — a study of family-based drama serials in western Europe in the light both of particular national television traditions and the recent popular success of the US program *Dallas*. The countries chosen for the study were Britain, France, Germany, Ireland and Italy. *Dallas*-like characters and situations occurred in several national serials and, in two cases, the German *Schwarzwwaldklinik* and the French *Chateauvollen*, there were more direct translations of the *Dallas* format:

> Our research has shown how the production of European fiction presents strong national characteristics which reflect the cultural and social identity of the country, its history and its traditions. This is true also for those programs such as *Schwarzwaldklinik* and *Chateauvollen* based on the American model. A French *feuilleton* is unmistakably French. An Italian television dramatisation is unmistakably Italian. (Silj 1988 p 208)

Cross-national adaptation studies then are occurring in the fields of media research and cultural studies. Heartened by the thought that others have found this a meaningful area of investigation, and have certainly not attempted to short circuit their inquiries by assuming that translation is invariably a simple, mechanical process, where a dominant meaning is transferred intact in the process of adaptation, let us turn to an investigation of particular examples of format adaptation, starting with the television game show. As a first step, we shall briefly survey some of the conceptual tools that various researchers have offered for the investigation of television game shows and nationality, most especially those few, like Skovmand, who have concerned themselves with game show adaptations and national identity.

Television Game Shows And National Identity

The game show is a 'fringe' genre not only in terms of its institutional position within television industries but also in terms of the paucity of analysis and research (Shaw 1987). Generally speaking, the most significant English-language research into television game shows has been interested in the particular ideological construction of knowledge and consumption (cf Mills and Rice 1982: Tulloch 1976: Fiske 1983,1987,1989; and Holbrook 1993). In turn, the meagre literature that connects the game show adaptations, nation and national identity falls into three types. The first is the incidental type where the researcher in analysing a particular game show, often aware that the program is a national variant on an international format, refers to the particular national 'colouring' of the version in question. Thus, as already noticed in Chapter 2, Brunt in discussing the British adaptation of *What's My Line?* is aware that the format was originally developed for US radio and was then licensed to the BBC where the program now has a 'naturalised Britishness':

> The choice of contestants appeals to a Britishness which 'all of us' are assumed to share: an enjoyment of eccentricity and an ability

> to laugh at ourselves — as transmitted and endorsed by one of Britain's favourite Irishmen. (Brunt 1984 p 25)

There are two other lines of analysis that have also been developed by researchers interested in the issue of television game shows and nationality. The first is a kind of 'mapping' exercise which broadly characterises national game show styles or preferences. Two examples can be cited. Pfeffer (1989) contrasts French game shows as celebrations of education and intellect, values that are institutionally dominant in French culture while American game shows celebrate merchandise and consumerism. More recently, Cooper-Chen has conducted a 50 country survey of national game show styles and preferences, suggesting the global presence of several 'taste-continents' including a 'European', 'Latin' and an 'Asian' cultural formation (1993; 1994). Instead of focussing on national styles in television game shows, as though they are a direct outcome of a pre-given reality such as the nation, the second approach concentrates on the analysis of specific television game shows, at the same time suggesting further connections between popular television, everyday life and political formations. Among the inquiries that might be cited here are those by Davies (1982), Luthar (1993), Whannel (1982; 1989; 1992) and Skovmand (1992). The particular relevance of the latter approach for the present inquiry into game show adaptations and national identity has already been mentioned and we can also note the particular significance of Whannel's article on national adaptations of the game show *It's a Knockout* (1982). With a pan-European version of the format broadcast by the BBC, *Jeux sans Frontieres*, and a British version, *It's a Knockout*, Whannel is able to compare two variants of the same television format, focussing on iconography, narrative competition and the discursive universe of the two versions, thereby noting the particular ways in which 'the nation' is constructed in each:

> The audience position offered by *It's a Knockout* is from the perspective of the (British) nation. That image of nation (is one) composed of small town communities. The competition of the individual programs is framed by the harmonious unity of the nation that holds and encompasses all these fun and games. The audience position offered by *Jeux sans Frontieres* is also from the perspective of the nation rather than Europe as a whole. We are invited to view events still from the position of members of a nation (Whannel 1982 p 47).

To recapitulate the discussion to this point, we can note that there is a long established tradition of inquiry that seeks to understand texts in terms of their national origins and that this mode of investigation has been continued in television studies. To the limited extent that researchers have engaged with game shows, most accounts have focussed on the ideological work they preform, especially in their representations of education and consumption. However inquiry into the game show and national identity have also got their own precedents so that the discussions that follow, on particular national adaptations of particular game show formats find sanction here.

The 'Short Form' Television Game Show: *Sale of the Century*

Of all television genres whose formats are adapted across national territories, the 'short form' game show is the most impervious to variation, especially those motivated by a sense of national difference. Nevertheless some significant differences can exist in the interstices of these adaptations as a short examination of one set of translations reveals. *Sale of the Century* first appeared in 1969 when the program went to air on the NBC Network in the US (Graham 1988). Subsequently the format changed hands and a new cycle of translations of the format has occurred. This cycle consists of versions in Australia from 1980 to the present, Hong Kong (retitled *Dai Sou But*) in

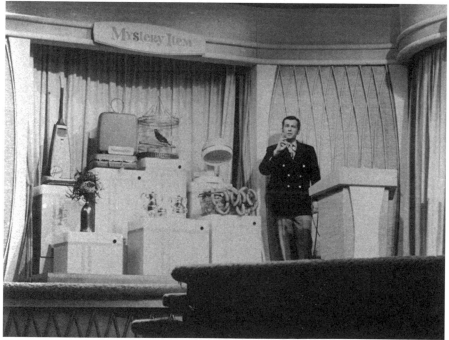

Original US version of Sale of the Century, *broadcast 1969-73*

1982, the US from 1982 to 1988, the UK from 1989 to 1991 and 1997, New Zealand from 1989 to 1993 and 1995, Germany (retitled *Hopp Oder Top*) from 1990 to 1993, Greece (retitled *To Afentiko Trelathike*) in 1994/5, Paraguay (retitled *La Venta del Siglio*) from 1996 to the present and Indonesia in 1997/8, altogether 10 different versions (Moran 1997b). Several episodes of each of these versions, with the exception of the original US, the Greek and the Indonesian adaptations, were available for analysis and the results can be summarised as follows. No national adaptation has a 'reflectionist' relationship with the nation state from whence it originates but nevertheless they still display some obvious national traits. Each version is in the language and

German remake - **Hopp Oder Top**

accent of the particular country even though a present day version might have to introduce significant variation. Thus, for example, the Hong Kong version used the Cantonese version of the Chinese language whereas a version made in that territory in 1997 would be in Mandarin Chinese. Similarly other national references also abound in such features as the regional origins of contestants, the national media celebrities who are featured on the fame game board on some versions, the local character of some of the prizes and

Paraguayan version - **Venta Del Siglio**

the kinds of indigenous knowledges that questions often assume. Beyond these differences, there are other variations that begin to suggest larger cultural differences between the audiences for the different national versions. Thus the Australian version of the format consistently diminishes both the competitive and product promotion segments of the program. Instead the emphasis falls on the warm interaction, often comic, between host, hostess, models and contestants. On the other hand, the Chinese version is oriented towards a younger audience and although more formal than the Australian is also more consumerist in orientation. Energetic expressionism is the central motif of the US version. Lights flash, editing is rapid, the general tempo is upbeat,

Longest running version - the Australian host and hostess of **Sale of the Century**

the host is fast-talking and even the contestants are extremely talkative and exuberant. The fourth version, from the UK, has far less colour and it is only the host's particular British regional slightly smutty cheekiness that breaks the pattern. The New Zealand version is among the more formal and abstract of the various adaptations. Little time is devoted to chatting with the contestants although the contestants themselves are constructed as sporting rather than competitive. Host and hostess are courteous and polite to contestants. By contrast, the German version is emphatic in promoting competition

inside strictly controlled boundaries. The time given over to the knowledge contest constitutes the highest percentage of any national version. At the same time, the version is marked by a highly stylised and coordinated appearance of all figures seen in the program with the host adopting a stance of informal formality. Finally the second most recent adaptation, that produced in Paraguay, appears to be the most anecdotal with the longest time set aside for chats.

Clearly these elements in the different versions serve to mark each version off, one from another. In addition, while not reflecting the nation or the national, nevertheless it is possible to see some parallels between text and national context although one should be cautious about attaching too much significance to this kind of detail. In any case, these differences are very much in the interstices of a format that is strictly controlled and very close to invariable. Other television genres, including other types of game shows, are more open and pervious to differentiation.

The 'Long Form' Television Game Show: *Man O Man*

While the 'long form' game show also firmly belongs to the genre of light entertainment, a genre that frequently has recourse to its own utopian imagery, nevertheless the particular format and adaptations to be considered here registers sufficient differences such that national audiences have responded to them as culturally distinct. Where *Sale of the Century* might be described as a quiz show, a game in which contestants compete by being first to answer general knowledge-type questions correctly, *Man O Man* is a light entertainment/game show, a kind of male beauty contest where the male contestants are required to perform a number of activities, such as dancing and singing, and it is an all woman jury, among an audience of women, who decide who will be eliminated. The series was developed by a local producer in Germany and went to air on Sat 1 as *Mann O Mann* in 1992. Subsequently

The Italian version - **Beato Tra Le Donne**

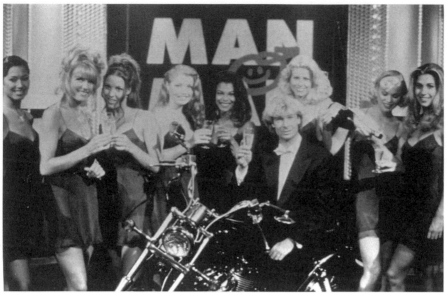

Dutch remake of the **Man O Man** *format*

Grundy licensed the format for all territories outside Germany and to date have produced 12 adaptations, 10 have been national versions (Australia, Belgium, France, Italy, The Netherlands, Portugal, Spain, Turkey, UK and US) while two others have been pan-national (a Nordic version transmitted to Denmark, Norway and Sweden and a South American version broadcast to Argentina, Paraguay and Uruguay). Six of these adaptations were available for analysis: the Australian, the Dutch, the original German *Mann O Mann*, the Italian *Beato Tra Le Donne*, the Scandinavian *Mann O Mann*, and the Spanish *Elles I Ells* (a more recent Spanish version, *Uno Para Todas*, is in production for a different network). The analysis focussed successively on the paradigmatic and the syntagmatic axes of the different versions – examining under the former heading such elements as title, set, decor and colours, dress, the selection of participants, actions, and features of camera style, and, under the latter heading, the process of narration at work in the different versions. The results of this investigation have been reported in detail elsewhere (Moran 1996b) and therefore can be summarised.

Australian version

Although based in the Asian Pacific region, Australia is a country where the majority of the population are of European descent. Thus, it is interesting to note that this adaptation has most in common with the Scandinavian version in terms of length and rhythm. However, this version lacks the humanity of the latter, substituting instead a formality and sexual correctness. Like both the Nordic and German versions, this version celebrates masculinity. Again, like the Nordic in particular, it focusses on the male body as a site of power and muscularity. However this is compromised by the already-mentioned atti-

tude of correctness and formality so that what is celebrated is idealised and abstracted. Overall then there is a restraint and a propriety at work that has the effect of holding the Australian adaptation back from the various directions taken by the others from the show business utopianism of *Beato*, the communalism of the Nordic version and the competitiveness of the German.

Dutch version

This version can be bracketed with the northern European versions generally, although it is closest in feeling to the Scandinavian. Like the latter, the Dutch contains a strong masculinist emphasis and is frank even vulgar about male sexuality.

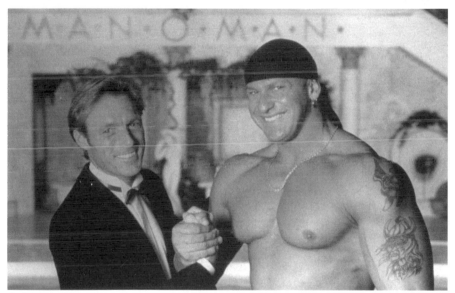

Belgian adaptation

It shares much the same rhythm as the Scandinavian and the Australian. adaptations. Like these, it is shorter in duration, more economical in both the initial number of contestants and the total number of routines performed and more emphatic in building the tempo of its last rounds than are some of the other versions. However it also pulls back from the intense competitiveness of the game engendered in the German version and instead, like the Scandinavian, emphasises the pleasure and fun involved in the game. In fact overall, communalism is elevated over competition. A democratic impulse is at work, drawing all the other human elements into an equivalence. The equivalence is, in its own way, a highly figurative one. After all the hostesses in their short, green dresses with shoestring tops, remain in the same mould as their counterparts in, say, the Italian version while the female studio audience is all-white and not representative of the female population of the Netherlands as a whole.

One of several Spanish versions of **Man O Man**

Nevertheless, within these boundaries, the Dutch version does emphasise good cheer and lack of inhibition and the overall mood is one of good-natured hedonism.

German version

In the German version, the presence and role of the women participants as hostesses, jury and audience, is diminished: the hostesses are involved in few activities; the jury's role is minimised; and the women audience wears day clothes and their bodies exhibit a wide range of ages and shapes, unlike the glamorous evening dress and body shapes mostly found in other versions. Instead as the title sequence of *Mann O Mann* suggests, the dominant note of this version is one of male competition. Unlike the Australian, Dutch and Scandinavian versions, what is under examination here is not the struggle of male bodies but rather one of male performance. There are repeated references in the credits to the fact that the program is male-centred. Males are there to be compared and judged and the point of the program is producing winners and losers. Thus while other versions, most especially the elongated Italian version, are oriented towards entertainment and escapism, the German version is an intensive game where there are winners and losers. The final round is more protracted than in any other version with all three males engaged in directly comparable activities. Thus viewer address in this version encourages an intensive scrutiny of the three to decide who might be the winner.

Italian version

Beato Tra Le Donne is taped in summer in the Bandiera Gialla (Yellow Flag) discotheque in the fashionable Adriatic resort town of Rimini and thus the pro-

gram refers to a particular setting, time and mood. The setting is that of the beach and the sea, the time is the summer holiday season and the mood is one of enjoyment, escape and carnival.

Throughout this version, there is a consistent emphasis on the female body as a site of display and sexual attraction. The Italian title, translates as (heavenly) happiness among women. In a country with a deep and complex Catholic heritage, the title conjures up a sense of the blissful and beatific completeness constituted by women and this is confirmed in the program's imagery and action. The set is the largest of any version with a constant feeling of endless space and there is much exuberant camera work. The utopian plenitude suggested in the title is confirmed by the size of the studio audience consisting of around 1,000 women. Some 200 of these form the program's jury — the largest, most physically attractive with the lowest-cut dresses of any of the juries. Similarly the hostesses, who double as dancers, are more numerous than their counterparts and their costumes and dance actions further emphasise their sexual attractiveness. The imagery invokes the aura of light entertainment and show business discussed by Dyer (1974;1977) and the succession of comedians, singers and dancers de-emphasises the competitive elements of the format. But the imagery also invokes the sea as a site of pleasure and escape, a kind of secular utopia.

Like the other Mediterranean version considered here, *Elles I Ells*, *Beato* has a marked elongatory rhythm. The program is slow to eliminate its large number of contestants and thus is slow to allow males to become foci of attention. Instead by limiting the number of male activities in each round, *Beato Tra Le Donne* and *Elles I Ells* allow for a repeated number of sequences of jury women voting and hostesses dunking the unsuccessful males. The final round and the individual male victory receives relatively little attention in these two versions – indeed *Beato* begins its final credits before the winner is acclaimed.

Nordic (Norwegian) version

The Nordic adaptation is generally closest to the Australian, Dutch and, to a lesser extent, the German versions. The male contestants are young and handsome so that the power of the male body, including its sexual attractiveness, appears to be emphasised. But what makes the masculinity of this version more apparent than real is the particular imaging of women taking place. The sexual attractiveness of the hostesses is stressed although qualified by a degree of formality in their dress that the Australian version shares. More generally though, as against the idealised version of Women contained in *Beato*, the representation in this version is 'realistic'. Instead it is males and their sexuality that is idealised. The Scandinavian *Man O Man* is set in a small studio and this helps generate a communalism missing in most other versions. Above all, this is a community of women whose cheerful heterosexuality seems confirmed in their response to the male

contestants. The stage set is factory-like and mechanical which in turn implies a setting where community struggles to survive against more abstract elements. Overall then this version shares the interest in males found in the Australian and Dutch versions but this is contained within a warm communalism generated by the women jury and audience.

Spanish version

Like the Italian version, the Spanish version of the format, *Elles I Ells* (The Woman – Female – in Women), places a primary emphasis on women. Generally speaking, it too is deliberately slow to eliminate its large number of male contestants. The Spanish version avoids an early identification of possible winners. Instead the males remain relatively unknown until late in the piece and the emphasis instead falls on the women audience, jury and hostesses dealing with the men. However *Elles I Ells* is organised within the more restricted space of a nightclub set, mounted in the television studio and common to the other four versions, rather than the location setting of *Beato*. Again, like the Italian version, the hostesses in Elles are presented as sexually attractive. However, unlike *Beato*, and like the Scandinavian, the women audience and jury are a mixed one in terms of age and beauty and there is more emphasis on male sexuality.

In other words, while *Elles* generally resembles the Italian version in stressing the feminine, it is more restrained in its spectacularising of women with an increased interest in masculinity.

Overall, it is clear that while *Man O Man* is a tightly controlled format, it does, nevertheless, contain a variety of elements whose shape and place in the overall organisation is a result of specific choice. No two versions are quite the same and indeed their differences are obvious and distinctive. Again, without suggesting that these adaptations are reflective of some kind of national essence, it is clear that they have acquired national colourings such that they can be seen to be Italian, Dutch and so on so far as their national audiences are concerned.

★ ★ ★

This chapter has been concerned with questions of the relationship between adaptations of the television game show and national identity. As we have seen, the game show is in many ways an unyielding form and national colourings in particular adaptations have to be sought in the interstices of the adaptations. However, game shows are not all of the same kind and it was found that the format of *Man O Man*, chosen as an example of the 'long form' of the game show, demonstrates itself as being more porous to such registrations as the 'short form' game show such as *Sale of the Century*. Within a broad pattern of similarity, game shows, especially the latter type, appear to be able to develop significant differences in their par-

ticular national adaptations and we can follow Skovmand (1992) in cautiously correlating these with their national origin. Thus in the present instance, *Beato Tra Le Donne* with its utopian overtones and feminine excess might seem to be distinctly 'Italian' while the original *Mann O Mann*, broadcast on Sat-1 in Germany, a version which foregrounds the male principle might be said to be 'German'. Soap opera, on the other hand, is a more open-ended genre in the present context and it is to several groups of adaptations of particular soaps that we now turn.

WIP Shows:
Prisoner – Cell Block H,
Dangerous Women and
Vrouwenvleugel

Nation and Soap Opera

In a recent overview essay on the current state of critical knowledge of theatre and film melodrama and television soap opera, Gledhill (1992) notes the pertinence of investigations of connections between soap opera and the nation. As she puts it: '... national comparison is a subject for another project. But important to note here is the complication of national specificities by the national circulation of television fiction through which the practices of, in particular, American popular culture provide resources to others' (Gledhill, 1992 p 22). Confirming this interest in domestic trends in soap opera in the light of international developments, Allen has recently edited a collection of essays, sub-titled 'Soap operas around the world' which usefully offers much insight into national, regional and international changes in various sub-types of the genre (1995). The collection is the most important contribution to studies of the relationship of soap opera and national identity since the *East of Dallas* study and will be referred to below. However, apart from these two studies, other useful insights into the relationship between nationality and soap opera are few and must be inferred from incidental remarks and references in particular studies. We can therefore briefly attend to these.

Delineation of national specificity in soap opera occurs on three levels, ranging from micro studies of one or two particular soap operas and nation to more macro international studies that focus

on particular national variants of soap opera or specific soap opera formats. Three examples of the first approach can be mentioned: inaugurating what they call cross-cultural criticism of television serials, Krautzner and Seiter have contrasted *Dynasty* and the German *Die Schwarzwaldklinik* (The Black Forest Clinic) and demonstrated their Americanness and Germanness respectively (1995); Newcomb has written about *Dallas* as both an American television program and as a more regionally specific soap (1987); and Griffiths has investigated the Welshness of the serial *Pobol y Cwm* (People of the Valley) (1993;1995). The strength of the micro approach is that it comes to grips with the complex discursive interplay at work in a particular text and is thus able to suggest the variety of cultural identities that inhabit a nation. A second level of approach focusses on a group of soap operas, noting common features and attempting to connect these with the national culture or cultures from whence they came. Thus, for example, Geraghty has analysed British soap operas in the 1980s and early 1990s, linking them with political, social and cultural changes in the UK (1995), while Craven has developed an account of the 'Australianness' of several soaps produced in Australia and broadcast on UK television in the 1980s and early 1990s (1989). A variant of this middle range investigation of soap opera and the nation is that which focusses on national differences in the style and content of soap opera. Thus Frentz Norton has contrasted the Australian and British soap opera (1985). Similarly, Lopez has delineated the important features of the Latin American telenovela and has elaborated specific national differences in the genre such as those found in the Brazilian and the Mexican variants (1995). The third approach is particularly germane to the present study. It is concerned with the national variants of a soap opera format or subject. The *East of Dallas* research project that analysed several national European adaptations of the format of the US serial *Dallas*, remains the classic example of this approach (Silj 1988). The past decade has seen little in the way of follow-up studies that adopt this focus although one recent example is Gillespie's comparison of two variants of the same serial format – the Indian sacred story *The Mahabharata* as dramatised both in a British/European television production and a version produced and broadcast by the Indian government television network, *Doordarshan* (1995).

Having outlined this tradition of inquiry, we can return to three clusters of soap operas based on several Australian drama formats that have already been mentioned in Chapters 4 and 5. The accounts that follow are designed to emphasise some of the different national colourings that the adaptations of these formats offer their national viewers. Various strategies were adopted in order to facilitate this inquiry, most especially the use of translators in relation to Dutch and German serials. As will be clear both below and in the next two chapters, the translators were used not only to make character dialogue intelligible but, more importantly, to indirectly report on some of the cultural capital that Dutch and German audiences bring to the viewing of these programs. In turn, these facilitations of reading were amplified and compli-

mented by other more analytic, written accounts that helped develop under-standings of some of the many ways that these soaps can speak to national audiences.

Women in Prison: WIP as Television Drama

Of the three original Grundy drama formats dealt with in this Part of the book, *Prisoner* is the serial that has attracted the most popular interest and attention (cf Curthoys and Docker 1997). This soap began on the Australian 0-10 Network in 1979 and was an immediate ratings success, so much so that a clone serial depicting life in a men's prison, *Punishment*, began on the same network the following year but was soon cancelled. Altogether 692 episodes of *Prisoner* were produced. The serial was among the first Grundy programs to be exported, playing on cable network in California as early as 1980. Outside Australia, to prevent confusion with the British ATV 1967/8 series, *The Prisoner*, the title of the serial was modified to *Prisoner – Cell Block H*. The serial was to prove enormously popular with audiences, despite what became a common feature of its programming. In Australia, it was initially broadcast two nights a week in an early prime time slot but was later moved into a later, adults-only, slot, still within prime time. Despite these changes, the serial built a loyal, even a cult following, sizeable although still a minority. In the US and the UK, the program acquired true cult status among a sizeable group of fans. Two British authors have testified to this standing:

> Early on, it was exported to the USA and was second only in the ratings to *Charlie's Angels*. It was a particularly big hit on the West coast and, when the lesbian character, Frankie, died in the series, women bikers in San Francisco held a wake. It arrived in Britain in the late eighties and got its first airing in ITV regional television in 1987. Although it was confined to the late night 'kamikaze' slot, it enjoyed an audience of 10 million viewers. In a number of regions, it is still on its first run although Central, which screened three episodes a week, completed the series and by popular demand started broadcasting it again in 1992. Carlton...initially had no plans to continue the series. A campaign was spearheaded by gay radio and thousands of distraught 'blockies' jammed the Carlton phone lines, demanding its return. Consequently, it was reinstated into its late night (and sometimes later night) slot once a week, where it continues to reside. *Prisoner – Cell Block H* just won't go away. (Zalcock and Robinson 1996 p 88-9)

In keeping with this interest, various spin offs have occurred, some unsanctioned and spontaneously generated by fans and some developed by Grundy or others under licensed arrangements. Among the first was the organisation in the UK of a fan club which produces a monthly fanzine and which organised the first British concert tour of one of the major figures in the serial, Bea Smith/Val Lehman; the making of *Prisoner* T shirts and other paraphernalia; the debut of another figure from the serial, Joan Ferguson/Maggie Kirkpatrick at

a famous gay nightclub in London; and the production of an alternative theatre show called *The Great Escape*, organised by the UK fan club. Among the commercially generated material has been two novelisations of early episodes of the program, two books about the program's production and its characters, a record of the theme song, the release on video of early episodes, and the production of a West End musical based on the series which later played theatres in London and the British Midlands, New York and Sydney.

In 1992, Grundy's Los Angeles office produced an American version of the format, *Dangerous Women*, for showing in the US television syndication market. Altogether 52 hour-long episodes of the American version were produced. Subsequently in various markets, such as the UK, *Dangerous Women* has played back-to-back with *Prisoner – Cell Block H* as though the two are part of a larger serial. In that same year, 1992, Grundy also made a submission to RTL 4 in the Netherlands to produce a Dutch version of the format. However, the broadcaster commissioned *Vrouwenvleugel* (Women's Wing) from JE Productions, Grundy's erstwhile partner in the production of *Goede Tijden, slechte Tijden* but now clearly a competitor. Compared to the Australian original, the Dutch serial was 'pretty raw and close to the bone' (Murphy 1995). Grundy briefly considered taking legal action over infringement of *Prisoner's* format but as the Dutch program used different characters and different storylines than was contained in the Australian version, such a charge could not be sustained. *Vrouwenvleugel* began on air in 1993 and altogether some 78 one-hour episodes were produced. The program was enormously popular with the Dutch audience and has been repeated several times since. (More recently still, in 1997, Grundy/Ufa began production of yet another adaptation of *Prisoner – Cell Block H* for RTL 2. The new series was entitled *Hinter Gittern* (Behind Bars) and initially the company planned to adapt the original Australian scripts for this weekly series that would be broadcast in prime time).

Each of the three serials was made with a national audience in mind. When *Prisoner* began production, there was little or no export market for Australian drama serials. Similarly, *Dangerous Women* was produced primarily with an American television audience in mind. Of course, being produced in the US, the possibility of international marketing was obviously in the mind of the company but only after the program had succeeded in the North American market. And, given a general international tendency on the part of national broadcasters, not to purchase programs for dubbing or subtitling in languages other than English (Henry 1995; de Swaan 1991), *Vrouwenvleugel* does not appear to have been screened outside the Netherlands. In other words, each of these three serials might be expected to affirm the nationality of their origins and it is to that matter that we now turn.

The Australian-ness of *Prisoner*

The international response to *Prisoner* has been mentioned at some length to underline the fact that many legitimate readings of the program are

not motivated by a concern with the national origins of the serial. Clearly viewers bring many kinds of interests and cultural capital to bear on their reading of particular texts and one should not be surprised to find that the text has been situated in a way that ignores its national character. That is precisely the case with the Zalcock and Robinson analysis of *Prisoner* cited above. Instead of an interest in the nationality of the serial, these British authors are concerned with the gender relations and identities that the program constructs. Nevertheless, elements of nationality can be found in the margins of their account. Primarily, they are interested in the generic background of *Prisoner – Cell Block H*, a television serial they see as marrying a cinema tradition with a television tradition, a legacy that had already been noticed by Stern (1982). The cinema inheritance lies in a particular genre of films that concerns the situation of women behind bars. The WIP (Women in Prison) film cycle is a product of the Hollywood cinema and is constituted by an interconnected series of 9 feature films ranging from *Caged* (1950) to *Reform School Girls* (1986). On the other hand, the authors see soap opera primarily as a British genre, citing not only *Coronation Street* but also, in a footnote, the 1973–8 series *Within These Walls*. In turn, this union of parents of different nationalities has given rise to an offspring, *Prisoner – Cell Block H*, which, although it may have been produced in Australia, is none the less truly international. Zablonsky and Robinson's opening sentence signals this claim, noting that the serial was first broadcast in 1979 – 'significantly, the International Year of the Woman'.

The Australian inmates of Wentworth Detention Centre in **Prisoner – Cell Block H**

Although it is perfectly valid to read *Prisoner* as a text without nationality or as one that is international, nevertheless it is equally possible to insist on its Australian character. Even though a serial set in a women's prison would appear to offer little opportunity for registering national references and allusions, it does in fact provide considerable scope for just that kind of contextualising. After all, prisoners escape, go on leave and are released, all into the outside world, the same world that guards and others who enter the prison each day come from. Whether in the confined space of the prison or that greater public world, accent and vernacular remain the same. Although all the central characters speak Australian English with prison officials such as Meg and Mrs. Davidson having Educated Australian accents while many of the prisoners such as Bea, Lizzie and Doreen all speak with more working class accents, nevertheless, several other guest characters speak with accents to be found elsewhere, most especially in the UK. The plurality of accents might be justified on the basis that Australia is a multicultural society that has received a large number of migrants from the late 1940s onwards. However, the linguistic community of *Prisoner* does not extend to many of those for whom English was not their first language. In addition, in keeping with this aural registration of Australia, there is a consistent use of a national vernacular.

The serial is set in the fictional Wentworth Detention Centre, which in turn is located in Melbourne, itself a part of Australia. Here, the name of the prison reminds us not only of the explorer figure who is celebrated in school text books on Australian history but also of the convict origins of white settlement in Australia. If there are very occasional historical allusions, there are more frequent references to Australian places. Thus Bob, father to one of the prisoners, visits Adelaide on a business trip. Wayne, boyfriend to Margo, one of the inmates, gets out of Pentridge Gaol, a prison on Melbourne's north side. Lizzie's husband worked in the Australian Outback while her friend Syd was in Brisbane during the War. Judy briefly works in a massage parlour where Doris, on of the other prostitutes, formerly worked in Sydney's most famous red light district, Kings Cross.

Iconographically, there is, admittedly, little to tie most of *Prisoner*'s interiors to Australia. One exception is the ever-present picture of Queen Elizabeth II hanging on the wall in the Governor's office, reminding an Australian audience that that figure is not only Queen of the United Kingdom but also the Australian Head of State. However, the action of the serial consistently moves outdoors into a physical world known directly or indirectly by much of the program's Australian audience. There is extensive use of the grounds of the Melbourne Channel 10 television studios as visitors to Wentworth come and go, prisoners and others walk along grassed areas next to chain mail fences and prison guards open and close large wire gates. In public streets, Holden cars are a frequent sight, overhead tram cables are often glimpsed while the distinctive uniforms of the Victorian police are never very far away. There is a striking use of this landscape in the group of episodes concerning the

attempted payroll theft organised by Wayne, Bazza and Margo with the robbery ending in a siege and hostage situation. In narrating this representative story of what can happen on the outside, *Prisoner* employs a particular landscape in working-class, inner suburb Melbourne, whose features and significance has been well described in relation to an earlier crime drama cycle on Australian television:

> ... the dramatic character, action and ethic are embodied in a world we know. – the sub-industrial landscape of narrow-gutted South Melbourne timber cottages, Carlton back streets and lanes, the Victoria Docks, the Dynon Road railway yard ... more than anything else, the location shooting makes the series good to look at ... and again it all sustains that consistency of tone I've been talking about. If a smalltime drunk-roller is being pursued by the boys in blue, then he'll be hunted down through smalltime back streets, alleys and courtyards ... the squalidness of the settings echoing the squalidness of the crime. (Murray 1973 p 18)

However, even beyond this multiplicity of contingent references to things Australian, the program develops against a background of ideas, particularly to do with both feminism and prisoner action, that has been usefully sketched by Curthoys and Docker:

> There was through the latter 1970s considerable public attention, especially in New South Wales and Victoria, to prison issues generally and the position of female prisoners in particular. Key events around this time were the Bathurst Gaol riots, the Nagle Royal Commission into New South Wales' prisons in 1976 and 1977, and the founding of Women Behind Bars in 1975, with its very sustained and eventually successful public campaign for the release of Australia's longest serving female prisoner, Sandra Wilson. In 1978, *St Theresa*, a low-budget discussion film, was made in Sydney by independent filmmaker Dany Torsch with a script by feminist journalist and historian Anne Summers and music by folksinger Margaret Roadknight. An active women's movement, prison action groups and an atmosphere of public inquiry, and media attention, together laid a basis for an interest in the lives of women in prison. (Curthoys and Docker 1994; 1997)

These observations can be extended by briefly considering the intertextual context of the serial. One area is the filmic and television representations of women in prison in the period prior to the appearance of *Prisoner*. Curthoys and Docker mention *St Theresa*, a low budget independent film which had limited circulation and a small audience. However, the Australian feature films *Eliza Fraser* and, especially, *Journey Among Women*, which both appeared in 1976, had much wider distribution (Pike and Cooper 1980). In television, the mini-series *Luke's Kingdom* (1976), *Against the Wind* (1978), and *The Timeless Land* (which although screened in 1980

had been several years in development) had large audiences with *Against the Wind* attracting immense attention, gaining excellent ratings and being repeated in 1979, the year that *Prisoner* went to air (Moran 1993). Moreover as all these works were historical in their representation of women as convicts or captives, there was clearly room for a program that would give the subject of women prisoners a contemporary setting. A second area, suggested by Curthoys and Docker, which might also be amplified, concerns the body of feminist writings that appeared in the 1970s. The most important of these was Anne Summers' feminist history of the colonisation of women in Australian society which appeared in 1975. Her title, *Dammed Whores and God's Police*, identifies two particular representative types of Australian women – the bad and the good, as it were – although Summers argues that the two were interdependent and equally oppressed.

Guard and Prioners confront each other in the Australian **Prisoner – Cell Block H**

It is certainly tempting to apply the characterisation of Summers' title to the residents – both the prisoners themselves and the women officials and guards – of Wentworth Correction Centre in *Prisoner*. Many elements of the descriptions and analyses in Summers' book have corresponding resonances in *Prisoner* but one will suffice to end this discussion. Summarising the argument of the book as a whole, the author writes:

What I have tried to show is that women's experience in being Australian differs fundamentally from men. While many men are hampered, restricted or exploited by their class or race, all derive some compensatory benefits from their sex. They have a freedom of movement which is denied to women, and they have the existential security of an identity bestowed by possessing a name. (Summers 1975 p 461)

Dangerous Women as an American Serial

Dangerous Women is both an adaptation and a sequel to *Prisoner*. Like the Australian serial, much of the American serial is set in a woman's prison and it is an easy task to notice the individual translations that have occurred. Thus Wentworth Detention Centre has become the Women's State Prison; Mrs. Grayson is now the governor and the portrait of Queen Elizabeth II has been replaced by the American flag; Meg Jackson and Vera Bennett have been supplanted by good guard Nell Patterson and bad guard Jack Fisher; top dog prisoner Bea is now Rita while the older woman prisoner who was Lizzie is now Minnie. In addition, the serial also continues *Prisoner*'s imagery of steel bars, prisoner identification black and white photos, cell doors slamming closed and the general iconography of cells, guard rooms, corridors, governor's office,

Warden, guard and prisoner in the US **Dangerous Women**

prison yard and so on. In point of fact though, *DangerousWomen* develops a second permanent setting within the pilot episode such that the serial is as much about life outside the prison as it is about life on the inside. The action of the serial shuttles backwards and forwards between two settings, one more pastoral and the other more 'realistic', the Cedar Lake hotel located among hills

and forest and Women's State Prison set in a more urban setting. Like the general title imagery of *Prisoner*, also adopted in the Dutch *Vrouwenvleugel*, *DangerousWomen* identifies a group of women prisoners, six in number, who are the main proponents of the serial. The fact that within the first 10 episodes at least four of these are living at Cedar Lake Hotel means that the program develops a different emphasis than the Australian and even the Dutch versions.

Without exhausting the range of its national references, we can, for present purposes, divide allusions at work in *Dangerous Women* into two groups to do with US daytime soap opera and Hollywood feature films. Overall, the American adaptation is concerned not only with the relationship of the women prisoners to each other but it is also particularly concerned with the same women's relationships with their sons and daughters. Of a central group of 9 women prisoners in the early episodes, five have offspring who are at least older teenagers, two have no children while the parental status of the other two is unclear. Moreover, these families are, in effect, single parent ones where the mother has become the sole provider: fathers have either disappeared or else have abused their children in various ways. Thus Rita Jones, one of the prisoners who escapes from Gaol to Cedar Lake where she is sheltered by the other women, later tries to kill her ex-husband for the way he has treated their daughter, Debbie.

And indeed in this adaptation, that develops a particularly strong female address, the representation of men is especially polarised into soft, caring, feminised men like Joe Holland and Jerry Vernon or cruel, greedy, violent figures such as Jack Fisher who rapes Holly Warner and Ben Cronin who slashes his wife's face with an open razor. By contrast, the women represented in both *Prisoner* and *Vrouwenvleugel are* generally more three-dimensional. We might also briefly note some features of the narrative action that aligns *DangerousWomen* with the day time US soap opera. In general the serials storylines move between two poles. The first is a kind of everyday, low-level realism such as the story of the young boy who goes missing from camp near Cedar Lake. During the search, Patricia Meadows and Joe Holland realise that they are attracted to each other. Meantime the boy, Andrew, turns up at the Hotel and is cared for by Cissy, his grandmother, although the latter is unable to disclose her identity to the boy. At a more melodramatic pole are stories such as that of Holly Warner who is raped by her employer, falsely accused of kidnapping his son, brought to trial and found guilty, and sent to gaol, raped again by a guard, falls pregnant, wants an abortion although by taking a drug overdose brings about a miscarriage. If this mixture of ingredients is standard for the genre of soap opera, we can also note storylines that introduce more generically foreign elements, thus hybridising the programs in ways that have been noted by Allen (1995; 1997). These concern the continuing crime cum mystery storylines surrounding the figure of Faith Cronin/Patricia Meadows. Her husband, Ben, is a criminal who has been involved in laundering drug money for the Mob. Ben has Faith's lover, formerly one of his henchmen, murdered and disfigures Faith's face but is

unable to recover the money that the latter had taken. Faith leaves prison, has plastic surgery and fakes the murder of Faith by Ben so that the latter is forced underground. However, he is still in the wings and Joe Holland's bitchy ex-wife discovers Patricia's secret. Meantime, Patricia has hidden the missing money in the Hotel.

The second body of references that are relevant to an American reading of *Dangerous Women* are those that evoke scenes and figures from the Hollywood cinema. Several such allusions can be briefly mentioned. First the figure of Crystal Fox refers to a rich line of 'dumb' blondes in American films, most especially that of Marilyn Monroe. In turn, the storylines involving drug money, laundering, the Mob, treachery and theft among criminals, apparent murder, revenge and blackmail is indebted to a very large number of

The caring Afro-American mother in **Dangerous Women**

Hollywood crime films. Similarly, the figure of Cissy Jones, the Afro American woman, who is released from prison and becomes cook and housekeeper at the Hotel belongs to a long line of black servant women, the ever reliable source of affection and confidence. As Bogle has suggested, this tradition was at its strongest in Hollywood in the 1930s, with memorable representations such as that of Aunt Delilah in *Imitation of Life* (1934) and Mammy in *Gone With The Wind* (1939). As he puts it:

> ... their loyalty too demonstrated that nothing in life was completely hopeless. The servants were always around when the boss needed them. They were always ready to lend a helping hand when times were tough. It was many a down and out movie hero or heroine who realised his Negro servant was his only real friend (*sic*). (Bogle 1994 p 36)

101

Although the figure has been seen again since the Depression era, most notably in *Pinky* (1949) and the remake of *Imitation of Life* (1959), nevertheless, it is a distinctly archaic one to reappear in *Dangerous Women*. However reappear it does in the figure of Cissy. Not only is the good Afro American mother replicated in the former convict but so too is the situation of the film *Imitation of Life*. In *Dangerous Women*, as in *Imitation of Life*, the good black mother is spurned and abandoned by her daughter; in the film ethnicity is the principal reason (the daughter is able to pass as white) although class also enters the equation while in the serial it is more directly based on class although, again, ethnicity enters the decision. Similarly the situation, returned to several times in the course of this adaptation, of a group of women of very different personality, physical shape and outlook, bonding together to defeat a more powerful male has connections with a recent cycle of post-feminist Hollywood films including *9 to 5* and, more recently, *The First Wives' Club*. And finally, the Faith Cronin/Patricia Meadows story is also richly suggestive: the change of identity recalls other Hollywood transformations, most especially in the genres of family melodrama and the women's film such as that of Joan Crawford in *A Woman's Face* and Bette Davis in *Now Voyager*; the violence of a male gangster towards a woman partner that results in her facial disfigurement echoes other films such as *The Big Heat*; and, the woman's disappearance, made to appear like death, is reminiscent of *Sleeping With The Enemy*. Overall then, there are certainly sufficient elements at work in *Dangerous Women* that recall Hollywood and allow *Dangerous Women* to be read as American.

Dutch Soap: *Vrouwenvleugel*

As we shall see below and in Chapter 9, two young Dutch backpackers, Sascha and Madelaine, were used as translators and cultural reporters on both *Vrouwenvleugel* and *Goede Tijden, Slechte Tijden*. They were generally familiar with the former drama serial which was set in the women's wing of a Dutch prison, having watched many episodes in the Netherlands some time earlier. However they had not followed this serial with the same loyalty as *GTST*. Indeed, *Vrouwenvleugel* generally attracted an older audience among Dutch female viewers than does the other serial. Sascha mentioned that her mother always watched *Vrouwenvleugel* whereas she did not watch *Goede Tijden Slechte Tijden*. And, indeed, some episodes for the research had been taped in the Netherlands by a grandmother who was a devoted fan. However Sascha and Madelaine were delighted to find that *Vrouwenvleugel* was much more gritty, funny and fast moving than they remembered it so that their viewing for the purpose of the research was laced with real discovery and pleasure.

Accent and language were the first points of contact with the program. Thus Teon, a lesbian prisoner in *Vrouwenvleugel* has a strong Amsterdam accent while Goedele, her Belgian girlfriend, has a Belgian accent. Guusje, the older prisoner, is upper middle class and talks with an accent associated with that class ('A potato in her throat', as Sascha put it, echoing a popular Dutch

saying). In addition, there are other accents present that suggest the multicultural reality of contemporary everyday life in the Netherlands, especially in larger cities such as Amsterdam. Thus Marvin – brother to Baby Miller, another of the prisoners – has a distinct Surinamian accent. Kocksal, the guard, has a Turkish accent. Snoos Riveen is from Morocco and also speaks Dutch with an accent. In addition, there is ever present in the program that modern Dutch earthiness that forms a distinct lingo of its own. Thus, when Teun is about to be visited by Goedele, the other prisoners engage in a lot of good humoured banter about the sex the two will have. Despite her class origins and smart appearance, Guusje constantly engages in a comically salacious patter. She jokingly tells Jan the guard that he has nice sexy curly hair and refuses to take Vitamin E because it makes her horny. Natalie, an upper class prisoner and very much the bitch figure of *Vrouwenvleugel*, is often the verbal target of the other prisoners. In the dining room, Teun mutters 'Fuck a duck' as she passes Natalie. At another point, Guusje taunts Natalie for her prejudice towards lesbianism. Out tumbles the expression about hypocrites: 'Zei de boer en neukte zijn varken'. Sascha and Madelaine laughingly translated this insult as: 'Said the farmer and then he fucked his pig'.

Vrouwenvleugel is set in Amsterdam. Although it does not feature that city's more famous tourist landmarks, nevertheless for a Dutch viewer, especially one familiar with the city, the location is unmistakable. Not only are there recognisable sights such as city streets with trams, cars and bicycles, parks and gardens, coffee bars that also sell soft drugs and old buildings but occasionally an episode will contain more specific reference to various parts of Amsterdam. Thus, for example, in one story, Smorrie, a prisoner on weekend release, returns to the Bijlmer, an Amsterdam suburb characterised by high-rise apartments and a large proportion of migrant residents. In turn, this fictional Amsterdam is firmly located in a larger Dutch and European world. Goedele, for example, wants to escape a Belgium that is less tolerant than the Netherlands and live in a city such as Amsterdam although Teun, her girlfriend, wants to settle in Weesp, a small town. When Joy as a young child, came to the Netherlands from Surinam, she and her family lived in Amstelveen, a small village close to Amsterdam. Similarly, after stealing money gathered through dealing in drugs, Charlie plans to flee by motorboat to Belgium, travelling by water from Amsterdam to Rotterdam and from there to Antwerp. There are also more remote countries, referred to but never seen – such as Indonesia, Morocco, Turkey and Surinam – from which various of the characters emigrated, at one time or other, to the Amsterdam of *Vrouwenvleugel*.

The episodes we watched were replete with references to objects, practices and beliefs that are part of the texture of Dutch life. For example, in one episode, Jan Browuer treats the prisoners to stroopwafels, a kind of Dutch cookie. In the prisoners' communal work room, there is a poster for Teijenoord, a well known soccer team from Rotterdam. There is a very

Women's prison as a community in the Dutch **Vrouwenvleugel**

marked communalism in the prison and the prisoners constantly break into song as they work – one song they sing with great gusto and spirit is 'Aan oe Amsterdamse Grachten'. In addition, in *Vrouwenvleugel*, greeting friends and family by three kisses on the cheek is the common pattern, causing Sascha and Madelaine to remark that that is also the customary form of greeting in the Netherlands. Towards the end of the serial, the older prisoner Jantje decides to write to Queen Beatrix to ask to be released from gaol. The serial also displays a good deal of sexual tolerance: thus, for example, Browuer decides to help Troos, another guard, to get a girl and not resort to the red light district. In addition to this chain of incidental references, there are other allusions to everyday life in the Netherlands. Take for example the story of Snoes, one of the prisoners, and her brief romance with Charlie, a young drug dealer. On a weekend release, she and Charlie go to a house party, an infamous institution (according to Sascha and Madelaine) in the Netherlands, Germany and elsewhere. As is common practice, Snoes takes cocaine to have the energy to dance for most of the weekend. Charlie has been dealing drugs from Mia's coffee bar and plans to take the proceeds of this trade and flee to Antwerp with Snoes. Asked if that means that Charlie will give up his involvement in drugs, Snoes tells another prisoner that she believes that the Netherlands is planning to legalise drugs and that Belgium will inevitably follow. However Mia, owner of the bar, partner in the drug dealing and also Charlie's erstwhile lover, has him executed. The shooting is similar to many drug related incidents reported in the media in the Netherlands and elsewhere.

Although *Vrouwenvleugel* was not as successful in the Netherlands as *Goede Tijden, Slechte Tijden*, which will be discussed in Chapter 9 below, and therefore did not produce Dutch television stars like the latter, nevertheless it has featured many performers familiar to the Dutch television audience. Several actors in this serial also appeared in a previous serial, *Spijkerhoek* (Jeans). These include Cynthia Abma (Rietje Verdonck), Joop Sertons (Dr. Paul Jaspers), and Wilfred Klauer (Charlie). In addition, Henriette Tol, who played the murderous Mia has also played in both *Goede Tijden, Slechte Tijden* and the sitcom *Niemand De Deur Uit* (Nobody Out Of The Door). Another habituee of the coffee bar in *Vrouwenvleugel*, Joris, played by Jasper Taber, is the son of famous actor, Peter Taber, and often appears in minor roles in Dutch television dramas. The serial also includes another actor son of a famous father. John Jones who plays David the guard is the son of famous black singer Donald Jones. In an episode of *Vrouwenvleugel*, David's mother explains his skin colouring by the fact that his father was a black American soldier. Other well known performers to appear in the serial include Danny de Munk (an actor and singer, who plays Kees, one of the two sons of Nel, a former prisoner turned guard), and Jaap Stobbe (famous for the Dutch children's television series *De Poppenkraam*), who appears in this serial as Wilberto, a philandering husband. Even Marjan Berk, principal writer of *Vrouwenvleugel* and recognisable to Dutch audiences from regular television appearances on panel and talk shows, makes a guest appearance in the last episode. Finally, we might mention yet another allusion to Dutch television culture. The guard Regina who has previously been married and is certainly no virgin plans to marry Wilberto in a white wedding dress. She excuses this on the basis that Sally Spectra dressed the same way for her wedding. The fact that the latter is a character in the imported serial, *The Bold and the Beautiful*, makes the reference both funny and indicative of how much this American soap opera is also a part of everyday popular culture in the Netherlands.

If, like *Prisoner* and *Dangerous Women*, *Vrouwenvleugel* is concerned with the general subject of women in prison, nevertheless there is a distinctness in the Dutch serial which is directly related to the multicultural address it adopts. The serial is especially progressive in its attitude towards cultural and ethnic difference. The Amsterdam location is important as that city is seen to be the Dutch melting pot, the city where the widest range of cultural identities is present. The program contains several committed homosexuals including Wimpie, the son of Nel, and Teun, one of the principal prisoners and also registers much incidental detail about gay and lesbian lifestyles. Unlike *Prisoner* and *Dangerous Women*, *Vrouwenvleugel* is strongly anti-racist. Thus, for example, in Joy's cell, there are two posters proclaiming Peace. One of these has a white hand joining with a black hand while the other depicts a black Dutch soccer star, Frank Rijkaard, from Ajax, the most popular team in Amsterdam. Baby Miller realises that the white woman who raised her was a racist who taught her to hate herself. And indeed it is partly the experience

Sexual and ethnic difference in the Dutch serial **Vrouwenvleugel**

of being in the women's wing that she encounters a genuinely multicultural and tolerant community where individuals are judged not on the basis of their different skin colour or cultural background but rather on their capacity to share and support each other. This community includes an Indonesian guard, two prisoners from Suriname as well as one from Morocco and a Turkish guard who is Muslim. The only outsider to the group is wealthy prisoner, Natalie, who is marked by red hair and white skin. And, indeed, this is one of the most important points that the program has to make, namely that a tolerant, multicultural society or community in the metropole is one that has to be continually striven for. It is not the case that it existed in a colonial society such as that of Suriname. Indeed, as Joy points out, Surinam itself is not an ethnically homogeneous society as might be thought to be the case from the distance of the Netherlands. Instead, there is discrimination there as in Holland, not whites discriminating against blacks, but coloureds against other coloureds. In Surinam there are ethnic prejudices formed around different ethnicities such as Creoles, Hindustanis, Negroes and indigenous peoples. Joy's own parents had a mixed marriage, her father was Creole while her mother was black.

★　★　★

Summarising the argument then, we can observe that where the television game show, especially the short form of the genre, offers only limited opportunities for the registration of national elements, the soap opera, by contrast, offers considerably more opportunities.

This chapter has shown how the television serial format of women in prison was successively Australianised, Americanised and Dutchified. To help secure the point that this genre contains more scope for the registration and articulation of national differences, we turn in the next two chapters to the examination of two more clusters of program adaptations.

A Tale of Two Cities: *Sons and Daughters* and *Verbotene Liebe*

This chapter is concerned with two versions of a drama serial format revolving around family melodrama. *Sons and Daughters* was commissioned by the Seven Network in Australia and began on air in 1982. At first the serial was stripped Monday to Friday in prime time access but later played two evenings a week in one-hour blocks in prime time. *Sons and Daughters* ran until 1987 with a total of 972 half-hour episodes being produced. With the international development of Grundy over the past 15 years, adaptations of the format were planned for broadcasters in Chile and France although these did not come to fruition. However a German version of the format, *Verbotene Liebe* (Forbidden Love), was developed in 1994 and the serial began on the public service network ARD in 1995. At the time of writing, it is in its third year on air. Later, yet another adaptation, *Skilda Varlder* (Worlds Apart) appeared on Swedish television in late 1996 but a discussion of the latter is beyond the scope of this chapter.

Primal Scenes

With the two versions of the narrative of twins, separated at birth, who meet and fall in love, *Sons and Daughters* and *Verbotene Liebe*, there are early textual differences that are motivated by a desire to 'Germanify' what was 'Australian' in the original. Thus the Australian serial turns on the polarities of two families, the Palmers and the Hamiltons. The Palmers are working-class, based in Melbourne with father David Palmer working as an interstate truck driver. The Hamiltons are wealthy and are based in Sydney with both a country property, Wombye, and a city residence on the rural fringe of the city. Neither Beryl Palmer, wife

to David, nor Patricia Hamilton, wife to Gordon and mother to Angela – one of the twins – works. In addition to these differences of detail, the early episodes of *Sons and Daughters* are, comparatively speaking, more linear and naturalistic in their narrative sequencing than the German counterpart. The fiction of the Australian serial begins in the year 1962 and briefly follows through the birth of the twins with Patricia fleeing the relationship and taking one of the unnamed twins. The narrative then jumps forward to 1982 to Melbourne and the Palmer family. However there is little connection between these two times and situations. Instead the serial offers a clumsy narrative motivation for the first meeting of the twins (a recurring dream of John, the Palmer twin, wherein he is matched with Angela, the Hamilton twin). Similarly, the second narrative motivation that will bring the twins together and will unravel the settled domestic networks of their parents and ultimately the other members of their families, the narration of a murder in the first episode, although it implicates John and causes him to flee to Sydney, casts no suspicions on the twin so far as the audience is concerned. Nor is the motivation of Patricia Hamilton fully worked out in these early episodes. She is, in the words of writer Jason Daniel, 'a rather empty-headed socialite' (1995) rather than the bitch-figure, Pat the Rat, that she will become in later episodes.

By contrast, *Verbotene Liebe* concerns two German families in the 1990s and there is little hint of the economic difficulties of some of the characters in *Sons and Daughters*. Instead the Brandners are middle-class – Arno the father is a builder with his own construction company while Christoph von Anstatten, step father to Julia, is an aristocrat with a great house, Frideneau, in the country and a penthouse in the city centre of Dusseldorf. Nor are the wives of these two tied to traditional feminine roles as are their Australian counterparts – Iris Brandner soon decides to return to employment now that her children are grown up, thereby causing a rift between herself and Arno, while Clarissa, the Pat the Rat figure, is a business woman owning her own lingerie enterprise in Dusseldorf, an element that underlines the constituent of new as well as old money in the von Anstatten family. These are early differences and can in part be seen as part of a process of recuperating the characters and situations in contexts that are more familiar and more specific to national audiences. With this in mind let us turn to later episodes of these serials and especially to a consideration of the ways in which they are Australian and German respectively.

Sons and Daughters as an Australian Serial

Of the many Australian drama serials shown in the UK in the 1980s, *Sons and Daughters* has registered as most different. Several writers, responding to its strong melodramatic qualities, have described it as the most American of Australian soap operas (cf Frenz Norton 1985; Craven 1989). But melodrama is by no means confined to culture industries in the US, so that this kind of national label is easily discounted. However, a more particular

American source for the serial, or at least some parts of it, can be invoked. Like its effect elsewhere, most especially in Europe, *Dallas* impacted heavily on the genesis of *Sons and Daughters*. The latter serial began screening on Australian television in 1978 but without the cultural controversy provoked elsewhere, most especially in western Europe. Australian television had long imported significant volumes of US programs so that *Dallas* excited no out-cry about 'Americanisation'. Nevertheless, the serial did have an impact on how Australian producers and writers of soap opera, especially those at Grundy, saw the range of dramatic and narrative possibilities in the genre. While another Grundy serial, *Taurus Rising*, produced later in 1982, after *Sons and Daughters* had gone to air, exhibits a much stronger debt to the American prime time serials, nevertheless *Sons and Daughters* is also indebted to *Dallas*. But, unlike the later Grundy serial, the *Dallas* legacy is more marginal in *Sons and Daughters*, where it is almost entirely confined to the representation of the wealthy Sydney family, the Hamiltons. The drama of the impossible love

Dallas melodrama in the Australian **Sons and Daughters**

between the twins, Angela Hamilton and John Palmer, and much of the domestic and romantic adventures of the phallic mother, Patricia Hamilton, have other sources. Nevertheless, various parallels are clear between the Australian and American serials. Thus, for example, the Hamilton family's residents, in the city and at the country property at Wombye, echoes *Dallas'* double location at the South Fork ranch and in the business offices of down-town Dallas. One can also see obvious connections between the dramatic function served by Gordon Hamilton's private company Ranberg in *Sons and Daughters* and JR Ewing's oil wells in *Dallas*. Similarly, the intricate per-

sonal/business rivalry between Gordon and his son Wayne with Patricia frequently becoming a third party echos the three way relationship between Jock Ewing, his son JR and wife Sue Ellen. At the same time however there are obvious changes, most especially in the dramatic distribution of villainy and goodness. In the Australian serial, in an interesting partial regendering along lines suggested by *Dynasty*, itself an adaptation of *Dallas*, Patricia inherits most of the melodramatic wickedness that in *Dallas* was associated with JR, although some of this also spills over onto Wayne. In keeping with the 'feminised' elements in *Dallas*, Bobby Ewing's goodness has passed on to Gordon although some of the same virtue can be found in figures such as Barbara Armstrong, Gordon's friend, and Rosie the Hamilton family's housekeeper.

However, although *Sons and Daughters* is indebted to the generic impact of the American prime time melodramas that included *Dallas*, *Dynasty*, *Knots Landing* and other imported serials shown on Australian television between 1978 and 1981, nevertheless to understand the Australian-ness of *Sons and Daughters*, one must look elsewhere. We can begin with the simple observation that – of all the Grundy serials based on the format of the twins, separated soon after birth, who as young adults meet and fall in love – it is the Australian version that puts the most physical distance between them. In *Sons and Daughters*, the two reside in Sydney and Melbourne, state capital cities separated by a distance of about 540 miles or 900 kilometres. In the projected Chilean version, *Amore Prohibido*, the twins live in Santiago and Valpariso, the capital and its nearest port, separated by about 40 miles or 70 kilometres. In the German version, *Verbotene Liebe*, the two live in Dusseldorf and Cologne, cities that are approximately 24 miles or 40 kilometres from each other. The distance is even less in the most recent version, the Swedish *Skilda Varlder*, where the two have grown up in different suburbs in Stockholm. By contrast, the Australian version has chosen geographic locations where the distance separating the two is truly tyrannous, a physical handicap that parallels both the internal remoteness of Australian places, one from another, as well as the external distance between the island continent and, in one direction, Europe and, in the other, North America, thereby recalling a central theme in Australian cultural history. As the author of the definitive account of distance in shaping the experiences of white Australia has put it: 'Distance is as characteristic of Australia as mountains are of Switzerland'. (Blainey 1966)

The fact that in *Sons and Daughters* the twins have grown up in Sydney and Melbourne adds even richer elements to the serial. Although Australia has six major cities that are state capitals to the colonies that federated in 1900, nevertheless it is the two largest of these, Sydney and Melbourne, that are most usually singled out for description, comment and analysis. Very often this kind of inquiry goes further and involves the bracketing together of the two cities for the purpose of comparison and contrast. This kind of 'twinning' of Sydney and Melbourne has a long history and spans over a century. Here the

The Australian twins in Sons and Daughters

tradition can be conveniently indicated by an early and a later comment. In 1883, the visiting British traveller R E N Twopenny wrote:

> I well remember that, although I had taken some trouble to read up information about Melbourne, I was never more thoroughly surprised than during the first few hours of my arrival ... Although Sydney is the older town, Melbourne is justly entitled to be considered to be the Metropolis of the Southern Hemisphere. The natural beauties of Sydney are worth coming all the way to Australia to see, while the situation of Melbourne is commonplace, if not ugly, but it is in the Victorian city that the trade and capital, the business and pleasure, of Australia chiefly centres. (Twopenny 1973)

A little over 100 years later, in 1985 while *Sons and Daughters* was still in production, the Melbourne-born but Sydney-resident, Australian author Barry Oakley made his contribution to the tradition of comparing the two cities:

> Some time ago there was a competition in the *Sydney Morning Herald* for the most boring headline in an Australian newspaper ... Another certain finalist would be writer discusses Sydney Melbourne differences. But if one has to speak on Great Rivalries, what is there to match this? ... Sydney was always to mean raffishness, sweat, humidity, corruption, abandon. Melbourne was an apple, hard and unyielding, and Sydney was a tropical fruit. And its fleshy centre was King's Cross. (Oakley 1985)

In the years between these two observations and since, there has been a myriad of commentaries ranging from the popular and anecdotal to the scholarly and critical, from casual asides to book-length inquiries into

economic, geographic, intellectual, cultural and social aspects of these two cities. Of course, in the space of more than a century, the economic, political, social and cultural standing of the two cities has changed and this has created opportunities for continued comment. The truth and accuracy of the observations are not in question. What is relevant is both the longevity of the tradition and, most especially, the very fact of bracketing together these two cities as siblings but also as rivals. Like Siamese twins, they seem forever joined together, so that each city is both itself as well as the other's 'other'. In turn, there has been two different approaches for comprehending this bi-polar opposition. One is to decide on the necessity of choosing between one or the other, an acceptance of permanent antithesis. Thus, the nineteenth century traveller prefers Melbourne while the twentieth century emigre writer chooses Sydney. However, a second strategy is to invert opposition. In this regard, for example, we notice that a projected city, Canberra, became the federal capital of the new nation state of Australia in 1901, because delegates to the Federation Conventions in the 1890s could not agree as to whether Melbourne or Sydney should be the new political capital. Similarly, the same process of neutralising opposition between the two might also be found in a television situation comedy series, *Barley Charlie*, produced in Melbourne at station GTV 9 in 1964, soon after that station became linked by coaxial cable to a counterpart in Sydney as part of the Nine Network. This sit com also refused the choice of Sydney or Melbourne, opting instead to locate its comedy in a roadside garage, halfway between the two cities.

In the years immediately before the production of *Sons and Daughters* (1982–1987), three events had helped rekindle the Sydney/Melbourne 'debate'. These were the publication in 1974 of John Docker's study of different cultural traditions in Sydney and Melbourne, *Australian Cultural Élites*; the intervention of the then editor of the literary journal *Meanjin* in pointing up the movement of different kinds of cultural power to Sydney and away from Melbourne (Davidson 1979); and the 'St. Petersburg/Tinseltown' conference sponsored by *Meanjin* and held at the University of Melbourne in 1981. Again the two responses to the Sydney/Melbourne polarity were in evidence – dichotomous choice and subversion of opposites. Thus, the *Meanjin* article was a reasoned outcry at the preferential treatment being accorded to Sydney so far as federal cultural funding and the location of federal cultural institutions were concerned while Docker ended his book by looking at how political and cultural opposition to the Vietnam War had helped transcend the differences between intellectuals in the two cities.

There is no evidence that the writers and producers of *Sons and Daughters* were aware of the *Meanjin* debate. On the other hand, as members of the Australian television industry, they were keenly aware of employment opportunities in the two cities. Indeed, the general development of communications both in and between the two cities forms a further important backdrop

to the production of *Sons and Daughters*. Transportation and communications between Sydney and Melbourne in the years before 1982 were becoming faster, more efficient and cheaper than ever before. Sea travel had mostly ceased as an efficient means of transportation by the early 1960s and the duration of the train journey was considerably shortened by the elimination in 1964 of the need to change trains on state borders because of different railway gauges. To prevent their rail competitor gaining market advantage, airline companies introduced jets for the journey between the two cities in the same year, thereby making air travel more regular, cheaper and faster. In addition, again in 1964, operator connected telephone calls between Melbourne and Sydney were replaced by an automated system, STD, thus making it cheaper and easier to telephone one city from the other (Moyal 1984 p 232). These elements all make their presence felt in *Sons and Daughters* where the miles between the two fictional cities, the equivalent of a train journey from Liege in Belgium through Germany and Austria to Budapest in Hungary, is repeatedly transcended by the serial's narrative. In *Sons and Daughters*, nobody travels by sea or train between Melbourne and Sydney. Indeed, it is only David and John — because they work for road haulage companies – that make the journey by road. Rather, flying is the preferred mode of travel and it is remarkably fast and efficient. In one episode, for example, grandfather Doug Palmer, his granddaughter Lynn Palmer and her baby son Davie leave the Palmer living room in Melbourne in one scene, exiting to the right of screen; after a commercial break, they emerge from right of screen in Fiona Thompson's living room in Sydney, talking about their journey. The telephone also helps transcend distance with the familiar series of bips at the beginning of an STD call between Sydney and Melbourne, briefly reminding the audience of the geographic polarities of the serial. Finally, we should also note that a television serial that (although filmed in Sydney with some location shooting in Melbourne) appeared to be a native of both cities had the potential to attract good ratings in both Sydney and Melbourne, the two most important markets in the country.

I have previously written about *Sons and Daughters* although not in terms of its historical or social context (Moran 1985). Nevertheless, it is worth quoting some earlier remarks because of their emphasis on a particular quality of movement in the serial, a permanent oscillation between two polarities that include the two cities as well as the two twins:

> Two of the most important narrative twists ... have come from a mysterious past, bound up with guilt and family secrets. The serial began with John Palmer and Angela Hamilton meeting and falling in love. Almost immediately, however, there is an unexpected blow – Patricia Hamilton, Angela's mother, has to forbid the match: John and Angela's love is incestuous; they are brother and sister. Twins, they were separated when very young because their mother and father married other partners. Their 'family romance' is shattered, they are separated as lovers to rejoin as 'children', brother and sister, linked in familial love.

The guilty father and mother, David and Patricia, briefly occupy the position of lovers themselves before each one goes in search of another sexual partner … The narrative action then becomes occupied with the continual filling, vacating and refilling of these positions. This might be 'all in the family' … but the family is no hierarchy: it is disordered, out of control. The drama is … oedipal. The serial delivers the miscellany that the theme song promises. There is a proliferation of familiesset variously in Sydney and Melbourne … figures are no sooner invoked than the jostling for positions begins. They move in and out of families, in and out of relationships, backwards and forwards between Sydney and Melbourne. (Moran 1985)

This oscillation between opposites might be broadened both by reference to the serial and also through referring to the larger cultural context. Besides the geographical inversion of opposites, two other kinds of inversion, both to do with characters in the serial, might be mentioned. The first has to do with incest, a transgression of familial boundaries, which recurs in the serial and not only concerns Angela and John but also Jennifer and Peter, children of Martin Healey. At another stage in a serial where parent figures tend to multiply, the twins – John and Angela – also acquire another 'real' father in the shape of Martin Healey. Nor does this 'twinning' stop there. Late in the narrative life of Sons and Daughters, there is further bifurcation. Like a hermaphrodite, capable of auto generation, Patricia, played by actress Rowena Wallace, gives rise to another figure, a 'twin', Alison, who later is discovered to be Patricia (now played by actress Belinda Giblin after Rowena Wallace had left the serial). The new Patricia comes about after the character had fled a murder charge by having plastic surgery in a clinic in Rio de Janeiro. Nor does the proliferation end there. Another woman in the clinic had lost her memory, innocently took on this patient's identity, thereby giving rise to yet another 'Patricia' (Kingsley 1989).

These semantic moves at work in Sons and Daughters can be theorised against developments in semiotic theory, especially work on carnival and masquerade (cf Bakhtin 1981, Barthes 1982 and Ivanov 1984). In particular, Ivanov has suggested that carnival is itself part of a larger semantic figure of inversion of bi-polar opposites and has bracketed several other phenomena under the same figure including bisexuality, incest, transvestism, androgyny, hermaphroditism and carnival (Ivanov 1984). Obviously several of these elements are absent from Sons and Daughters; as 'family entertainment', the serial is unable to take the liberties that a feature film such as Priscilla, Queen of the Desert could several years later. Nevertheless we can conclude this discussion by positing a homologous relationship between Sons and Daughters and other Australian cultural texts of approximately the same era. One such phenomenon is the advent of the Sydney Gay and Lesbian Mardi Gras. The latter which began as an annual event in 1978 is a modern day equivalent of carnival and a striking celebration of inversion of fixed, exclusive categories of the sort that in its own way that Sons and Daughters is also about refusing.

Verbotene Liebe as a German Serial

The move by German public broadcaster ARD to commission a daily soap opera was part of a determined effort to win back audiences and therefore advertising revenue which had been in decline since 1985 when the first independent, commercial television broadcasters came on the air. Although several soap operas, such as *Lindenstrasse* and *Marienhof*, had been broadcast on ARD for some years, these were produced and broadcast once a week and could therefore include a significant proportion of outside location filming. In a major revision of its evening schedule covering the time zone allocated for advertising, ARD commissioned both *Verbotene Liebe* and a revamped *Marienhof* as daily soaps that would fill an early evening time slot each weekday with the former acting very much as a headliner of ARD's evening programs. The two serials were seen as complementary. *Marienhof* is set in a fictional town in Germany and is concerned with everyday life; it deals with a range of social

First meeting of the German twins in **Verbotene Liebe**

problems such as unemployment, immigration and abortion. In contrast to this serial and also, at least in part, to *Sons and Daughters*, *Verbotene Liebe* is set among a different class of people and is particularly focussed on its younger characters. In other words, ARD programrs hoped that *Verbotene Liebe* might attract both the loyal family viewers who would stay on to watch the revamped *Marienhof* as well as new younger viewers.

Three young German women in their 20s helped me to make sense of *Verbotene Liebe*. Alexandra, her sister Tanya and her friend Barbara had become regular viewers while studying and writing dissertations for higher degrees at several different German universities. Although Barbara now worked in an office, she continued to watch even though she found that the program's early screening time often resulted in missed episodes. *Verbotene Liebe* has much less media promotion and engenders less popular interest than RTL's immensely successful *Gute Zeiten, Schlechte Zeiten* so that choosing to watch the former was a culturally significant choice. *Verbotene Liebe* has an overall quality image that marks it off from its Australian predecessor. ARD is the oldest and most venerable of all the German television broadcasters. Known for its superior information and educational programs, ARD has a popular dimension compared to the regional ZDF which broadcasts less in the way of popular drama and young people's programs. On the other hand though, Alexandra emphasised the 'seriousness' of ARD as against the 'sensational' programs on the commercial stations, an opinion with which the others con-

curred. Given this sentiment, it was no surprise that the women favoured *Verbotene Liebe* over *Gute Zeiten, Schlechte Zeiten*. The former had more general appeal than the latter: people across the range watched [it] from PhD students … to kids at school whereas (the latter) is more for the youngsters'. Acting in *Gute Zeiten, Schlechte Zeiten* was 'poor' and 'bad' while *Verbotene Liebe* had some 'really professional actors'. In addition, the RTL serial was ' cheap', ' trash' and 'boring'. Tanya summed up their feelings about the two serials: 'I don't like the actors and I think its … you really get the impression that it is really cheap. The problems that they have are really unreal. Ok in *Verbotene Liebe* they are not everyday problems but I do feel … OK, that could be me. In *Gute Zeiten, Schlechte Zeiten* these are sometimes over the top.

The general image of the network and the perceived level of acting performance are two indicators of quality in this serial but there are others. In spacious studios built by the network for the production, *Verbotene Liebe* uses a comparatively large number of sets with directors frequently employing complex *mise-en-scène* and camera movements. But most especially this quality can be located in the differences between the settings of this version and its Australian predecessor. Compared with *Sons and Daughters*, the characters in *Verbotene Liebe* are distinctly higher on the social scale. The parents who raise the male twin, David and Beryl Palmer, are working-class, living in an older, wooden cottage that is sufficiently close to the heart of Melbourne to be on the tramline; the Brandner family by contrast is much more middle class. Where David is a long distance truck driver, frequently dressed in work shorts and navy singlet, whose favourite gesture on returning home is to reach into his fridge for a large bottle of cold beer, Arno Brandner is an architect/engineer with his own business who often wears a suit. The Brandner house is free standing, built of stone with a full garden while inside is orderly at mealtime with a fashionable kitchen and dining room setting. The contrast between *Sons and Daughters* and *Verbotene Liebe* is just as marked with the families in the second city. Gordon Hamilton has a house on a property on the semi rural north western edge of Sydney as well as a country property called Woombye. However Christoph von Anstatten is from an aristocratic family who owns a chateau near Dusseldorf as well as a penthouse apartment with views of the city. In other words, the families in *Verbotene Liebe* are very prosperous, thereby conforming to another stereotype of German society (Pross 1991).

As we have seen in the previous section, the *Sons and Daughters* format is most consistently focussed on the 'family romance' with two particular families constituting the central axis around which its stories must inevitably oscillate. *Verbotene Liebe* continues this emphasis with two German families. Thus, after more than two years on the air and nearly 700 episodes broadcast, the situation of *Verbotene Liebe* early in 1997 was that Julia was pregnant and it was unclear whether her husband Tim or her twin brother Jan was the father, Florian Brandner had returned to Cologne and sought to resume his relationship with Anna Konrad while Suzanne Brandner has had a letter from her husband Oliver who early in the serial was convicted for the manslaughter of

Anna's father. This emotional patterning is very emphatic, causing Tanya to remark:

> When I first heard the title of the new soap opera ... I didn't think of sister and brother falling in love ... I thought more of the stories ... between two boys and one girl ... and about a half a year ago when Julia was marrying, I thought now its over because she's married. The title is not matching the story any more. Then again they (the twins) fell in love. They are still in love. Other things are happening that also can be regarded as forbidden love.

Modern German affluence - the fathers in **Verbotene Liebe**

If then, the course of the narrative in *Verbotene Liebe*, like its Australian predecessor, is emphatically sinusoidal, repeating the pattern although not the narrative detail of the original, it is equally insistent on its geographic location. Where most other serials – such as *Gute Zeiten, Schlechte Zeiten* – present their location as an anonymous although implicitly national-everywhere, the narrative action of this format insists on bracketing two actual places. As we have seen, these urban twins become both the locales and the boundaries of the narrative action. In *Verbotene Liebe* the two cities are Dusseldorf and Cologne. Although there is some regional competition between these two German cities, there is none of the nationally recognised tradition of rivalry that obtains between Melbourne and Sydney. Neither Dusseldorf nor Cologne have the size or political importance of other German cities such as Berlin and Munich nor is there a significant geographic distance separating them. Dusseldorf is the political capital of the state of North Rhine/Westphalia, the seat of government of that region and a more fashionable and more affluent city than Cologne. Although the city has some old buildings, the serial settles for a view of Dusseldorf's night skyline as seen from the balcony of Clarissa's penthouse apartment.

The twin's marriage in **Verbotene Liebe**

Dusseldorf is also the acknowledged centre of the German fashion industry and this provides a second reference for *Verbotene Liebe*. The city's most famous shopping street, Koenidskllee (Koe), is an imaginary place in the serial

but one that is often referred to by the characters. In early 1997, for example, Sophie and Cleo went shopping there and the program took the opportunity to mention the new extended shopping hours that had recently come into effect in Germany. Dusseldorf's fashion industry is an important point of reference in *Verbotene Liebe*: Clarissa von Anstatten has a clothing design company in a city high-rise, business block, Barbara von Stanneck is a famous designer while Jan Brandner briefly works as a male model.

Cologne although located only 40 kilometres from Dusseldorf is a larger and a more beautiful city. According to Alexandra, Tanya and Barbara, it is also 'for younger people, the more kind of party place', evident, for example, in the Winter Carnival. The city has its own icons, most especially those glimpsed in the opening credits of *Verbotene Liebe* – the Gothic cathedral, the city railway station and the Rhine. Nor is the serial afraid to locate its actions against these sights. Thus, for example, Arno Brandner, father of the twins, takes Annalise, a woman friend, out to lunch at an open-air summer restaurant, across a square from Cologne's famous Cathedral, while Anna Kovacs empties a box of Florian's photographs and letters from a bridge over the Rhine. In turn, this imaginary axis of the two cities is amplified by further geographic references. In the first episode of the serial, Jan returned from working as a ski instructor in the United States; Alexander has moved to Frankfurt where he has a child from a previous relationship; Suzanne has been in London attending an English language course; and, her brother Floriann has been living in Munich and has just returned to the Brandner house in Cologne. More occasionally the journeys are even longer. Rajan, for example, was from India while Raymond, recently living with the Brandners, is from Caracas in Venezuela. The latter is a particularly interesting figure and has become a regular character in the serial. As an outsider, he is doubly marked. His complexion is dark and his hair is long and curly in contrast to the straight blonde hair of several of the other characters. Recently he has also disclosed that he is HIV Positive, having contracted the virus from a medical instrument while in his home country of Venezuela. Raymond is clearly a figure deriving his significance from a particular cultural and political situation in Europe and Germany at the present. And here too the program is delicately poised, offering audiences the possibility of both reactionary as well as progressive readings. On the one hand, Raymond is ethnically other and his body is a medical threat. On the other hand, the serial mythologises his disease so that it is not an outcome of his sexual activity but rather was something outside his control. The Brandners fully accept him. The others display no fear or loathing but rather demonstrate to viewers the need for tolerance to those who have this disease.

If *Verbotene Liebe* is detailed in terms of geographic location, it adopts a fictional licence so far as the accents of these imaginary inhabitants of Dusseldorf and Cologne are concerned. The actual and distinctive accents found in the two cities are absent from *Verbotene Liebe*, replaced by a hochdeutsche that is understandable throughout the various German-speaking countries where the pro-

gram is broadcast. From time to time though, other dialects and accents are heard. One such linguistic variant is the English theme song of the serial, 'Forbidden Love', which serves to remind the viewer of how common English words, phrases and songs are in the aural landscape of Germany (de Swaan 1992). An even more curious note, pointing to the general aural elisions that the program practices, occurred in late 1996 when a lost son of Benedict von Anstetten, Rajan, got a job at the von Anstatten stables. However although this lost son was from Bombay in India (the figure was of a general West Asian appearance), the actor had a Bavarian accent.

Of course like other popular narrative, soap opera must walk a line between accuracy and fiction, the credible and the imaginary, and this applies just as much to *Verbotene Liebe*'s negotiation with a German identity. Take, for example, the city streets, most especially those of Cologne, as they appear in the series. These are indeed real streets with inhabitants seen in the background as the everyday lives of the characters briefly take them away from their anonymous indoor settings into a more outdoor, public world. Anna meets Paul at an open air restaurant, Raymond and Jackie sell necklaces in a street market, Anna journeys on a Cologne tram and so on. And yet these images have their own unreality as the cars that are a daily part of life in German cities are mostly absent. For Tanya, Alexandra and Barbara, a more interesting case requiring a greater suspension of disbelief and a more complex negotiation with various cultural and national knowledges – concerned the figure of Clarissa, the bitch mother to the twins and former partner of both Arno and Christoph. As Barbara put it:

German version of the bitch mother

> Clarissa is really the kind of person which for me makes the thing unrealistic. She is so much like a character that does not exist, you know ... She's very ... yeah that is a bit like in an American soap kind of thing. It's very unGerman, I'd say. Being such a powerful woman ... having all the power to do the kinds of things that she does. Not a typical German woman ... Just having all the influence and all the power and being able to get into everyone's lives.

However, as we have seen, Clarissa has her counterpart in Patricia in the Australian version. Both figures in their respective texts are clearly important sources of melodramatic excess and, as we have already noticed, the melodramatic element is the ingredient that inclines some viewers of these serials to suggest that the particular text is foreign. In the case of *Sons and Daughters*, the melodrama leads to the charge that that serial was the most

American of soap operas produced in Australia. Here it registers as the belief that Clarissa is 'un-German'. In both cases, there is an assumption of what is native and what is imported: melodrama is seen as falling into the latter category. This claim – about the national otherness of melodrama – was, as we saw in Chapter 6, a claim that Silj and his associate had to consider and finally reject in their *East of Dallas* study. We can therefore end the present Chapter by recalling Silj's argument, one that has an important bearing on the issue of the Australian and German character of *Sons and Daughters* and *Verbotene Liebe* respectively:

> … American programs for export contain all the stereotypes, not so much of American life but rather of those traditional values of anti-American propaganda: money, power, violence, ambition, intrigue, etc. However these also happen to be essential ingredients in the packaging of a popular melodrama. Evidently the Americans are not the only ones who resort to these ingredients or expedients. But they have an advantage over we Europeans: they know how to use them without the guilt complexes, without the scruples and limits imposed, more or less unconsciously, by cultural legacies. (Silj 1988 p 209)

Clearly *Sons and Daughters* and *Verbotene Liebe* have that same lack of cultural guilt and self-consciousness about using the mode of melodrama and they should therefore be seen respectively as important contemporary texts in Australian and German traditions of melodrama.

Try, Try and Try Again: *The Restless Years*, *Goede Tijden, Slechte Tijden* and *Gute Zeiten, Schlechte Zeiten*

The Restless Years was only the third drama serial produced in Australia by the Grundy Organisation. The serial was made for what was then the 0–10 Network and began on air late in 1977. Altogether 781 half-hour episodes were made. Subsequently Grundy has entered into co-venture arrangements in the Netherlands and Germany to produce national adaptations of this format. *Goede Tijden, Slechte Tijden* (Good times, bad times) began on RTL 4 in the Netherlands in 1990 and *Gute Zeiten, Schlechte Zeiten* (Good times, bad times) started on Germany's RTL in 1992. Both adaptations used the original Australian scripts, with very minor modifications, for some time – 460 episodes in the case of the Dutch and 230 in the case of the German – before employing local writers who created original storylines. While the original Australian serial was popular enough, its commercial success has been far surpassed by its European siblings. *Goede Tijden, Slechte Tijden* was both the first, locally produced, daily soap opera not only on Dutch television but on European television. It quickly became immensely popular in the Netherlands and, even after 8 years on air, has an enormous following. *Gute Zeiten, Schlechte Zeiten* was also the first, locally produced daily serial on German television and, while it was slower to build a large audience, it is now a cult serial. Not surprisingly, each serial, on examination, turns out to speak to its national audience about many domestic situations and matters.

The Restless Years and Australian Identity

The Australian accents of the characters in *The Restless Years* are no indicators of place. Rather they tend towards the educated, accent generally associated with particular parts of several Australian cities including the North Shore suburbs of Sydney. The serial was produced at the studios of Sydney's Channel 10 and thus the geography of its imaginary community is a set of suburbs close to the water, either in Sydney Harbour or the northern beach suburbs. Alan Archer's parents own a beachside house and control of the house is in dispute when the parents decide to divorce. Some broader, more working class accents are in evidence from time to time although their paucity highlights a social absence in the serial. Similarly, holding to the fiction that *The Restless Years* is set in the more affluent beach or harbour suburbs of Sydney, there is a noticeable absence of ethnic accents and appearances among the characters. We can note yet another elision in the serial so far as its location is concerned. Missing is that imagery and sense of place associated with another Sydney, 'out west' in the great south west and western sprawl of suburbs. This other Sydney houses most of Sydney's population and yet apart from media reports, mostly to do with social problems, as well as a handful of feature films such as *The FJ Holden* and *Fast Talking* largely goes without representation in the Australian media (Powell 1993). In other words, if *The Restless Years* is set in Sydney then this is a particular affluent, picturesque Sydney that is not inhabited by many of the city's actual population. On the other hand though, the serial is not a saga of the rich and powerful. It is concerned with the affluent but not with the wealthy. Indeed it was not until *Taurus Rising* that Grundy would attempt to emulate the milieu of *Dallas*. How then do we focus on the serial's inclusions rather than its exclusions?

Earlier, in 1983, I had noted a particular tension in the Grundy serials of the 1970s such as *Class of 74/5* and *The Young Doctors* which were poised between the working-class locations of some earlier Australian programs such as *My Name's McGooley – What's Yours?* and *You Can't See Round Corners* and the more tourist-oriented images of water, beach and bush to be found in series such as *Skippy* and *The Rovers*. In noting 'an erosion of social ambition', I sought to articulate the somewhat hesitant groping and often contradictory impulse of these serials towards affluence and middle-class comfort and social problems and issues. In other words, I would suggest that where earlier Australian series located social problems in poorer, working class suburbs, of both Sydney and Melbourne, the Grundy serials – at times hesitantly, at times in a confused and contradictory fashion, found these in more affluent surroundings (Moran 1985). Thus, in *The Restless Years*, it is only Peter, one of the original school leavers, who is relatively poor and has a working class father in the shape of Bill Beckett. Rayleen is more distinctly working class. Yet the affluence of many of the other characters is a thin one. The school the students leave at the beginning is a co-educational school located in relative modern red-brick buildings, a free, public rather than the more expensive private school. Similarly, paid

work is important for the older characters and not just the school leavers. Thus Alison Clark's parents have to move away from Sydney when her father's business fails and he gains employment elsewhere.

Sydney school leavers in the Australian **The Restless Years**

In other words, *The Restless Years* can be seen as socially grounded in the experiences of its Australian audience in the late 1970s. That social context is mobilised at a series of levels and four examples can be offered here. The first concerns the students' nickname chosen for Miss MacKenzie, the former high school teacher. She is Big Mac. McDonalds, the fast food chain, had opened its first store in Australia in Sydney in 1971 and, by 1977, when *The Restless Years* began on air, this food item had become part of Australian popular culture. The second detail also concerns food and has to do with the fact that Peter Beckett is briefly manager of a food and drink outlet where Rayleen works as an assistant. In the Dutch and German adaptations, this venue is a coffee shop but in the Australian version it is a milk bar. Yet another Australian element concerned a club for older people with which Miss MacKenzie is briefly involved. In a distinctly Antipodean form of social organisation and purpose, the Over 60s Club is relentlessly cheerful with endless rounds of bingo nights, bushwalks, bus trips and chuck (chicken) raffles. The last reference concerns a distinctively Australian social type, whether real or imaginary, that is variously incarnated in several figures in *The Restless Years*. The type is the Ocker. The term refers to a socially and often comically clumsy type whose poor manners, lack of breeding and social graces were seen to be an outcome of both inferior social position as work-

ing class and also of Australia's geographic distance from metropolitan Britain and the civilising effects of its culture (Oxley 1979). While the figure of the ocker was by mid-century seen to be something of an anachronism, nevertheless the type was powerfully revalorised by the emergence of Australian television comedian Paul Hogan after 1971 (Fiske, Hodge and Turner 1987: O'Regan 1988). First in the persona of a Sydney garbage collector who was also a laconic commentator on political affairs and then, as an extension of this figure in his own television program, Hogan in the 1970s came to typify the Ocker for Australian audiences. In turn, the figures of Raeleen, Sharmaine and, to a lesser extent, Hoggo in *The Restless Years* have to be seen against the Ocker and Hogan's embodiment of the type.

This last point about the mixed social and cultural references of the Ocker figure underlines a more general issue about the cultural and social knowledges that are mobilised by soap opera audiences. The original Australian audience for *The Restless Years* was no exception and part of the intertextual context of the serial can be mentioned. Stern has invoked the US television series *Marcus Welby M.D.* as background for the long-standing figure of Dr. Bruce Russell in *The Restless Years* (1978) but a far more relevant context is provided by the Grundy serial *The Young Doctors* which began on the Nine Network about a year before *The Restless Years*. Similarly, the figure of Miss MacKenzie and the school should be set in the context of two other Grundy serials, *Class of 74/75* and the contemporaneous *Glenview High*. The latter is particularly relevant to this serial as it had a woman, Margaret Gibson as head of the Sydney high school represented in the program (Kingsley 1989; Moran 1993). In addition, although none of the large cast of the serial had

The teacher, the doctor and the lost son in the Australian **The Restless Years**

star status nevertheless several of the actors in *The Restless Years* had familiar personas so far as the Australian viewing public in the late 1970s was concerned. The ABC serial produced between 1973 and 1977, *Certain Women*, had indelibly stamped the image of actress June Salter as a middle aged career woman who had never married and had a family, a persona that is continued in her role as Miss MacKenzie in *The Restless Years*. Similarly both John Hamblin and Benita Collings had had long associations with the ABC's *Play School*. Joy Chambers, who appeared more infrequently as the devious Rita Merrick, was particularly known to viewers in her home city of Brisbane both as a television personality and actress and also as wife to the owner of the Grundy Organisation (Beck 1984).

Although the serial did not overtly claim to be social realist, nevertheless the program constantly touches on social themes and issues. A part list of some of the concerns raised by *The Restless Years* includes the following: parentless children; adultery and marriage breakdowns; alcoholism; social loneliness; domestic violence; unemployment of older as well as younger people; breakdowns in health; youth homelessness; unscrupulous recruitment of teenage prostitutes; teenage pregnancy and forced marriage; and backyard abortion. These are all social issues so that the title of the serial can be seen to have a much more socio-historical reference than might have been thought at the time. In other words, the title of the serial can be seen to be 'about' social developments that are a product neither of individual psyches or of destiny but are rather human forces of social dislocation and disharmony brought about by social and economic policies of government and commercial institutions.

In this sense, the key social problem that is repeatedly touched on in *The Restless Years* from its first episode to the last is the problem of unemployment, especially that of youth. unemployment. From about 1950 to 1974, the Australian economy had generated full employment and a high degree of social prosperity. That changed in 1974 with the first Oil Crisis and steady growth in unemployment. Between 1974 and 1978, this trend was most pronounced among young people. Youth unemployment jumped from 9 per cent to 22 per cent These figures are taken from academic author Keith Windshuttle's contemporary sociological study of Australian unemployment, a book that was written in the months after the first episodes of *The Restless Years* had gone to air and appeared the following year (Winshuttle 1979). The range of social issues dealt with by Windshuttle concerned not only unemployment but also a set of other interlocking social phenomena that are of immediate relevance to the serial. These include the cultural responses of youth to unemployment in the form of punk music and youth discos, social escape through the use of drugs and chemicals, and the appearance of new types of shelters for homeless youths, the impact on this social dislocation on the family in the shape of divorce and instability, wife battering, child abuse, expulsion of children from home and single-parent families. It is no coincidence that many of these issues are dealt with at one stage or another by *The*

Restless Years. Windshuttle also analyses a growth in crime and the impact on social health of suicide and depression. Of course, these phenomenon were part of a general social dislocation which while not directly caused by unemployment was considerably exacerbated by its advent. In this sense, the title of *The Restless Years* can be seen as, unintentionally, referring to this social crisis and dislocation.

Clearly to pursue in detail each of the particular social issues mentioned in the previous paragraph as they are constructed in *The Restless Years* would take the discussion far beyond what is necessary here. However, one specific context for one of the particular discourses of the serial might be noted as a way of concluding this discussion. Windshuttle has argued that from 1975 to at least 1978, the Australian media as well as the federal government pursued a campaign of scapegoating and punishing those who were on unemployment relief (1979 p 38-79). These 'dole bludgers', especially the young, were seen as involved in various forms of 'dole rip-offs', from drawing more relief than what they were entitled to to making no effort to find paid employment. The thrust of such a campaign was, in effect, to suggest that much of the high volume of figures for Australian unemployment was, in fact, due to individual laziness and greed, that jobs were really there, provided one looked hard enough and that those who were unemployed were morally delinquent, if not criminal. While this discourse was particularly prevalent in the popular media, including tabloid afternoon newspapers and talkback radio, nevertheless such views were subjected to some degrees of contestation elsewhere, including in some of the quality newspapers, in radio and television documentaries, in several ABC Television's social problem drama series such as *Beat of the City*, *Pig in a Poke* and *Spring and Fall* and the feature film *Mouth to Mouth*. Similarly, in its own way, *The Restless Years* can be seen as intervening in the 'dole bludger' debate that occupied Australia in the mid to late 1970s. However, as I have already suggested, the producers of this serial were never imbued with social realist ambitions for their stories and so this intervention is occasional and frequently inconclusive. Nevertheless, in retrospect, this context provides the Australian backdrop for the serial.

Dutch Identity and *Goede Tijden, Slechte Tijden*

Goede Tijden, Slechte Tijden was not only the first domestically-produced daily drama serial on Dutch television but it has remained the most popular. The program has been of immense significance for Dutch broadcasting not only in economic terms but also in cultural terms. As Dutch writers such as Ang and Madsen have suggested, the popular success first of imported soaps such as *Dallas* and then of domestically-produced serials such as *Goede Tijden, Slechte Tijden* has broken the stranglehold of public-service 'quality' drama as the only legitimate form of fiction on Dutch television (Ang 1991; Madsen 1994). Madsen, a long-time producer of *Goede Tijden*, has written:

> A more general reason why a daily soap serial on Dutch television
> is important is that the audience gets accustomed to the Dutch lan-

guage as a language for fiction. Why is it that they say that it is bad acting when they hear 'Ik hou van je' instead of 'I love you'? We are convinced that it is a necessity to make television drama in your own culture, your own language. (1994 p 52)

'Television drama in your own language' - the Dutch **Goede Tijden, Slechte Tijden**

This point about language was underlined by the research situation wherein I accessed the text of *Goede Tijden*. Two young Dutch women in their early 20s, Madelaine and Sascha, acted as translators of the text. Both were keen fans of the serial which they tried to watch on a daily basis. By talking about the program with friends. they also kept in touch. One friend of Madelaine's was writing to her on a daily basis while she was travelling and including updates on the Dutch soap. For Sascha and Madelaine, watching selected episodes for the purposes of the research was like meeting old friends – a chance both to revisit some characters and narrative situations, no longer current, as well as to see episodes which played on Dutch television after they left the Netherlands. And, in turn, although both spoke good English, it was entirely apposite that the two should converse with each other in Dutch as they watched these episodes just as the fictional characters that we talked about in the course of our viewing were also speaking in Dutch. There were, however, certain linguistic disjunctions in the overall situation. For while Sascha and Madelaine spoke to each other in Dutch, they spoke to me in English, explaining who various figures were, translating significant dialogue and constantly summarising past incidents and story events. In addition, there was also a gap between the Dutch spoken by the translators and that spoken by the characters. Sascha and Madelaine were from Rotterdam so

their Dutch had a particular accentual inflection although probably tempered by their education. (Madeleine was a school teacher and Sascha had just finished a post secondary course in art.) Nor were regional accents entirely missing from the broadcast program. For example, one of the commercials shown in the advertising break that occurs about a third of the way through an episode – a commercial for Tide washing powder – featured a Dutch housewife who speaks with an accent found in the south of the country near the Belgian border. On the other hand, the Dutch spoken by the characters in *Goede Tidjen, Slechte Tidjen* deliberately attempts to overcome regional variation and is best described as an accent found in the Randstads region, especially around Hilversum where the Dutch television industry is located. Or as Madeleine and Sascha put it: 'It's not really a gap, we can understand everything easily – only that pronunciation is a little bit different than ours'.

If *Goede Tijden, Slechte Tijden* deliberately avoids specification of region, so too it elides place. Although other Dutch soaps have deliberately represented cities such as Rotterdam in *Het Oude Noorden* and Amsterdam in *Vrouwenvleugel*, nevertheless the intention in this serial – like another produced some years earlier, *Spijkerhoek* – is to construct the stories as taking place in a moderately large but unspecified Dutch city. Thus, the characters speak a 'national' Dutch language and live in a 'national' place. However if the representation is obviously contrived at this level, the serial more than compensates for this with a plethora of elements such as physical objects, social behaviours and routines drawn from everyday life in the Netherlands. Some examples make the point. One incidental item present in many scenes was flowers; as Madeleine explained: 'That's probably Dutch. Flowers are … you see a lot of flowers in houses, on tables in Holland. The flowers are there all through the year – different types of flowers. You bring them when you go out or visit someone. You bring flowers or when its someone's birthday'. Equally, a basket containing fruits such as apples, bananas, and oranges is also quite common. Sascha noticed Jessica using a *kaasschaaf*, a Dutch knife for cutting cheese. Sometimes elements of Dutch topography are drawn into the dramatic action. For example, in episodes broadcast in late 1996, Roos, Arnie Alberts' wife, is upset at his disappearance. She narrowly avoids crashing her car into a sloot, a type of mini-canal.

Jessica's uncle, Govert Harmsen, is the most stereotypical Dutch figure in the serial, a kind of walking repository of cultural troches and practices that are traditional to the Netherlands, a caricature of certain kinds of national behaviours and attitudes. At one stage he is seen collecting tea labels in an envelope, a thousand of which will make him eligible for a gift. Thrift is his password and Sascha and Madeleine saw him as representative of an older generation:

> He constantly refers back to the War. He doesn't want to spend money. He is always talking about not spending so much money. And … he is always saying You didn't live in the War … when goods were in short supply and everyone had to be thrifty … That's

the typical Dutch attitude, not spending so much money on food. Because you don't eat it all ... older people are a bit like that. The program does that to make fun.

Harmsen rides a bicycle and takes no chances with the weather, wearing an overcoat, a deerstalker's hat, and an umbrella tied over his shoulder. Indoors, he always stays warm within an invariable covering under his jacket, either a knitted cardigan or a camel's hair waistcoat. He holds to traditional Dutch cooking, including pea soup. His kitchen contains a picture of Queen Beatrix, a painting of a windmill, a copper plate with a Dutch scene and a woven cloth hanging.

However, if Harmsen represents a particular Dutch cultural identity which the young backpackers recognised but did not subscribe to, then we must look elsewhere to understand the kind of Dutch identity that *Goede Tijden, Slechte Tijden* offered them. Obviously while youth is a key component of the audience of the program, it is not the only segment. However it is a key element so far as advertisers and broadcasters are concerned. We might start our reflection on the role the program plays in Dutch youth culture by noticing that the program has been on air for eight years. For Sascha and Madelaine, it has been part of their cultural experience both as teenagers and as young adults. Marketing and promotion play their part in helping to construct the serial as an on-going part of Dutch culture, especially but not exclusively youth culture. The Dutch telecommunications provider has a telephone hot line devoted to the program which updates stories for callers. The program features heavily in teen magazines and television magazines in the Netherlands. Stickers, wall posters and so on can be had from these and other sources.

Dutch youth culture obviously draws on materials and icons from elsewhere, most especially the US, but again we will only concern ourselves with its Dutch component and the way that *Goede Tijden, Slechte Tijden* marshals generic and intertextual knowledges of other soaps and other programs on Dutch television, as well as other kinds of cultural consumption available as part of a Dutch youth culture. As already mentioned, this soap, which Sascha and Madelaine explained was referred to in the Netherlands either as *Goede Tijden* or *GTST* but never by its full title, forms part of a larger soap opera culture that includes the sub-titled US import *The Bold and the Beautiful*, which plays earlier each evening on the same network. More importantly, this soap culture also includes several domestically-produced serials such as *Onderweg Naar Morgen* and two recently defunct weekly serials, *Spijkerhoek* and *Vrouwenvleugel*. In 1997, this body was swollen by the advent of yet another daily soap, *Gold Coast*. Seen in the context of this larger Dutch soap culture, *Goede Tijden, Slechte Tijden* becomes a temporary stage for various Dutch actors and performers who have appeared or will appear in some of these other soaps. Nor is the Dutch intertextual references limited only to this genre of television. *GTST* is part of a Dutch youth culture that also includes pop music, film, theatre, clothing and fashion. Reinout Oerlemans,

who played Arnie in the serial for over six years, has his own show, *Postcard Lottery*, while Tim Immers who plays Mark also has a television music show, *Rabo Top 40*. These Dutch stars turn up on panels in game shows on Dutch television. Babette van Veen and Guusje Nederhorst (Linda and Roos in the serial) had their own show, *Call TV*, which included segments where viewers could ring them live on camera and talk to them. In addition, Linda/Babette is known to many in the Dutch audience as the real-life daughter of a famous father, the Dutch singer Herman van Veen. Linda/Babette and Roos/Guusje, together with Katja Schuurman (who plays Jessica Harmsen), have had a big hit song in *Ademnood*. Indeed, Katje Schuurman is currently the most popular star in the Netherlands and is much sought after for TV commercials. One of the original cast, Anthonie Kamerling, who played Peter Kelder, left the serial several years ago and now works in films and theatre. Similarly the styles and fashions of clothing worn by characters in the program are those accessible to the youth audience watching the serial. Among the brands of clothes worn are Naf Naf, Espirit, and Benetton, international brands and styles, that help to confirm the characters as Dutch members of a cosmopolitan consumer culture.

Appealing to youth and older audiences in the Netherlands. Peter and Robert in **Goede Tijden, Slechte Tijden**

In addition to this dense network of Dutch references, *Goede Tijden, Slechte Tijden* also frequently develops storylines that construct the Netherlands and the Dutch in terms of that which is nationally other. Thus from time to time, some characters visit or indeed become lost or die in other places, thereby implicitly affirming the fact that the majority of the characters remain in the (fictional) Netherlands of the serial. Sometimes these

other places exist only as verbal references: when, for example, Rick wants to take Anita to Finland, this country is nothing but a figure of speech. Sometimes it is more: for example, Arnie studied for a time in America and he continued to be seen not only in telephone conversations with various characters at 'home' in the Netherlands but also with his father, Robert, in New York, visiting some of the various sights of that city. More usually though, in contrast with the everyday familiarity and safety of the Netherlands of the serial, these other places represent isolation, mystery, danger and possible extinction. Thus, for example, Annette van Thijn was killed by terrorists in the Middle East while Simon Decker disappeared in the frozen wastes inside the Artic Circle. In late 1996 Arnie disappeared while on a plane trip over Venezuela. His parents, Laura and Robert, made a trip to Venezuela to search tropical beaches for some sign but in vain. However, Laura came to believe that he is still alive and consulted John Serrei. The latter is exotic looking, apparently an expert on the jungles and indigenous peoples of the region where Arnie has disappeared. The study where Laura visits him is bathed in shadows and adorned with native masks, strange wall hangings and exotic palms and other tropical plants. A drum throbs away on the soundtrack during their conversations. Later still, Laura and Robert return to Venezuela and journey through jungles and mountainous tracks to try to find Arnie.

The Netherlands itself in the serial is not impervious to migrants and visitors. Their presence helps make the incidental point that the society of *Goede Tijden, Slechte Tijden* is an increasingly multicultural one. Two of the most important such characters, figuring in several different storylines, have been Arthur Peters and Fatima Yilmaz. Arthur, his mother and father are from the former Dutch colony of Suriname. Tracy Peters failed to follow Dr. Simon Dekker's medical advice and this had disastrous occupational results for her and personal consequences for Simon. She and her husband decided to return to Surinam, leaving their son Arthur settled in the Netherlands, guilty about not joining his parents and unaware that he had mistakenly laid blame on Simon. The second set of storylines also involved complex ideological issues concerning an outsider's decision to remain settled in the Netherlands. Fatima is from Turkey and, at one stage, was under pressure from her brother not to have a Dutch boyfriend and, indeed, to return to her homeland. However the very seriality of *Goede Tijden, Slechte Tijden* then allowed other ideological issues and ideas to be explored and yet remain narratively unresolved. Fatima is a dress designer although she finds that, because of a contract she signed with Frits van Houten, she is not allowed to put her name on the label of her designs. Instead, Frits passes these off as being those of Linda Dekker. Fatima is physically intimidated by Frits and forced to hand over her designs. The matter is concluded when Linda learns of the situation but this does not resolve the more general issues of economic and often physical exploitation that faces the new settler.

German Identity and *Gute Zeiten, Schlechte Zeiten*

Like its counterpart in the Netherlands, *Gute Zeiten, Schlechte Zeiten* was the first domestically-produced daily soap on German television. The serial was slow to build an audience but, by 1994, had become the second, most popular soap opera on German television, outstripped only by the public broadcaster ARD's *Lindenstrasse* (Akyuuz 1994). However given that the latter is broadcast only once a week, *Gute Zeiten, Schlechte Zeiten* has a much higher cumulative audience. Influenced by the enormous success of this first daily soap, Grundy/UFA over the last three years has received commissions for three further daily soaps.

Merchandising **Gute Zeiten** *as part of German popular culture*

Except for occasional moments in *Gute Zeiten* when the characters use a word or phrase from another language, usually English, or a background song is in English, all dialogue in the serial is in German. I therefore enlisted aid in understanding the German dialogue. Tanya was a young woman from Bavaria who had settled in Australia over seven years ago, although she had consciously retained her language and contacts with Germany. Language is the most important and most powerful component of national culture (cf Heinderyckx 1994). Thus, in noting that the language spoken by the characters in *Gute Zeiten, Schlecte Zeiten* is German, one is doing more than remarking on its linguistic disposition. Rather one is noticing the capacity of the program to speak in a familiar way to audiences not only in Germany but also in Austria, parts of Switzerland and France, and Lichtenstein. But, given the very different religious, historical, political, and geographic backgrounds of these regions, as well as the same intranational differences between states

and regions within the German federation, there is inevitably a politics of dialect and accent at work in the program's Germanness. So far as the fictional linguistic community represented in the serial is concerned, the choice is one lying along a continuum between a multi-accentual community (where regional differences are present, even emphasised, and the characters are represented as, say, Bavarian or Oldenbergian and German-ness is the abstract, sum-total of these differences) through to a mono-accentual community (where the characters are German rather than Bavarian-German or Saxon-German).

The first approach has been taken by the Welsh television soap opera *Pobol y Cwm* (Griffiths 1993, 1995). In German television, a similar multi-accentual approach was evident in a long-running police series, *Tatort*. Individual episodes were produced by the regional public service stations and broadcast across Germany by the stations' national network, ARD (Strauss 1995). With each 90 minute episode following the simple formula of a policeman investigating a crime, the program is a kind of umbrella series, a national container. Each policeman is based in a different city synonymous with a specific region and operates in his own particular fashion with his own political opinions, just as each city has its own separate issues and crimes and its own distinctive populations. As Peter Struss put it : 'Each station which represents its own region has its own policeman. The intention was ... (to stress) regional identity. There was not one (single) police officer over the series, there were 12 or 15. Every station had their commissioner that might appear only once a year.' (1995). In the event, there were several factors that militated against such an approach in favour of one that is mono-accentual. Unlike the public broadcaster ARD, which is committed to a regionalist view of the German nation state, RTL — the commercial broadcaster which commissions *Gute Zeiten, Schlecte Zeiten* – is oriented towards a national market for its advertising (Hofmann 1992).

In addition, given the integration of east and west Germany that began in 1991, a multi-accentual approach could have had the potential to draw politics into the fictional world of the serial. And finally, there was the example of the program's two predecessors, *The Restless Years* and, especially, *Goede Tijden, Schlecte Tijden*, neither of which had foregrounded regional accents within their fictional national setting. In the German version of the format then, the continuing characters mostly speak *hochdeutsch*, a particular German dialect which initially emerged from Hanover but which is now an (accent-less) state-German. Some other accents are heard. Ollie, for example, younger brother of Milla Engels, speaks with a Dresden accent. However, by and large, *Gute Zeiten, Schlecte Zeiten* can be seen as conducting a particular political operation so far as German accent is concerned, one that is in line not only with state policy but also with commercial culture.

The extensive use of *hochdeutsch* by the characters in *Gute Zeiten, Schlecte Zeiten* offers a further clue to the geographical location of the serial. Although produced in Berlin, nevertheless there is in the program a deliber-

135

ate de-Berlinisation of the text. Instead, in place of Berlin, the program creates a fictional location that is nevertheless representative of Germany. The initials on car number plates in the serial are ET, designating a fictional region that could be anywhere in the country (although, in turn, the program's producers and writers jokingly see these initials as standing for Entenhausen, the German name for Duck Town in Walt Disney comics).

If place is anonymous, nevertheless accents suggest that the soap is set in a large urban centre or city where regional accents are mostly absent. In turn, the *mise-en-scène* of apartment blocks, the outside of restaurants and bars, mansions and office buildings as well as residential streets, gardens and parks confirms this metropolitan impression. Thus the permanent characters constitute a small segment of contemporary, cosmopolitan Germany. This is further solidified in *Gute Zeiten, Schlechte Zeiten* by the frequent invocation of a Germany set within an imaginary international geographic other. Characters frequently travel from and to this larger fictional territory, thereby, indirectly confirming that the space of the serial is Germany. Thus, for example, wealthy businessman Mattias Zimmerman left his business and his marriage and was thought to be in Argentina or Brazil before being reported dead; Milla marries the South African Josef de Witt to prevent him being deported; and Manjou Gunakar Neria is an Indian girl who, at one stage, seemed set to have to return to India with her businessman father. And, indeed, Manjou's Indianness (evident in her skin and hair colours, hair style and clothes and exotic looks) as opposed to the Germanness of the other characters (white skin, often blonde hair, familiar hair styles and woollen and linen clothes) is sometimes used as a means of subtly exploring complex issues of what it is to be a social outsider. Take, for example, the story of the young schoolteacher Mr. Killian. Manjou's class, especially her three blonde girlfriends, came to suspect that he was homosexual and infected with AIDS. Manjou however was, initially, less condemnatory, both because of Killian's personal kindness to her and also because she was aware of the prejudice of her companions. In the event however, she joins them in their prejudicial behaviour. When she and they drive the innocent teacher from the school, the program is able to examine some of the costs that outsiders pay for social belonging.

Time also plays its part in the depiction of this contemporary, cosmopolitan and anonymous Germany. The serial is set in the present and its scheduled broadcast has been arranged so that the calendrical time of national anniversaries, holidays and celebration days is generally observed. Thus, very late in 1994, the characters were clearly in the Christmas season even while the German audience was in its own Christmas season. Likewise *Gute Zeiten, Schlecte Zeiten* has also represented the carnival season with storylines involving the carnival that has been designed for airing in February. More generally, there is a broader congruence between the fictional time inhabited by the characters and the seasonal time inhabited by the program's audience. Thus, when it is winter in Germany, the characters are wearing warm coats

in outside scenes while in late summer and early autumn, shorts, T-shirts and short skirts with cooling iceblocks and drinks are the order of the day.

Beyond the crucial detail of language and the more incidental detail of place and time, *Gute Zeiten, Schlecte Zeiten* develops its Germanness through the social and generic knowledges that it mobilises in its viewers. For example, while watching one scene, Tanya, my translator, drew attention to a set detail of both an outside door as well as an indoor cover in an entrance, an arrangement necessary in a country such as Germany in winter. Another scene, where businessman Clements Richterin a reverie recalls, in a montage flashback, past images of his estranged wife Vera, caused Tanya to remark about the character's hair style: 'That looks awful It used to be fashionable for a while in Germany. I hated that hair style'. Even beyond these incidental, everyday references to aspects of German life, there are also more mythic and folkloric invocations at work. For example, in a scene between rich, matriarchal business woman Beatrice Zimmerman and her daughter-in-law, Tina Zimmerman, the latter discloses a plan to start a perfume manufacturing company. Beatrice's reply caused Tanya to laugh: 'Ah, that was mean. She (Beatrice) says: Well if I would be you, I would start with a room spray, *Tiana's Forest Spray – And With Tina's Forest Spray You Will Really Sit In The Forest*. And its a German saying … it means that you're lost and broken. So its an insult'.

However some of the knowledges mobilised by *Gute Zeiten, Schlecte Zeiten* are both more contemporary and more complex. Take, for example, the criss-crossing narratives to do with both the opulent Zimmerman family – Beatrice, Mattias and Tina – and also with the two half-brothers – wealthy Joe Gerner and aspirant Patrick Graff. Most of these plots centred on bitter, inter-family rivalry, on power politics and on sexual intrigue, thereby conjuring up an image of a group that is intensely materialistic, competitive and rapacious. It is no accident that such an image was one that was seen to typify German society – at least that of the Federal Republic of Germany (cf Pross 1991; Rilke 1994). Nor is this element irrelevant to Germany after 1990 as has mistakenly been argued by two Australian researchers: '*Gute Zeiten, Schlecte Zeiten* is made within walking distance of the site of the Berlin Wall, but never so much as a whisper in the program alludes to what it represents' (Cunningham and Jacka 1996 p 156-7). In point of fact, since unification of the two states of East and West Germany (or colonisation of the German Democratic Republic by the FRG), this domestic image of (west) Germany as a rapacious, wolfish, free-market capitalism has been intensely revalorised (Rilke 1994). And while the program does not contain contrasted images of east and west Germans, as does a cycle of other recent domestic productions, nevertheless this embodiment of intensely competitive and uncaring forces of the free-market have a particular resonance in the light of recent German political and social history (cf Kilborn 1994). In other words, even if *Gute Zeiten, Schlecte Zeiten* makes no overt reference to recent events in Germany, the imagery of free-market capitalism contained in the program links with this larger network of media representations and a tangled matrix of social, political and economic issues.

The **Dallas-***like Zimmermans in Germany's* **Gute Zeiten, Schlechte Zeiten**

However the narratives of domestic, sexual and business intrigues among members of rich and powerful families has another equally strong background in *Dallas* and *Dynasty* (Hoffmann 1988). *Dallas* began on ARD in June 1980, 'domesticated' by being shown without commercials, dubbed into German, and proved to be immensely popular. In turn, this revalorisation of melodrama in a popular television genre was taken up in home-grown series such as *Die Schwarzwaldklinik* (The Black Forest Clinic) and *Lindenstrasse* (Linden Street), both of which – especially the former – owed a direct debt to the American prime time soap operas (Hoffmann 1988; Krewtzner and Seiter 1995).Equally though, there are other generic references at work in *Gute Zeiten, Schlecte Zeiten* that mobilises cultural capital that some segments of the German audience will bring to its viewing. Take, for example, the character of the medical practitioner, Dr. Michael Gundlach. Although the figure of the doctor in this serial has its counterparts in Dr. Bruce Russell in *The Restless Years* and Dr. Simon Dekker in *Goede Tijden, Schlecte Tijden*, nevertheless Gundlach must also be contextualised in a tradition of German representations of the medical doctor. Here again, *Die Schwarzwaldklinik* is the most immediate predecessor to the present serial. In the latter, Professor Brinkmann runs the clinic of the title whose staff comprises himself, his son and a nurse who becomes his wife as the series unfolds. In a reflectionist reading that posits a direct relationship between the representation of gender in the serial and German society, Krewtzner and Seiter have recently pointed out that the doctor figure, Brinkmann, controls both his family and his clinic with a firm but wise patriarchal authority (1995). However, even while insisting on a more complex mediation between this kind of representation and German society, it is still useful to contrast the doctor figures from the two German serials. Michael Gundlach, by contrast with Brinkmann, lives his life in a certain amount of

domestic and professional chaos. Although he aspires to an authority commensurate with his social position as a healer of society's illnesses (frequently, for example, being brusque and rude to his assistant, Elke Opitz) he is far from being able to control the direction and circumstances of his life. His wife Iris has died and he is caring for their adopted son Dominic. In 1994, there were at least two storylines that saw the figure foundering in various difficulties, unable to fully direct his personal affairs. In the first, Gundlach as a single father was at the mercy of the child welfare agency of the state and repeatedly close to losing the child to a state home for children without two parents. Later, this was further complicated by Gundlach's abortive affair with a call girl, Ursula Berger. After first being attracted emotionally to Ursula, only to be rebuffed, he is then insensitive to the real affection that she develops. The relationship founders because he insists that it is a business one between client and call girl. This not only destroys the chance for personal happiness but also reopens his difficulties with the child welfare authorities. Altogether then, Gundlach is a much more interesting and ordinary, everyday figure and can be read as a critique of the god-like Brinkmann in *Die Schwarzwaldklinik*.

The not so God-like German doctor in **Gute Zeiten, Schlechte Zeiten**

To summarise the argument then, one might say that *The Restless Years*, *Goede Tijden, Slechte Tijden* and *Gute Zeiten, Schlecte Zeiten* are national not by dint of mirroring their respective societies as though the latter were a single, homogenous wholes. Instead these cultural artefacts stand in a complex relationship with larger social realities both receiving but also presenting them with representations wherein they might articulate themselves. The

Australian-ness, Dutch-ness and German-ness of these artefacts are always both obvious and banal, and also subtle and elusive, conservative and petrified yet progressive and challenging. Although seemingly trivial and everyday, they yet form or can form part of a much larger repertoire of images and practices generated in the media, popular culture, education, religion and elsewhere out of which social groups can fashion various cultural identities, including national identities.

★ ★ ★

The past four chapters have focussed in detail on particular format adaptations in two genres, game shows and soap operas. We have been interested not only in what is different between different adaptations of the same format but, especially, in just how these adaptations might contribute to a sense of particular national belonging. As was suggested in Chapter 2 and supported by the analyses in this Part of the book, television program formats in different genres support lesser or greater degrees of variation in translation. The 'short form' game show offers little space for registrations of differences that might be read as national whereas drama serials facilitate considerable variation to the point where the adaptation and the original have very little in common. In other words, the national patterning in the latter kind of adaptation is clear and striking. The recognition of this national patterning always involves readers and reading and we have been careful in this Part of the book to recognise this. The role of particular readers, ones familiar with the language and the culture, in deciphering the adapted texts has been emphasised, not least through the use of what we have called cultural translators. However, if individuals are, briefly, reading subjects so far as these adaptations are concerned, they are also historical subjects who bring various aspects of their past, including their pasts as national subjects to bear on the reading of these adaptations. The next Part of the book examines some of the wider social context of this process.

Part Three

National Audiences, Programs and Cultural Identity

'... no such thing as typically German': German Audiences and German Images

This chapter and the next are concerned with the question of how national television adaptations provide domestic audiences with particular sources of cultural identification between themselves and the nation. The conceptual aim was an initially modest one – to verify that, so far as some particular national audience segments were concerned, selected programs were read as national fictions. This turned out to be the case although, as we shall see, 'fiction' and 'nation' constitute a complex association and perceived nationality is invariably a subtle, mediated one. The research into connections between national fiction and domestic viewers revolves around four different drama serials, two produced in Germany and the other two made in the Netherlands. Because of various exigencies of the general research situation, most especially the fact that I am located in Australia, two different methods were adopted to facilitate the audience field work. German reception was documented using the survey questionnaire while data concerning the Dutch was generated through focus group interview. Before turning to the detailed findings of the field work, we can briefly situate this kind of inquiry in terms of recent work in the area of television studies.

Domestic Reception of Domestic Television Programs

Inquiring into the domestic reception of nationally produced television programs may seem like a redundant exercise, a case of bringing coals to Newcastle. However, not only is such a con-

sideration entirely within the logic of the present study, but it also has its recent precedents. Four studies can be cited here. The first was the five nation research project on the European response to *Dallas* (Silj 1988). As already discussed in Chapter 6, this study was concerned not only with the European distribution of the American soap opera but also examined several loose adaptations of the *Dallas* format, produced by television broadcasters in countries such as France and Germany. As part of the study, the investigators also conducted audience research in the national territories, finding that domestic audiences in a country such as France preferred their own versions of the *Dallas* format over the American original. The second study, relevant to the concerns of this Part of the book, also concerned *Dallas*. In a 'cross-national' study of readings of the serial, a joint American and Israeli project, an investigation was undertaken of 'ethnic' responses to the serial on the part of Israeli, Moroccan, Arab, Russian and Japanese audiences (Liebes and Katz 1993). To facilitate understanding of these foreign readings of the serial, the American program was also shown to a domestic audience. Focus group interviews were conducted in Los Angeles and two principal findings about American readings of this American serial emerged. First, the American retellings of an episode of the serial was symptomatic of what Liebes and Katz call a feminised culture. In addition, US viewers drew on an extensive cultural capital acquired in relation to American television. The third study, the most interesting and relevant research into national audience appropriation of particular national television texts so far as the present book is concerned, has been that conducted on the reception of the Welsh television serial *Pobol y Cwm* (Griffiths 1993, 1995). Here the audience research took the form of a series of ethnographic interviews with a group of Welsh students in a bilingual school in south Wales, the interviews following a screening of an episode of the serial that narratively opposed Welsh and English characters. Griffiths' aim was to explore the forms of identification that the students had with the serial and the extent to which they believed that it constructs and contributes to specific Welsh identity and discourse. Her overall conclusion was that this Welsh audience did indeed view the serial as Welsh, although that identification was always a subtle, shifting and complexly mediated relationship. As she puts it:

> Ideas and idea systems in *Pobol y Cwm* cannot in any simplistic sense be isolated or perceived as containing any 'commonsense truth' about 'Welshness' or what is understood by the term 'Welsh identity'. (1993 p 18)

In these three investigations – those by Silj and associates, Liebes and Katz, and that of Griffiths – there was a good deal of cultural congruence between audience subjects, the particular television programs and the researchers. Griffiths, for example, was Welsh and spoke that language, even though she conducted interviews in English. The last study is much more extraordinary in this regard. It concerns an ethnographic inquiry into the television consumption of Punjabi Sikh families in Southall in London and especially their

viewing of a 92 hour serial, *The Mahabharata*, a dramatisation of the epic story contained in one of the two holy books of the Hindu religion (Gillespie 1995a, 1995b). This serial was produced by Doordarshan, India's state monopoly television network and broadcast with English sub-titles on BBC2. For the Indian family that Gillespie observed, this television serial had a religious authority based on written sacred text, a foundational document of Indian culture, so that the family's 'devotional viewing' involved both pleasurable entertainment and the development of religious knowledge and understanding. Gillespie's research is groundbreaking in many respects, not least in revealing a dimension of viewing of national texts that is mostly unknown in the west.

Overall then, these four studies alert us to the fact that inquiry into the domestic reception of domestically-produced television programs is far from being a redundant and an empty exercise. Rather it is an indispensable first step in any investigation that seeks to call itself either cross-cultural or cross-national. National audiences are far from being homogeneous and domestic readings will be multiple, diverse, even contradictory, sometimes even reading programs as a-national. With this in mind, let us return to our own studies of domestic television reception of national adaptations.

The German Surveys

Qualitative surveys of the reception of two of the programs already discussed in Part Two – the serials *Verbotene Liebe* and *Gute Zeiten, Schlechte Zeiten* – were conducted in Germany in 1996 although the survey questionnaire was developed in Australia in the previous year. The latter consisted of 32 questions, both closed and open, that were especially concerned to offer respondents repeated opportunities to indicate a variety of ways in which the particular program was national. Although one question asked respondents to report on very recent narrative events in the serial, it was not possible to explore particular narrative situations that might have dramatically opened up questions about nationality in the way that Griffiths did through replaying particular past episodes to her respondents.

The survey questions were first trialled in Brisbane, further refined and subsequently used in New Zealand research into schoolchildren's responses to the New Zealand-ness of *Shortland Street* (Moran 1996). The survey form was then modified to allow research into comparable issues in relation to the two German soaps. The questionnaires were in German and were translated into English for the purposes of data analysis. It should, incidentally, be noted that when the respondents answered the open ended questions, many of them gave multiple answers and thus the numbers given for any one answer respond to the number of times the answer appeared. Similarly, the percentages given respond to the number of people who gave that answer as a percentage of the number of people who answered the question at all.

The majority of respondents to the two surveys were in the age bracket of 15 to 16 years of age and were female. The surveys were undertaken in

Hamburg, Mainz and Solingen, among teenage girls and boys attending senior or secondary schools, who were intending to then undertake vocational training rather than university study. Over 50 per cent of the respondents in these surveys were aged between 15 and 16 years of age with the rest spread from those aged 13 to 19 years of age. The students were given the choice of completing one or other of the two surveys. In the event, 79 elected to answer questions in connection with *Verbotene Liebe* and 126 choose the *Gute Zeiten, Schlechte Zeiten* survey, indirectly confirming the greater popularity of the latter serial. The overall intention of the survey was to substantiate that the students did see the programs as German. The object was to document some of the ways in which they recognised national colourings in these two programs. However, as I have already suggested, the kinds of national knowledges that audiences will bring to bear in viewing a popular cultural form include social and cultural knowledges. The latter are obviously interrelated in a complex and dialectical manner so that representations of Germany and its institutions are often subtly mediated between text, audience and the overall social context. Thus, unlike other popular forms such as situation comedy, mini-series and feature films, that often explicitly foreground questions of nation and the national, this kind of television drama is, for the most part, concerned only with the everyday lives of the characters with national elements so unexceptional and generally invisible as to be mostly taken for granted and therefore unremarked by its domestic audiences. At least that is one conclusion suggested by the survey. However, initially at least, the two serials were differentiated in that students were asked to select one or other of the survey forms and it is worth addressing the individual analyses in turn, before drawing some general conclusions.

Verbotene Liebe

Adopting an aphorism drawn from another national setting, we might begin with the point that for the survey audience there was no such thing as typically German, there was only German. Thus the students were aware that, for the most part, *Verbotene Liebe* did not trade in stereotypical images of German life so far as locations were concerned. Everyday life in Germany, as represented in the serial, involved characters moving through spaces that, while generally familiar, were not unique to that nation. As one of the students put it, 'there is no such thing as typically German – the flats, coffee shops, offices, discos look the same elsewhere'. Another student emphasised that the serial's limited number of location shots were symbolic of the country: 'from all areas – town and country (except industrial areas)'.

Not surprisingly, most respondents to the *Verbotene Liebe* survey saw the serial working in terms of narrative situations that were not nationally specific but instead were common to soap opera as a genre. Asked to identify these problems, some 47 per cent of respondents pointed to those to do with relationships as well as identifying elements that struck them as being either non-German or else indifferent to national interrogation. As soap opera, *Verbotene*

Liebe is both like and unlike serials from other cultures. Armed with this recognition, three of the students felt that the program would not appeal to audiences elsewhere, not because it was specifically German in its references but rather because it was 'too much the same' as their own and 'they have enough programs like that'. However, a much larger group, 18 of 49 students (36.7 per cent) who answered the question felt that the serial did call on national cultural capital, such that foreign viewers would not get much out of the program. Two of these mentioned that it depicted a 'different culture' and was 'specifically made for German Society'. Touching on perceived national styles of soap opera narrative, two other students felt it would be 'interesting for the English but not the Americans, it's too bitchy for the Americans' while the second wrote

> Well, we watch series like *Beverley High* or *California High School* ... why shouldn't the English speaking countries watch German soap operas? And it is almost the same anyway. If German people like it, English people will like it.

Reflecting both the bias of their age group and the fact that *Verbotene Liebe* is strongly oriented towards its younger characters, 15 of 42 students felt that the soap was popular because it was representative of young people across Germany. However other explanations spoke not of the nation or the national but instead focussed on personal issues and problems. Two answers did touch on questions of the German: one student mentioned that 'you can identify with the (German) actors' while another thought the program was popular because it was a 'typical German production'. Identification was also mediated by the play of textual elements such as the particular class and subcultures being depicted in a national setting. Issues of class and social position particularly came into play in survey responses in relation to *Verbotene Liebe*. As we have seen in Chapter 8, this serial depicts both an affluent middle class family and an aristocratic one. Not surprisingly, the students, who were generally oriented towards trades, felt a qualified identification with these characters. This became evident when the student respondents were asked about typical German traits depicted in the program. Among the behaviours identified were intolerance, small mindedness, stuffiness, ambition, inhibition, work addiction, the ability to inflate problems, the focus on money and work, vanity and arrogance. More specifically, for the students surveyed, the two fictional families were the focus of particular 'German' behaviours. Five thought that the Brandner family was representative and one in particular commented that 'it was the all perfect family who wanted to work, wanted to do well'. In addition, two students thought the 'Dusseldorf royalty', as yet another respondent described the von Anstatten family, were also archetypal.

Of course the serial is both a fictional text and a nationally representative document and the play of these two elements further complicates the interaction of identification and disbelief. Responding to the accents to be heard in *Verbotene Liebe*, twenty-nine students, over half those who responded, felt that these were very German. Four noted that the accents were high

German. In turn, three of these respondents, considering the spread of this accent through the general population, thought them to be 'very unnatural' although the other respondent, focussing on the fictional nature of the serial, believed this accent was appropriately typical of the upper classes in Germany. Yet another student hinted at the same perception, noting that, at times, the characters sounded 'stuck up' but felt this was typical of the class and the age group of the characters.

With its particular class emphasis, the serial clearly ignores much of the social order. To amplify the sense in which *Verbotene Liebe* is a national fiction, the survey therefore asked about the social elements of German society that were missing from the serial. Of course there is a fine line between what *Verbotene Liebe* might depict and remain the same serial and what would transform it into something else. Nevertheless, the answers are valuable indicators of some of the ways that the respondents saw the program as being German. Thus the survey noted that the least common group to appear was 'average people'. Many social groupings existing in Germany as well as elsewhere were noted as absent: these included the unemployed, the mentally ill, the poor, alcoholics and drug addicts, the homeless; street kids; and old people. Reflecting on the rise of far right wing groups in Germany, three students listed neo-Nazis and political extremists as absent while another mentioned skinheads. Clearly, these exclusions are deliberate and indicative of the fact that while the serial is German it does not seek to be explicitly representative or realist. Finally, we can note that the survey observed that *Verbotene Liebe* had a complex, even contradictory relationship with older and more stereotypical images of the German people. Four respondents mentioned the absence of beer drinking Bavarians, southern Germans and East Germans. More astutely, one student noticed a particular ethnic emphasis, citing 'people with black hair' as an absence in the serial. The claim is an exaggeration, although the perception is based on the fact that there is a significant number of blonde haired characters in *Verbotene Liebe*.

Gute Zeiten, Schlechte Zeiten

In general, the students surveyed were unhesitating in identifying *Gute Zeiten, Schlechte Zeiten* as a German serial. The double designation – German serial – is important because the students were clear that the program was not a documentary film that attempted to reflect Germany and the German people in a faithful and realistic way. Instead the program was a fiction with its own generic norms and conventions so that the ways in which it might be said to be 'about' Germany were always going to be complex and multiple. Nevertheless, despite this mediation, it was still possible for the respondents to identify several ways in which the connections are secured.

Asked whether there were German elements in *Gute Zeiten, Schlechte Zeiten*, the students answered positively. There were indeed various German touches at work, even though the responses mostly identified different

signs of this German-ness. Among those cited were: 'stuffiness'; 'cunning'; 'no sense of humour'; 'ambition'; 'selfish'; 'helpful'; 'career minded'; 'vain'; 'liar'; 'wanting an ordered life'; 'reliable'; 'unforgiving'; 'superficial' and 'very conservative'. Overall though, language was recognised as the most common German element. Language is a central component of culture and questions as to whether the program would work for non-German audiences if it were dubbed or subtitled elicited a negative response from over a third of students. One respondent pointed out that *Gute Zeiten* depicted a German lifestyle and the dubbed language and this lifestyle 'would not go together'. However, although the language used in the serial is German, especially when considered in relation to other national languages, it was, at the same time, a language that was in various ways different to that spoken by the respondents. Two thought that the way the characters spoke 'seemed very unnatural', eight felt it was very proper German. Several went further and suggested that this was an artificial convention:

'They talk very proper German and also without any mistakes.'

'No. They don't talk like this in real life.'

One other student hinted at the same perception, noting the absence of Bavarians in the serial and therefore the distinctive dialect associated with that region.

If language is a typical German feature of the serial, albeit in a qualified way, then there were other elements that the students pointed to in terms of the Germanness of *Gute Zeiten*. Some of these were incidental details, although again cumulatively these are important in Germanifying the program. Aryan characteristics were noted: three students pointed to blonde hair as emblematic of this German-ness while a different three noted the presence of blue eyes. One student saw continuities between the (German) characters and the domestic audience, noting that the characters were 'people like us'. Four students thought the businessmen were typically German. Clearly this range of answers indicate that the students were more unanimous in appropriating *Gute Zeiten, Schlechte Zeiten* as a German program than they were about precisely what particular elements were German. Elsewhere in the survey, there was more agreement about the different ways in which the program is German.

Most answers agreed that *Gute Zeiten, Schlechte Zeiten* did not trade in traditional and familiar images of Germany and the Germans. Depending on one's point of view, such images were either an essential ingredient and a guarantee that the program was German or else a cliche and stereotype that was better avoided as a way of generating a more contemporary representation of the nation. As an instance of the first attitude — and also as a striking revalorisation of the mythical association between Romanticism and Nationalism — we can cite the response of one student who was critical of the program because it did not show the German countryside. More

muted echoes of this attitude could be found in complaints about the minimal amount of location filming in the 'real' Germany:

> 'The outside surroundings are not very German.'

> 'You hardly ever see any scenery.'

On the other hand, several students had a much more positive attitude to the absence of these traditional images. Three students (4.9 per cent of those who answered that particular question) felt the program broke with stereotypical representations of Germany:

> 'Normal people are shown. The typical German clock maker is not there.'

> 'Yes I believe so because usually everybody imagines the Germans in lederhosen or in little mountain huts and this series shows the normal life.'

A third mentioned that the serial did not depict radical political groups 'which is good because a lot of people think that all Germans are right wing extremists and this is not true'. Instead as another respondent put it, 'it would let people know about the German way of life and how young people live in Germany'.

However, if the serial is not concerned with German stereotypes, then – the reverse side of the coin – it can become more difficult to be certain just where what is specifically German ends and what is more cosmopolitan begins. The last response puts a finger on this, alluding to youth culture which is both German and international. Many responses to different questions conveyed this impression of German life being steeped in a cosmopolitan consumer culture which while part of German everyday experience was not unique to that society. As we shall see, it was evident in the perception that *Gute Zeiten* as a soap opera had many features in common with soap operas from elsewhere. The same perception registered in answers about the kinds of figures portrayed in the serial. The poor, it was repeatedly noticed, were a notable absence although that amorphous category appeared under a series of different names such as old people or pensioners, the unemployed, the poorly educated, beggars, immigrants, foreigners and the disabled. Many registered this elision and some grasped connections between their absence and consumer culture. According to one, the only groups shown were those who were always 'well dressed … with proper makeup'. Yet another student noted that 'people who cannot afford fashionable furniture' were not depicted and neither were those who were 'not set up for the future'. Elsewhere, one student, who described the flats as 'normal', went on to point out that 'they looked like they were out of a furniture catalogue' while another noted that public eating places were 'expensive restaurants'.

At the same time, this complex sense of a national/international continuum was further mediated by the awareness that the serial was fiction and stood in a complex intertextual relationship with other television serials, including those in other countries. Four people (7.4 per cent) questioned that there

was such a thing as typical German. As one of them put it: 'what is typical German? Hopefully not the people in this series'. Two went further: 'The people are not at all like Germans, but maybe a lot like the people would like to be' and 'nothing is really German. They act the same way as anybody somewhere else. Just trying to solve the problems like every human would'. One student thought it was 'a typical soap which portrayed characters who were rich, successful, beautiful and cool, same as in *Dallas*, while another made the same point about generic intertextuality, adding 'you could show the same show in any other country'.

Several others displayed this same awareness that *Gute Zeiten* was a cultural artefact with both industrial and textual dimensions. One of the students claimed that the anonymous setting of the fiction was deliberate so the program could be exported. This sense of an international industrial and cultural context for soap opera provoked a range of responses ranging from the perception that *Gute Zeiten* was a German imitation of what was a non-German genre through to the conviction that the serial was a German example of a pan-national genre. Several students were of the first persuasion. One, who had obviously watched foreign soap operas on German television, felt it was more typical of America or Australia while another, aware of the program's origins as *The Restless Years*, believed that it would work elsewhere if dubbed, because the 'show would have originally have been from Australia'. Yet another saw the serial as part of an international continuum: 'the series is really successful in Germany along with English and American shows'. The second view – that the serial was a German example of a pan-national genre – was suggested by one student who wrote that it would be popular in other countries because *Gute Zeiten* had correctly observed the conventions of the genre: 'Germany had many soaps from other countries and the problems (in this serial) were always the same (as these others)'.

The social context (and therefore the national context) of the serial's narratives, situation and characters as well as its audience also made themselves felt. One student believed that there was a national context for *Gute Zeiten, Schlechte Zeiten*'s popularity: 'It starts problems and then it solves them and our politicians and everyone else would like to be like that'. Another thought it was popular in Germany because it avoided dialects and therefore a regional bias. However, at least one student brought specific knowledge about the production situation of the serial to bear. Anna, aged 17 years of age, thought the show was popular because it was set in Berlin and clearly reflected the characteristics of people there. However the recognition of place is always a difficult and complicated matter. Despite this apparent recognition of Berlin, most registered an anonymity of place in the serial. Several thought the town was 'typical' although they did not attempt to name the town. One student did though cite Cologne as being a typical German city, the type of city depicted in *Gute Zeiten*.

There were further references elsewhere to the industrial dimension of *Gute Zeiten*. As an industrial artefact, the program is broadcast regularly each

weekday evening for the same amount of time and thus helps its audience set domestic routines in place. One student had a particularly strong sense of a dialectic of domestication between serial and audience: 'You can identify with the actors. It is part of the daily routine. You know the people. You get grumpy with them, you talk to them and if they are afraid, you are as well'. Two other students registered this same reality in yet other ways. Asked if the serial could have been produced elsewhere, one replied: 'No, because it takes a lot out of it if they use different bars, pubs, business and restaurants' while the other felt that it would not survive dubbing as 'it is a series played in Germany, the actors are German and it is made for German viewers'. Finally, we can cite yet one other respondent who was also sensitive to the social (national) context of viewing: 'they always solve the problems very quickly and the whole of Germany is dreaming about solving problems in a quick way'.

★ ★ ★

Clearly these surveys are useful in beginning to explore some of the ways that particular programs – in this case adaptations of formats first developed elsewhere – serve to articulate a Germanness of sorts for a segment of the national audience. However, there is no doubt that the finds reported here deserve much thorough exploration both in terms of fuller, more extended answers and also in terms of looking at other audience segments including other German-speaking peoples from other countries. What, for example, do particular groups of Austrians make of these two adaptations? That level of inquiry was obviously beyond the scope of the present undertaking. However it was possible to press the investigation of the domestic readings of national adaptations a little further. The second part of the audience reception field work concerns responses of Dutch subjects to two adaptations and it is to these findings that we turn.

'... not just a country with windmills, dykes, clogs, canals, tulips': Dutch Soaps and Dutch Audiences

Like the previous chapter, the present chapter is concerned with the issue of how television format translations provide domestic audiences with particular sources of national belonging. Again the case studies are indicative rather than representative, concentrating as they do on two small segments of a national population. Again, selected programs were read as national fictions, although as we shall also see, geography, culture and media are by no means symmetrical. Responses elicited from two Dutch groups in relation to Dutch soap opera adaptations richly illustrate the extent to which these promote certain ideas and values over others, and produce specifically Dutch discourses. However the focus interviews also opened up fertile veins of personal biography and history that allows us to begin to grasp how everyday life is an important middle ground between media representations on the one hand and national identity on the other.

Benedict Anderson has recently emphasised the combined role of transportation and communications in fuelling issues of nationality in the contemporary world (1992). He points to the way that these technologies have combined with recent economic and political developments in bringing about an unprecedent movement of peoples across national boundaries, whether as refugees, workers or tourists. This point was illustrated in the circumstances of the research situation of Dutch audiences for domestic soap operas. Using a network of colleagues in the

Netherlands, I had arranged to have relevant Dutch television programs recorded off air and sent to Australia, thereby accessing truly domestic programs. The interview subjects were part of what might be called the Dutch diaspora, an element of the Dutch nation found in countries outside the national territory, consisting in this instance of settlers and travellers. The research strategy employed was one of screening two episodes each of *Goede Tijden, Slechte Tijden* and *Vrouwenvleugel*, and following this by focus group interviews as defined by Merton and Kendall (1955). Working with a research assistant, I had identified key concepts such as representation, narrative and ideology and we attempted to trace responses relevant to these, especially as they touched on our overall concern. The conversational situation of the interviews could allow individuals to articulate their concerns on their own terms. The settler interviews took place at three different meetings with a mixed group of about eight people, held at Brisbane's Dutch Club, with a high degree of overlap between those present on each occasion. Similarly, the interviews with the travellers consisted of three sessions with slightly smaller groups, generally about six girls and boys, held in an open space at a migrant resource centre in inner-city Brisbane. Again, there was some overlap between these three groups of travellers, although most only attended one session. All sessions with both settlers and travellers adopted the same pattern of viewing extracts followed by open-ended discussion.

The Dutch Settlers

The settlers were Dutch migrants who settled in Australia in the 1940s and early 1950s. As Dutch-Australians, these had a number of cultural resources for fostering and sustaining a Dutch identity: these include a Dutch social group, special national events such as a Holland Festival held annually on a weekend in September, their own language radio program, a local Dutch language newspaper, a steady circulation of Dutch films and television programs on videotape, visits from Dutch relatives as well as their own occasional trips to the Netherlands. One man, a radio enthusiast, even listens to Radio Netherland on short wave. The location of many of their social activities, the Dutch Club, had been built and was maintained through their own fund-raising and was a kind of Dutch oasis on the outskirt of the city. A picture of Queen Beatrix hung on the wall in the foyer, the main area was the Tulip Room and the walls were adorned with posters and pictures – some supplied by KLM – that featured windmills and canals. Govert Harmsen, the older character in *Goede Tijden, Slechte Tijden*, referred to in Chapter 9, would have been entirely at home in such surroundings. With many of them now close to retirement, all the settlers had revisited the Netherlands, often on more than one occasion, and had frequently stayed for several months at a time, sometimes finding jobs for the period of their visit. If they finally chose to remain in Australia rather than resettling in the Netherlands, this was, in part, because their children had grown up in Australia and, in part too,

because the Netherlands had grown away from what they remembered. Nevertheless, they saw themselves as Dutch, belonging to the Dutch Club, frequently speaking their own form of their native language, at least in each others company. Thus, while in many of the other rounds of their everyday life – in terms of the language they spoke, the neighbours and friends that surrounded them, the media they used and so on – they were Australian, for at least the several hours of our video viewing and subsequent interviews they were Dutch.

One particular feature of the field situation with these settlers should be mentioned. The screenings and discussions had been publicised both at the Dutch Club and on the Dutch language radio program and the interview subjects had volunteered to participate. Nevertheless, several were quite puzzled by the situation they found. Although the nature of the material had been indicated, together with our purpose, several of these Dutch settlers had, all the same, come along, hoping to watch good quality Dutch television programs and were disappointed, even offended, at the choice of soap opera. In addition this also confused them about the purpose of the interviews. The complexity of my role as national outsider, researcher, invited guest of the head of the Club, university lecturer, and a non-Dutch speaker, cannot be ignored in any analysis of the findings. Moreover, several of the settlers were anxious to ensure that my perceived research needs were met and sometimes offered 'approved' answers. In any case, it should be remembered that these settlers had truly become bi-nationals and thus while they could understand the Dutch dialogue and cultural references, nevertheless, at other times, they stood outside the programs' address, drawing on an Australian frame of reference. There was much talk of the cultural differences between Australia and Holland, alternatively praising one and castigating the other. In such moments, the settlers displayed the fact that they were Dutch-Australians. This kind of reading position was clearly evidenced in the discussion about the coarse language in the two serials, especially in *Vrouwenvleugel*:

> Wim: 'The dialogue was very modern compared to what we are used to. They were using words and expressions that we would never think of using. Which made it more natural but coarse. The words are very hard to translate in English. They are so typically Dutch'.

> Joop: 'Well it's that the standard of conversation on the Dutch television is well below the standard that they used to have when I left. And it is below the standard that they allow here on TV. … The censorship here is a lot higher for the language than what it is over there. Thats what I notice … Two years ago I was in Holland and we watched the TV then and we were actually shocked at some of the things they say on TV. You hear it on the street or on the job site, a building site or anything like that but you dont hear it coming into the lounge room. You know. I mean … I'm not saying that I'm from the upper class or something like that … Any way we were not used to them using that sort of language'.

Elisabeth: 'Times have changed over there, just as they have changed over here. Like on the ABC you hear someone else call some one else 'bloody bastard'. But in the olden days when we first came here you would not hear someone called that. We cannot expect Holland to stay still in its language and Australia to progress'.

As this exchange suggests, the group of Dutch settlers was not entirely homogeneous. Elisabeth and her friend, Liddie, frequently adopted feminist attitudes, especially about the position of women in the Netherlands, a view not shared by many of the settler men and their wives. Triggered by an incident in *Goede Tijden, Slechte Tijden*, an issue arose around the fact that in the Netherlands a womancould initiate conversation with a man without the man thinking that it had any undertones. Elisabeth and Liddie saw this kind of tolerance as a positive feature of Dutch society and linked it to the tolerance of earthy language. For the men and their wives on the other hand, the relatively recent increase in swearing and vulgarity in the Netherlands was a sign not of tolerance and changing social norms but an indication of a deterioration of communal attitudes.

Overall, this group had a good deal of trouble in identifying with the two soap operas. There were at least two factors at work. On the one hand, many of the settlers present at the sessions were men and they evinced little sympathy for what is usually thought to be a woman's genre. On the other hand, these programs did not follow the kinds of conventions of documentaries and feature films from the Netherlands that are sometimes screened on the SBS television network in Australia, programs that might be described as pictureesquely Dutch. Thus, after one videotape screening, one man immediately indicated his hostility, declaring that 'the movie was crap, Dutch crap'. Another man, Joris, went on to explain what a Dutch television program should look like:

On SBS TV … they've been showing a series. *Iris* they called it. Now if you were looking for a Dutch picture, they had a typical..lot of Dutch landscape, lot of Dutch houses in there. And that was really Dutch. This one here, (it) could have..(been).. done anywhere, you know. If you were looking for a Dutch movie, I would wipe this off as a Dutch movie. I've seen things up here in Brisbane Australia that runs along similar lines.

Asked how he would produce a Dutch program, Joris replied that he would centre on a girl, have her go to college and pass a windmill on her way: 'You might show a scene in Amsterdam with a real old building. Similar lines, to make it look Dutch'. However once again, there was a discordant note. Elisabeth disagreed about this kind of representation, objecting to the Netherlands being portrayed in stereotypical terms of 'windmills and clogs'.

As already mentioned, most of the settlers had an aversion to soap opera, and none had seen these programs before (the exception was Johan who had a

small business concern selling copies of programs taped off air in the Netherlands to the Dutch community in Brisbane). Nevertheless, the settlers found that, despite these prejudices, they were soon drawn into the different storylines. They enjoyed listening to the characters speaking to each other in Dutch, even if they were aware that speech, especially in *Goede Tijden, Slechte Tijden*, was somewhat artificial in being relatively free of accent and dialect. Similarly, they also noticed small details and references that help make every-day life in the Netherlands subtly different to what it is elsewhere. Living in a different culture helped them to notice things in these two Dutch serials, such as the fact that the Dutch gave flowers as gifts but without wrapping them, the fact that the characters appeared to only drink coffee and never tea, and the ritual of three kisses on the cheek being the accepted form of greeting between family and friends.

However, everything in the two serials was not inevitably natural and famil-iar. In Chapter 9, we quoted the remark of Olga Madsen, the first producer of *Goede Tijden, Slechte Tijden* to the effect that the serial has been very impor-tant in helping to give Dutch people the opportunity to hear such expres-sions as 'I love you' in their own language. However, many of these older Dutch settlers found this linguistic development to be 'unnatural'. One fur-ther element at work here was the realisation, common to many of the set-tlers, that they were watching fiction. Thus, they were frequently unsure whether some of the textual details that they noticed were a product of the Netherlands or a product of television. For example, faced with the fact that the women prisoners in *Vrouwenvleugel* wore their own clothes, often jew-ellery and make up, the settlers were unsure whether this was a fiction of the serial or something that was now accepted in at least some Dutch women prisons. Indeed one of the women settlers became sufficiently curious about this point such that she intended writing and asking her brother-in-law in the Netherlands who worked in a prison. Similarly, the settlers recognised that drugs were hardly unique to the Netherlands, although the more tolerant attitude of government, police and others was much more characteristic. However one of the settlers, Herman, felt that this was television not 'real life and you could not tell from this'. He mentioned the serial *Spijkerhoek*, where drugs were sold but 'if you see how they sell drugs, in it, its like noth-ing else in real life'.

Of the two serials under present consideration, it was *Vrouwenvleugel* that generated most interest among the settlers. This was not surprising, given the fact that this program had greater appeal to older viewers in the Netherlands than did *Goede Tijden*. The prison serial, which features a more limited number of regular characters and more immediately recognisable sit-uations, was probably also easier to follow and therefore generated more interest. Language – at its coarsest in *Vrouwenvleugel* – has already been men-tioned but the settlers also registered the multicultural nature of this pro-gram. This feature was seen as a policy of the Dutch government which included equal rights for gays and lesbians:

Elisabeth: 'It (the representation of lesbian style by Teun) was typical the way she portrayed it. The hat and the mannerisms. I thought she made the film interesting. Yes'.

Maria: 'Well it means they have to put those in. You know they are not allowed to discriminate against homosexuals. It's compulsory. They have to put them in a movie like that. You know, I think they have to have their quota of homosxuals in the movie otherwise they feel they're discriminated against. So they insist there that the movie reflected too the role of the multinational society, as it is now. Because these things happen. And they actually get subsidies for doing what they are doing'.

However more central than the representation of sexuality in the serial was the construction of ethnicity. Here the settlers noticed the far greater incidence of black and coloured peoples in *Vrouwenvleugel* as against *Goede Tijden, Slechte Tijden*. However, in responding to the ethnic presence in the former serial, the settlers tended to disagree as to how Dutch government and other institutions in the Netherlands handled this issue. As Dini put it:

But we had the colonies you see. In the West Indies. And after the War those people came to the Netherlands. Because the social services were finer. They had Dutch nationality, you know. And now you have all colours. It's tolerant. There's not that much discrimination.

However, the group was far from unanimous that ethnic tolerance had completely triumphed in the Netherlands. Anneke noticed that Julia who was white was having a child to the black guard David and wondered whether the child would be black or white:

To me the interesting part was whether it would be a black baby or whatever. All these things had mixed… That the Dutch people had trouble with the… a grip on the dark people. The undercurrent was there all the time. 'Oh, can you tell me whether its going to be a dark baby?'. Yes. A race thing. Dutch people have much trouble coming to grips with that. More so than other nations.

The Dutch Travellers

The second segment of the Dutch audience was composed of a number of young backpackers from the Netherlands. These were visiting Australia with temporary work visas, which enabled them to have an extended stay for anything up to a year, alternating between paid casual work and sightseeing. Most were around 20 years of age, all had left school and some had begun trade apprenticeships. Their trip to South East Asia, the Pacific and Australia represented a brief respite between the end of school and study and the beginnings of their working life and adult responsibility. Only one girl, Marilla, varied this pattern in that she was an exchange student who had interupted her law degree at the University of Amsterdam and was under-

taking law courses while in Australia. Marilla also varied the pattern in that all the other travellers were from smaller Dutch cities and towns while she was from Amsterdam. The travellers were contacted at various hostels and agreed to take part in the viewing and discussion. Like the meetings with the settlers, the screenings and interviews with the travellers consisted of three sessions with mixed groups of six. We met first for a meal in a Vietnamese restaurant and then adjurned to a nearby migrant resources centre to have coffee and watch the programs. The meal was both a necessary enticement but also useful in enabling everyone to introduce themselves.

Unlike the settlers, the travellers knew both programs although only one boy, Martin, actually watched *Goede Tijden, Slechte Tijden* on a regular basis. Still, the others were quite familiar with both, sufficiently so in one instance for the group to spontaneously sing the theme song of *GTST* in a comically nationalist gesture. And in a further gesture of national solidarity, another group labelled themselves as 'Dutchies', a name appropriate to their situation not only as nationals of the Netherlands but also as travellers in contact with other national groups with their own nicknames such as Yankees, Aussies, Pommies and so on. Although the research situation as well as the circumstances of their travel tended to unify them, nevertheless, it is worth remembering that these travellers were not necessarily representative of the population of the Netherlands as a whole or even representative of the youth audience for Dutch programs such as *Goede Tijden, Slechte Tijden*. They signalled this heterogeneity in a discussion of whether the two programs were watched by the same audience in the Nederlands or whether they attracted different viewers. Confirming the impression of Madelaine and Sascha, reported in Chapter 7, Herbert mentioned that his mother watched *Vrouwenvleugel* although she 'hated soaps' while Kim thought that that serial was for the 'housemothers'. Several of the group then elaborated on the social context of watching *Goede Tijden* so far as some of its younger audience was concerned:

> Cindy: ' I watch *Goede Tijden, Slechte Tijden* and most of the people that we claim as our friends – they go to the same pub in the Hague and they get all the same people out of the same pub... most of us went to high school. Friends of mine went to high school. So its always fun to see those people'.

> Matthijs: 'Yeah, its also a better time – after dinner or during dinner ('Yeah, yeah' from two of the girls). So I'll watch it'.

> Ilya: ' Yeah, it's on every day. This (*Vrouwenvleugel*) is only Friday night? This is on every day. Next morning or ... 'Shit, what happened? What happened?' Conversation. And it's easy to understand ... it's Dutch. Although their acting is very bad' GENERAL LAUGHTER.

However even more important than the fact that social differences in Dutch society might register in the choice of different programs that groups might watch is the fact that the Netherlands is a multi ethnic society, the result both

of past colonising and more recent labour needs. Ethnic difference is present in *Goede Tijden, Slechte Tijden* and a conscious theme of *Vrouwenvleugel* so that it was inevitable that the issue would arise in the course of these discussions. The travellers mostly ignored the point that the latter serial constituted a plea for racial tolerance and equality. Instead, they read the fact that many of the characters had strong ethnic backgrounds as a direct reflection of life in the Netherlands in the present. Indeed one girl, Cindy, putting the cart before the horse, saw the presence of the Surinamian, Turkish and other characters as an outcome of the Dutch government's general policy of guaranteeing work and other social amenities to these groups, thus resulting in actors with ethnic backgrounds gaining roles in the serial. In any case, for the travellers, the multiracial composition of *Vrouwenvleugel* highlighted the ethnic issue as a key political problem in the Netherlands with the rise of right wing groups. As Peter put it:

> By the year 2000, the country will be 50–50. It's a big problem. Lot of political groups say we are full. One political group says Europe is for Europeans and Holland is for Dutch. They are a very dangerous group. They have more and more votes. It is violent. You can't be in Amsterdam late at night.

However, while they were prepared to read these serials on this occasion as though they were documentary reports on current social conditions in the Netherlands, elsewhere they saw the same material in more conventional terms. As textual representations of cultural differences, they felt that this kind of television program was not as clear a register as was available elsewhere. After all, these serials were not produced for the international market. Aware of this, the travellers were concerned to draw our attention to what they saw as more internationally famous films that had originated in the Netherlands:

> If you get movies, Dutch movies … a lot of them shot in Amsterdam. You really see Amsterdam. A lot of green parks, a lot of statues. You really know Amsterdam. Movies, movies – it's great to see where it is. But series are generally made in a studio … You ever see a Dutch movie. A cinema movie and there's always lots of sex. Always big sex parts in it. And lots of swearing, spewing and sex … Do you know that movie *Amsterdam* … there's everything in it. Sex, rude words … Also *Turkish Fruits*, one of our first Dutch soft porn movies. See everything. You can hear all the sounds. Expressions on face, the breathing. Its all there – just a soft porn movie … We've got another, a Dutch comedy. That's a comedy for kids and growing up adults. And that's got lots of sex, tits, everything. Having sex in bed, but covered with sheet, very detailed.

The travellers showed a high degree of sensitivity to the programs, identifying the various accents to be heard and the regions that they came from, both in the Netherlands and elsewhere. In addition they also showed the same cultural sensitivity to character names and the regional origins of various

names. Herbert, for example, thought that Akkie, the woman officer in charge of the prison in *Vrouwenvleugel*, was a name from the north of the country while Jaantje was a typical older name in Amsterdam. Nevertheless, while some of the dialogue in this series in particular provoked a good deal of pleasure, it was by no means the case that these young Dutch people had a simple, affirmative attitude towards Dutch television. Rather they were aware of distinct class and regional differences in the Netherlands and this could powerfully affect the extent to which they might identify with particular Dutch programs. This was especially the case with the accent that is common in Dutch television generally and is the preferred one in *Goede Tijden, Slechte Tijden*. Many of these backpackers felt that this Hilversum accent was not part of the linguistic community to which they belonged. As Herbert put it:

> Somebody started complaining about people featuring on Dutch television because most of the broadcasting is done from Hilversum. And those people up there are a little bit high society. And you can also hear their accent … And they've got a childrens program every Christmas. And the children sing songs for the Third World … You can really hear they are from that part. And thats annoying a lot of people … It sounds stupid as well for me and for everybody to hear about 'Kindred Spirits'. Aw yeah, you are on about kindred spirits. Aw yeah.

A second linguistic disjunction registered around yet another Dutch accent although on this occasion there was laughter rather than hostility. During the viewing of *Vrouwenvleugel* several of the travellers chuckled, the laughter being provoked by a particular Amsterdam accent that was now both familiar and strange. Asked about his laughter and whether the dialogue had been funny, Martyn replied:

> No, not really. Not humour. The real typical Dutch things. We wouldn't laugh about it when we were at home, but for me its been nine months ago. The real … Some of the women. The accents that those women had, its real Amsterdam accents. It just makes me laugh now because it sounds funny now. When I was watching this at home.
>
> Cindy: 'because it sounds normal then'.
>
> Several others: 'Just normal'.

If the travellers noticed the play of cultural differences in these programs, they also remarked frequently on the ways in which the serials were faithful to the patterns of everyday life in the Netherlands. Thus, like the settlers, the travellers were struck by the fact that the women prisoners in *Vrouwenvleugel* could wear their own clothes and jewellry and appeared to have some freedom in the prison. But generally though, this group was no more certain as to whether this was an accurate representation of conditions for women in Dutch prisons or whether it was a fiction adopted by the program.

Martyn: 'My first impression', the first thing I thought was the women wearing their own dresses and jewellery. Can't be true! Unreal. I think that when you go to prison the first thing you do is put on a uniform.. The old lady Jantje, she was wearing her Grandma dress, wearing necklaces. And the other girl who just walked into the prison room, the black girl. Aw no, she was going to see the black girl. But she was wearing earings. All that kind of thing'.

Indeed Matthiasjs, one of the travellers, was of the opinion that Dutch prisons were like 'hotel rooms'. However one of the girls, Ilja, had actually been in prison over a driving offence and pointed out that although you can take your own clothes and other things, nevertheless the punishment of prison lies in the deprivation of liberty.

The use of crude language in both serials fell into the same category of being an accurate representation of linguistic conditions in the Netherlands. On the one hand, several of the travellers felt that it was especially appropriate to *Vrouwenvleugel* because 'they are rough women like that and have criminal records'. But on the other hand, they also saw this language as symptonmatic of modern everyday expression in the Netherlands, especially among the young. Told that the settlers were also seeing these programs, they thought that they would be offended and also 'you Australians – you would be shocked'.

Finally though, we can notice that, if some of the elements in the two programs were seen as being either specifically or generally representative of conditions in Holland, other features were ascribed to conventions of the soap opera genre, although again on some occasions they also registered them as Dutch inflections. As far as the general *mise-en-scène* of *Goede Tijden, Slechte Tijden* was concerned, the travellers felt that there was nothing exceptional or particularly Dutch about it. The Alberts kitchen was very contemporary but this reflected the general affluence of that family rather than the Alberts' country of origin. Similarly, the Kelder household, seen in early episodes, was symptomatic of a more working class household. Indeed, as we noticed in Chapter 9, it is only Harmsen's kitchen that is 'Dutch'. On the other hand, the school, seen in early episodes of the serial, was more 'typically Dutch' – 'wooden doors', 'glass', 'co-educational' as well as students on foot and on bikes. The characterisation, they thought, fell mostly inside the general conventions of the genre although, on occasions, some of the characters could be seen as Dutch. Thus, Cindy believed that Wimpie, the homosexual son of Nel, who saw nothing strange about being in a relationship with two other boys – 'you see that in Holland too, especially with gays'. In a similar vein, Martin felt that 'the thing that is really Dutch is the old lady (Jantje) with the handbag. She takes her handbag everywhere. ('Yeah, yeah' from the others). When she's walking outside she has got this little scarf. And thats really Dutch – when you go out into the street'. Similarly, in *Vrouwenvleugel*, the travellers noted another element found in the Netherlands. This was the coffee bar that also sold beer and drugs, a convention far more common in Amsterdam than elsewhere in the country. As we have already seen, this bar

is the location for the story of Mia, Snoose and Charlie, including the murder of the latter. This kind of bar advertised with a 'little green plant sign in the window' and was 'kind of a sleezy type of bar'.

Altogether then, the travellers showed themselves to be more attuned to elements in the two programs, most especially those that related to contemporary popular culture in the Netherlands, than did their counterparts, the settlers. For example, they knew, from first hand experience, about prevalent attitudes towards homosexuals and drugs in their homeland and had a far more tolerant attitude towards the coarse language to be found in both serials, especially *Vrouwenvleugel*. However, in other areas, such as government ethnic policies and prison conditions, they were hazy and unclear just as were the settlers. Overall though, this investigation of these two segments of the Dutch television audience certainly confirmed the fact that the adaptations were indeed Dutch and were obviously read in this way by these groups.

★ ★ ★

The past two chapters have drawn attention to an important link in the relay between television program formats, adaptations and national identity, by focussing on particular national audience segments. As some of the findings reported in this and the previous chapter suggest, national populations are far from homogenious and different segments bring a different *habitas* to bear in their reading and use of national television programs that result from adaptations. Clearly, cultural identity, including national identity, is not so much contingent upon an individual episode of a television program or even a television series as a whole but on a much wider range of cultural texts. If this Part of the book has implied the need for more intensive ethnographic research on audiences' readings of adaptations, it also raises the need to consider a more extended context of viewing that involves other genres of programs, including news, documentaries and situation comedies. But even that inquiry has to be considered more broadly. As we have seen in this last Chapter, and also touched on in chapters 7 to 9, television viewing is itself only one part of a repetoire of cultural resources that fosters and maintains national identity. In a national setting, these resources are often so pervasive and taken-for-granted that it is sometimes difficult to begin to specify them. Here, however, there is a strong clue in our description of the Dutch settlers living in Australia who were the subject of the first part of this chapter and the meagre cultural resources that they have assembled in order to foster and maintain their Dutch sense of belonging. Obviously, television format adaptations are only one small link in the chain that binds viewers in a national community but equally obviously it is an important link all the same.

Part Four

Further Reflections

Television Format Adaptation and National Identity

The previous chapters have documented significant features of television industry practice so far as program format adaptation is concerned, They have also opened up the complex social question of the role played by adaptation in the circulation of national representations. Summarising the results of the inquiry, we can ask just what is the larger significance of this kind of cultural transfer and what lessons does it contain for questions of the nation and national identity?

One way in which the larger meaning of cultural transfer and translation might be registered is through historical inquiry. There are certainly precedents for the practice of television program format adaptation to be found in such phenomenon as cover versions of recordings in the music industry and the adaptation of successful book, newspaper and magazine formulas in different parts of the world. Indeed, the roots of this kind of transfer are probably inextricably linked with the development of culture industries themselves, after the invention of the system of mechanical reproduction. Febvre and Martin note that, following the development of printing in the fifteenth century, the first printed book to appear was the Latin Bible (1976). However, Latin was only understood by a small proportion of the population of Europe. To increase sales, publishers therefore had the Bible translated into several vernacular languages associated with particular regions of western Europe. This had the effect not only of increasing the sales of the Bible but also in standardising these vernaculars and making them national languages. (Anderson 1991)

A more complete historical inquiry into cultural transfer and translation in the culture industries must, however, be postponed

for the present. Instead, what can be canvassed are some ways in which this kind of transfer might be theorised, together with some further remarks about notions of national identity. The remainder of this chapter takes each of these issues in turn. The first part examines three ways in which the phenomenon of transfer, in this case that of television program format adaptation between one national television system and another, might be theorised. The second part of the chapter returns us to the notion of cultural identity. The emphasis is on recent theorisations in the social sciences of concepts such as identity, nation and modernity.

Conceptualising Format Adaptation

Three recent theories offer some conceptual grasp on the phenomenon of international transfer, namely the theory of cultural imperialism, semiotic theory and technology transfer theory. As we shall see, there are various overlaps and congruences between the three although there are also significant differences.

(i) Cultural Imperialism

Although the concept of cultural imperialism is the classical theoretical paradigm for the study of international communications, nevertheless the theory says nothing directly about the process of cultural translation. This silence is significant and we can understand just why the theory ignores this kind of exchange by examining some of its broader assumptions before returning to the issue of transfer and the question of how this approach regards that practice. The concept of cultural imperialism has already been mentioned in association with authors such as Guback (1969; 1984), Schiller (1969; 1977), Wells (1972) and Smythe (1981) in Chapter 1 and extensively critiqued by authors such as Tomlinson (1991) and Ferguson (1993) and its premises can be briefly outlined. The founding assumption is that domestically produced cultural goods speak to the cultural needs of particular national populations and, therefore, best suit the needs of those populations. However, there is now a world economy so far as the production and circulation of cultural goods and services are concerned and this has resulted in a situation of imbalance between nation states. A dominant few of these, such as the US, are massive exporters of cultural goods while most other nation states are heavy importers. This imbalance has cultural as well as economic consequences. Importation means that the range and diversity of nationally produced cultural goods, such as films, television programs, books, CDs and so on that are available inside the territory of a nation state, is likely to be restricted. The circulation of cultural texts from other places tends not to serve the interests and needs of the national population, both because the texts will inevitably refer to foreign situations and be imbued with values that the national population does not necessarily share with the original audience. Thus, these imported texts are a kind of cultural Trojan Horse through which false consciousness is generated.

Although proponents of this approach do not engage in micro analysis of reception, nevertheless, cultural imperialism theory is finally a theory about cultural consumption, rather than one about production or circulation. However, what is usually offered in accounts of national cultural situations is a description of the cultural environment that is assumed to shape the ideological outlook of national populations. This theory does have an implicit view of texts and the cycle of production and reception. Cultural texts are dominantly encoded with the ideological outlook of their producing organisations, usually media conglomerates and transnational corporations. Textual language is assumed to be instrumental, a carrier of ideological messages – a view that cultural imperialism shares with mainstream qualitative content analysis in mass communication research.

Television program format adaptation usually receives little attention from proponents of the cultural imperialism thesis. Where format trade is noticed at all, it is usually bracketed with trade in finished television programs and other goods (cf Strover 1994; Lull 1995; Sinclair 1996). The implication is that just as the cultural effects of finished cultural goods can be read off by reference to their national source and the ownership of producing companies, so formats inevitably carry the values and ideological outlook of their original source. Format adaptation does nothing other than spread these among the viewing population of the importing country. Because of the instrumentalist view of textual language, cultural imperialism can posit no fate for those who receive format adaptation other than perpetual colonisation.

This is not a view with which we concur. The theory is extremely pessimistic and finally denies human agency. It ignores a good deal of empirical evidence that audiences are active generators of meaning rather than passive recipients of dominantly encoded messages (cf Morley 1992a). It also pays little attention to a circumstance mentioned in Chapter 1, namely the paradoxical historical situation that is repeated many times over in particular national television markets where import-substitution begins to occur (cf Moran 1985; de la Garde 1994). These experiences appear to deny the Trojan Horse theory of cultural reception, posited by cultural imperialism, forcing us to look elsewhere for a more adequate explanation of transfer.

(ii) Semiotic Theory

Although semiotics has had currency in the English-speaking world since the 1960s, nevertheless it is to some recent work that we turn, in particular that associated with the figure of Yuri Lotman and his work on a semiotic theory of culture (Lotman 1990).

Lotman's theory operates at both a micro and a macro level and the connecting link is his notion of translation. According to Lotman, translation is fundamental to human thinking. Translation is the transformation of information from one language to another. This is seen as a rich, generative process: the translation of texts is invariably the production of a text that is

more than and other than the original. The text that appears as a result of translation will include the original message, new messages derived by readers as well as a kind of language lesson about the codes at work in the text. In other words, translation always has a creative dimension: far from the situation of the original text always imposing an everlasting dominance, even in a translated form, textual translation opens up the possibility of generating a range of texts that are original in their own right.

Dialogue, the mechanism of translation, is a process that not only involve single messages with individuals acting as transmitting and receiving agents, but can also involve large bodies of texts being exchanged between cultures. In other words, Lotman holds to a dialogic theory of interaction between cultures. As he writes:

> The development of culture is cyclical and like most dynamic processes in nature is subject to sinusoidal fluctuations. but in a cultures' self-awareness, the periods of least activities are usually recorded as intermissionsa time of pause in a dialogue, the time when information is being intensively received, after which follow periods of transmission. This is what happens in the relationships between units at all levels from genres to national cultures. So we propose the following pattern. The relative inertness of a structure is the result of a lull in the flow of texts arriving from structures variously associated with it which are in a state of activity. Next comes the stage of saturation: the language is mastered, the texts are adapted. The generator of the texts is as a rule situated in the nuclear structure of the semiosphere while the receiver is on the periphery. When saturation reaches a certain limit, the receiving structure sets in motion internal mechanisms of text production. Its passive state changes to a state of alertness and it begins rapidly to produce new texts, bombarding other structures with them including the structure that 'provoked' it. (1990 p 144–145)

The semiosphere is the space of semiotics. Here, Lotman, drawing on the analogy of the biosphere, the totality and organic whole of living matter and also the condition for the continuation of life, invokes a homologous space for semiotics, the total semiotic environment of the totality of texts and cultures (124). Just as individuals engage in dialogue so do cultures: 'Dialogic reception and transmission happens in the relationships between units at all levels from genres to national cultures' (144).

Clearly, this theory offers a very different reading of the situation of the interaction of cultures than that developed by cultural imperialist theory and is one to which this book is sympathetic. Cultural imperialism offers only a pessimistic account of continued dependence between transmitting and receiving cultures. On this account, as we have seen, television program format adaptation is equivalent to allowing the Wooden Horse within the city gates of Troy. Lotman's theory, by contrast, particularly his notion of dia-

logue, offers a much more dynamic view of the process of cultural exchange whether the exchange be that of program trade or format adaptation. Indeed, one can see that on Lotman's model, format adaptation is a kind of middle stage between text import and text export where the receiving culture is busy learning the new cultural language by developing its own versions of textual models from the transmitting culture. The words of the Dutch television producer, quoted in Chapter 9, are worth recalling in this context:

> A more general reason why a daily soap serial on Dutch television is important is that the audience gets accustomed to the Dutch language as a language for fiction. Why is it that they say that it is bad acting when they hear 'Ik hou van je' instead of 'I love you'? We are convinced that it is a necessity to make television drama in your own culture, your own language. (Madsen 1994 p 26)

Of course, Lotman is the first to admit that his theory is of necessity a schematic one. The semiotic space of the semiosphere is characterised not by just two cultures in uninterrupted dialogue with each other but rather many dialogues in progress between many cultures on many different levels and the dialogic cycle may not be fully realised. In any case, as Lotman notes, the dialogue that ends with the culture that was a receiver becoming a transmitter demands favourable historical, social and psychological conditions (147). Such an investigation is beyond the scope of Lotman's inquiry so that we must turn to a third theory that throws further light on these conditions.

(iii) Technology transfer theory

Recent theoretical work in the sociology of technological transfer. forms a useful complement to Lotman's theory so far as our present purpose is concerned. While the term technology is an elusive one, recent work has emphasised that the term has much wider application than the designation of a physical piece of hardware: technology is rather a social creation whose various constituents are brought together by individuals or organisations to solve a particular problem, to achieve a particular practical end (MacKenzie and Wacjman 1985). (Obviously it requires little imagination to see a television program format as a cultural technology.) Although some writers working in the field of technology studies, especially the transfer of technologies between nation states, are drawn to notions of technological dependence (Cochrane 1980; Hill and Johnston 1985; Wheelwright and Crough 1988), nevertheless it is by no means the case that such a premise of technological transfer is universally accepted. Others have adopted a more open approach that sees technological transfer as being complexly determined and eschew a priori assumptions of inevitable colonisation (cf Barnes 1974; Pollard 1981; MacKenzie and Wacjman 1985; Elliott 1989; Todd 1994). According to these authors, technological transfer must be viewed within a far broader context than the transfer of physical hardware. Rather, whole societies and their institutions have to be ready to receive a technology and crucial resources must

be available for successful transfer to occur. Without the social, political and economic conditions to create an effective demand for it, the human, financial and infrastructural capacity to put the technology into productive use, its potential will be unrealised.

The theoretical value of this approach lies in the fact that it sees technology as an outcome of a specific social environment or system. Because technology arises in a particular time and place, it embodies the characteristics that suit it for use and survival in that environment. Technological transfer is the process of transporting and relocating the technology in a new environment. Whether the technology will function effectively in the new environment will depend on a range of factors to do with the total system where it is transplanted. In other words, like Lotman's, this model is a communicative one in which one national system acts as an encoder and the foreign system functions as decoder, while the particular technology that is transferred is the message that is communicated from one system to another. As we have noticed, Lotman's theory is schematic and he does not elaborate on the factors affecting the transmission and reception of texts. However, technology transfer studies have done just that. Thus, an author such as Todd (1994) emphasises that a technology is a complex entity consisting of functionally interdependent parts, having characteristics different to those of its isolated components, and existing in a social, political and economic environment which is outside its control but which may influence its course. Elements of a technological system are the physical items such as machines and pieces of hardware; organisational components can extend from factory layout and internal management procedures to include such things as supplier firms and financial institutions; related knowledges comes in both intellectual and institutional forms, and includes books, articles, university teaching and research programs; legislative factors such as patent laws, product standards, and regulation of working conditions represent social conditions and values. Because a technological system is shaped by a particular national environment, consisting of various social, political and economic factors, the process of technological transfer to a new national setting, a new environment, will involve adaptation to new political, legal, educational, cultural, social and economic institutions, as well as geography, and resource conditions. Hence, it is possible to think of national systems of technology conditioned by a unique set of historical factors, reflecting certain national characteristics, institutions, values and goals. Clearly then, this bricolage drawn from Lotman and technology transfer studies offers a much more flexible and subtle instrument for investigating and understanding the practice of television program format adaptation than does cultural imperialism.

National Identity

Although this book in its succession of Parts follows the same pattern and sequence as the conventional model of the field of mass communications (Lasswell 1948), placing production in a pre-eminent position, in point of

fact, it is reception that is crucial for understanding how television format adaptations become national. A text conveys its meaning only through reception and interpretation which is defined by the common experience of recipients and objectified in social memory (Luther 1993). This is an insight that has motivated Parts 2 and 3 of this book and is congruent with the renewed, qualitative interest in audiences that has been recently evident in media studies (Jensen and Jenkowski 1991; Morley 1992). However, some critics have claimed that such an interest is subjectivist and constitutes audiences as sovereign. The approach concentrates on micropolitics and evacuates the field of notions of power and domination, which political economy never loses sight of (Schlesinger 1992). Such a claim seems to be overstated, but, nevertheless, it is worth bearing in mind as we attempt to make some connections between the technology of format adaptation and notions of national identity.

What then is cultural identity, most especially national identity, and how does it relate to questions of politics? Recent investigations of the concept of nation-ness have argued that national identity is not some kind of essential, pre-given reflection of the nation but is instead a complex cultural construction, that develops in particular historical circumstances. It is an imagined sense of belonging to a community, one that is based in representation rather than in direct contact with other members of that community (Anderson 1991; Gellner 1983). Moreover, identity is always a matter of negotiation: 'identities' are only constituted in and through their relations to each other thus we can develop a dynamic view of identity focussing on the ability of groups to recompose and redefine their boundaries' (Morley 1992 p 65-67). Social groups draw on a repertoire of texts as the basis of memory and identity (Luther 1993). National literary tradition consist of a canonical group of novels, plays and poetry as well as films, serials and hit songs which act as mnemonics to a stock of knowledge. Luger, for example, refers to the sources of Austrian national identity as it is constituted in a group of such texts including the *Heimat* films, song hits, operettas and Austrian sports victories(1992; 1996). In addition to these apparently spontaneous forms of collective action by groups who will appropriate and even subvert texts and other objects in the activity of identity formation and maintenance, the state also plays a central role. The administrative institutions of a nation state will often deploy particular cultural elements – the flag and various attendant rituals, the national anthem and other musical compositions, state ceremonies, national holidays and feast days – which are consciously designed to foster its version of national identity (Bennett et al. 1992). And, obviously, the state's construction of a national identity also involves particular media representations, such as the planned televising of national public ceremonies (the installation of a head of state, a state funeral, meetings of the parliament and so on) as well as more everyday television events such as national news broadcasts, current affairs programs and documentary films.

National identity consists of two parts. It is, on the one hand, a disposition of social inclusion and exclusion, a means of defining who are 'we' and who are

'them'. On the other hand it is also a means of categorisation or typification (Luthar 1993). In the case of the Dutch backpackers discussed in the last chapter, for example, there was – as we have seen – a fluid and often shifting identification with the abstraction of the Dutch nation. Speaking to the researchers, they were Dutch; watching a Dutch soap opera, they laughingly identified themselves as Dutch fans singing the program's theme song as a kind of national anthem; staying at hostels where they met backpackers from other countries, they were 'Dutchies'. However with the Dutch soaps, it was by no means the case that they had a complete or permanent identification with all the representations on offer. They saw clear boundaries between themselves and some of the Amsterdamers in *Vrouwenvleugel* and the women prisoners in the same series. They also distinguished between themselves and some of the ethnic Dutch population as typified in both serials, although they, in turn, differentiated themselves from two other Dutch agencies – the state, as it is embodied in specific policies in such matters as employment and housing, and racist groups on the extreme right.

Cultural identifications can exist both within and across nation states and these are different from and often in direct conflict with what might be called a national culture. Modern nation states are not homogenous, so that, inevitably, any representation that attempts to figure the national will do so at the expense of particular cultural communities. The specific textual politics of location and setting, of accent and vernacular, of groups, situations and stories, that is repeatedly touched on in Chapters 6 to 10, is sufficiently indicative of this point. Nor should the processes of national identification provoked or likely to be provoked by format adaptations be exaggerated. For the most part, these representations do not subscribe to the same imaging of the nation as that contained in either the repertoire of state-sanctioned symbols and beliefs or else that represented in actuality forms. Instead, as Tomlinson drawing on Giddens has pointed out, the representations in these popular cultural forms, most especially in television soap opera, is more that of everyday life as it is experienced in modernity where various cultural elements, including those that might be called national coexist in a mobile, active heterogeneity (1991). Nevertheless such representations should not be underestimated as they are capable of generating what Luther calls 'mnemonic energies' (1993). For what is finally important is not the fact that particular social meanings have originated in marginal cultural forms, such as the game show and the soap opera, but rather that they enter a repertoire of commonsense assumptions and understandings where they can become active agents in the constant, on-going process of 'recomposing and redefining (national) boundaries'.

As Marxist writers beginning with the Italian Antonio Gramsci and continuing down to the Latin American Martin Barbero have pointed out, the relations between organised political ideologies, popular cultural forms, and lived experience are nefariously complex. Despite the long tradition of investigation, the connections have yet to be clearly established, let alone

fully explored. Popular culture generally (and popular entertainment television in particular), is a crucial level of mediation between political ideology and the more disjointed, often internally contradictory level of everyday experience and commonsense. Even states that are founded on military dictatorship constantly seek popular legitimacy. The state attempts to speak for and on behalf of the 'people' and continually strives to use an idiom and an imagery that is contemporary and popular. Popular cultural forms with wide social circulation including songs, sporting events, clothing and fashion, radio and television programs, films and so on offers a fertile ground for identifying and resuming imagery with wide social resonance and relevance. Successful television genres with wide audience appeal such as the game show and the soap opera can act as a filtering agent, sedimenting the everyday in the form of particular and powerful television representations. And it is this level of figuring in these and other popular genres of television that feeds in turn into more organised political discourse. When politicians of different ideological persuasion attempt to galvanise notions such as those of 'nation', 'national identity and character', 'national interest' and so on, they do so not by referring to general and abstract ideas which have meaning only inside specific and highly specialist discourses such as those of law and philosophy but draw on more ordinary, 'commonsense' and popular discourses. In other words, they attempt to tap rich contemporary veins of popular imagery including a body of representations circulated in popular television. Popular Dutch television program format adaptations such as *Vrouwenvleugel* and *Goede Tijden, Slechte Tijden* provide a vocabulary of elements, both images and sounds, from which an imaginary harmony that is the Dutch nation can in turn be assembled. Thus, while from a wider social point of view - format adaptations may seem trivial and ephemeral, clearly these can have political effects which are neither of these things.

References

Aksoy, A. and Robbins, K. 1992, 'Hollywood for the 21st century: global competition for critical mass in image markets', *Cambridge Journal of Economics*, Vol.16, No.1, pp1-22.

Akyuuz, G. 1992, 'Local heroes' *TV World*, December, pp20-21.

Akyuuz, G. 1994, 'Soaps make a clean sweep', *TV World*, June, pp15-17.

Alexander, M. 1979, *The Political Economy of Semi-Industrial Capitalism: A Comparative Study of Argentina, Australia and Canada*, Montreal; Ph.D. thesis, McGill University.

Allen, R. C. (ed.) 1995, *To Be Continued: Soap Opera Around The World*, London and New York: Routledge.

Allen, R.C. 1995b, 'Introduction' in Allen *To Be Continued*, pp1-26.

Allen, R.C. 1997, 'Soap opera' in Newcomb *Encyclopedia*, pp1514-24.

Alvarado, M. (ed.) 1988, *Video World-Wide: An International Study*, London and Paris: John Libbey.

Alvarado, M. 1995, 'Selling television', in Moran *Film Policy*, pp62-71.

Alvarado, M. 1997, 'British Programme Production Companies', in Newcomb *Encyclopedia* pp224–227.

Alvarado, M. 1997b, 'British Programming', in Newcomb *Encyclopedia*, pp227-231.

Anderson, B. 1991, *Imagined Communities: Reflections on the Origin and Spread of Nationalism*, London: Verso.

Anderson, B. 1992, 'The new world disorder', *24 Hours*, February, pp40-46.

Ang, I. 1985, *Watching Dallas: Soap Opera and the Melodramatic Imagination*, London: Metheun.

Ang, I. 1991, *Desperately Seeking the Audience*, London and New York: Routledge.

Anon n.d., *Fremantle*, New York: Fremantle.

Anon 1973, 'Quiz king joins the drama race', *TV Week*, 22 September, p.14.

Anon 1977, 'Reg Grundy's multi-million dollar gamble: Aussie company's New York venture', *TV Week*, 3 December, p.13

Anon 1980, 'New frontiers in Aussie broadcasting: Reg Grundy', *Variety*, 30 April, p.19.

Anon 1985, 'MIP is springboard for Grundy in plans for European operation', *Variety*, 17 April, p.14.

Anon 1989, 'France', *Television / Radio Age*, 26 July, p.17.

Anon 1991, 'Grundy in US state of mind', *Broadcasting*, 29 April, pp28-9.

Anon 1992, 'Spain: Big bucks rule in Iberia', *Variety*, 27 January, p.42.

Anon 1993, 'Millions roll in and the soaps roll on', *Australian Financial Review*, 22 October, p.20.

Anon 1994, *King World*, New York: King World.

Anon 1994b, 'Grundy world wide', *Encore*, 15-28 August, p.6.

Anon 1994c, 'Grundy serious about Asia' *Encore*, 15-28 August, p.5.

Anon 1995, *The Art of Entertainment: Programs from Action Time*, London: Action Time.

Anon 1995, *Endemol Entertainment: Company Profile*, Laren, The Netherlands: Endemol Entertainment.

Anon 1996a, *Endemol Entertainment: Company Profile*, Laren, The Netherlands: Endemol Entertainment.

Anon 1996b, *ID TV Company Profile*, Amsterdam: ID TV.

Anon 1996c, *IDRA (Format) Catalogue*, Amsterdam: IDRA.

Appadurai, A. 1990, 'Disjuncture and difference in the global cultural economy', in Featherstone, *Global Culture*, pp295-310.

Atkinson, C. 1994, 'Good neighbours', *TV World*, July / August, p.7.

Attallah, P. 1991, 'Of homes and machines: TV, technology and fun in America, 1944-84', *Continuum: An Australian Journal of the Media*, Vol.4, No.2, pp58-98.

Auletta, K. 1992, *Three Blind Mice: How The TV Networks Lost Their Way*, New York: Vintage Books.

Bakhtin, M. 1981, *The Dialogic Imagination*, Austin: University of Texas Press.

Balio, T. 1995, 'Adjusting to the new global economy: Hollywood in the 1990's', in Moran, A. (ed.), *Film Policy: International, National and Regional Perspectives*, London and New York: Routledge, pp23-38.

Barnes, Barry 1974, *Scientific Knowledge and Sociological Theory*, London: Routledge and Kegan Paul.

Barthes, R. 1982, *S/Z*, New York: Hill and Wang.

Battersby, G.J. and C.W. Grimes 1986, 'Merchandising revisited', *The Trademark Reporter*, Vol.76, pp271-314.

Baudrillard, J. 1985, 'Child in the bubble', *Impulse*, (12-13) Winter, pp25-48.

BBC Worldwide Television 1994, *Formats*, London: BBC Enterprises Limited.

Bechelloni P. 1997, 'Italy', in Newcomb, *Encyclopedia*, pp836-40.

Beck, C. 1984, *On Air: 25 Years of TV in Queensland*, Brisbane: One Tree Hill Publishing.

Becker, L.B. and K. Shoenbeck (eds.) 1989, *Audience Response To Media Diversification: Coping With Plenty*, Hillsdale, N.J.: Lawrence Erlbaum.

Bell, A. 1995, 'An endangered species?: Local programming in the New Zealand market', *Media, Culture and Society*, April pp181-200.

Bell, N. 1994, 'Major men', *Television Business International*, April, pp24-7

Bell, P. and Bell, R. 1993, *Implicated: The United States in Australia*, Melbourne: Oxford University Press.

Bennett, T., P. Buckridge, D. Carter and C. Mercer (eds), *Celebrating the Nation: A Critical Study of Australia's Bicentenary*, Sydney: Allen and Unwin.

Berton, P. 1975, *Hollywood's Canada: The Americanization of our National Image*, Toronto: McClelland and Stewart.

Bhabha, H Homi (ed.) 1990, *Nations and Narration*, London: Routledge.

Biel, R. 1995, 'If you can't join them, beat them', *Television Business International*, 17 August, p.179.

Blainey, G. 1966, *The Tyranny Of Distance: How Distance Shaped Australia's History*, Melbourne: Sun Books.

Bleicher, J. 1997, 'Germany', in Newcomb *Encyclopedia*, pp686-9.

Blumler, J.G. 1991, 'Television in the United States: Funding sources and programming consequences', in Blumler and Nossiter, *Broadcasting Finance*, pp41-94.

Blumler, J.G. and T.J. Nossiter (eds.) 1991, *Broadcasting Finance in Transition: A Comparative Handbook*, New York: Oxford University Press.

Bogle, D. 1994, *Toms, Coons, Mulattoes, Mammies and Bucks: An Interpretative History of Blacks in American Films*, New York: Continuum.

Bordwell, D., K. Thompson and J. Staiger 1985, *The Classical Hollywood Cinema: Film Style and Mode of Production to 1960*, New York: Columbia University Press.

BRITE n.d., *Programme Catalogue*, London: The London Television Centre.

BRITE 1996, *BRITE Formats*, London: The London Television Centre.

Brook, A. 1995, Interview with Albert Moran, London.

Brown, L. 1977, *The New York Times Encyclopedia of Television*, New York: New York Times Press.

Browne, D.R. 1989, *Comparing Broadcast Systems: The Experiences of Six Industrialised Nations*, Ames, Iowa: Iowa State University Press.

Brunsden, C. 1995, 'The role of soap opera in the development of feminist scholarship,' in Allen, *To Be Continued*, pp49-65.

Brunt, R. 1985, 'What's My Line?', in L. Masterman (ed.), *Television Mythologies*, London: Comedia.

Burnett, K. 1994, 'Mañana sometimes comes', *TV World Guide to Spain and Portugal*, March, pp4-6.

Burnett, M. 1988, 'The protection of ideas for radio', *EBU Review*, Vol.39, No.1, pp32-39.

Camilleri, J.A. and Falk, J. 1992, *The End of Sovereignty*, Aldershot: Edward Arnold.

Castles, S. and Miller, M.J. 1993, *The Age of Mass Migration*, Bassingstoke: Macmillan.

Chiemelesky, J. 1997, 'Argentina', in Newcomb, *Encyclopedia*, pp78-80.

Cochrane, P. 1980, *Industrialization and Dependence*, Brisbane: University of Queensland Press.

Collins, R. 1989, 'The language of advantage: Satellite television in Western Europe', *Media, Culture and Society*, Vol.11, No.3, pp351-371.

Commission of the European Communities 1989, *Council directive of 3 October 1989 on the coordination of certain provisions laid down by law, or administrative action in member states concerning the pursuit of television broadcasting activities*, (Oj No.1,298, 17.10.1989 pp23-30) Brussels.

Cooper-Chen, A. 1993, 'Goodbye to the global village: Entertainment TV patterns in 50 countries', paper delivered at the Association for Education in Journalism and Mass Communication Annual Convention. Kansas City, August.

Cooper-Chen, A. 1994, *Games in the Global Village: A 50-Nation Study*, Bowling Green, Ohio: Bowling Green University Popular Press.

Couzens, M. 1997, 'United States: Networks', in Newcomb, *Encyclopedia*, pp1727-32.

Crane, R. 1979, *The Politics of International Standards: France and the Color TV War*, Norwood, N.J.: Ablex Publishing Corporation.

Craven, I. 1989, 'Distant Neighbours: Notes on some Australian soap operas', *Australian Studies*, No.3, December, pp1-35.

Crystal, B. 1996, Interview with Albert Moran, Los Angeles.

Cunningham, S. and Jacka, E. 1996, *Australian Television and International Mediascapes*, Melbourne: Cambridge University Press.

Curthoys, A. and Docker, J. 1989, 'In praise of *Prisoner*' in J. Tulloch and G. Turner (eds.), *Australian Television: Programs, Pleasures, and Politics*, Sydney: Allen and Unwin, pp52-71.

Curthoys, A. and Docker, J. 1994, 'Melodrama in action: *Prisoner* or *Cell Block H*', in J. Docker, *Postmodernism and Popular Culture: A Critical History*, Melbourne: Cambridge University Press, pp260-72.

Curthoys, A. and Docker, J. 1997, '*Prisoner*', in Newcomb, *Encyclopedia*, pp1293-7.

D'Alesandro, K.C. 1997, 'Pilot programs', in Newcomb, *Encyclopedia*, pp1258-9.

Dahrendorf R. 1990, *Reflections on the Revolutions in Europe: It's a letter intended to have Been Sent to a Gentleman in Warsaw*, London: Chatto and Windus.

Daniel, J. 1995, Interview with Albert Moran, Cologne.

Davidson, J. 1979, 'The de-dominance of Australia', *Meanjin*, Vol. 38, No. 2, pp139-53.

Davies, J. 1983, '*Sale of the Century* - sign of the decade', *Australian Journal of Screen Theory*, No. 13/4, pp19-33.

Dawley, H. 1994, 'What's in a format?', *Television Business International*, November, pp24-6.

Day, C. 1980, 'How rich Reg Grundy plans to get richer', *The National Times*, 11-7 May, p.58.

de la Garde, R. 1994a, 'Cultural development: State of the question and prospects for Quebec', *Canadian Journal of Communications*, Vol. 19, pp447-475.

de la Garde, R. 1994b, 'There goes the neighbourhood: Montreal's television market and free trade', Quebec City: Laval University, unpublished paper.

de la Garde, R., W. Gilsdorf, and I. Wechselmann (eds.) 1993, *Small Nations, Big Neighbours: Denmark and Quebec, Canada Compare Notes On American Popular Culture*, London: John Libbey.

Dermody, S. and Jacka, E. 1987, *The Screening of Australia Volume 1: Anatomy of a Film Industry*, Sydney: Currency Press.

Dermody, S. and Jacka, E. 1988, *The Screening of Australia Volume 2: Anatomy of a National Culture*, Sydney: Currency Press.

de Swaan, A. 1991, 'Notes on the emerging global language system: Regional, national and supranational', *Media, Culture and Society*, Vol. 13, No. 3, pp309-24.

Dizard, W.R. 1966, *Television – A World View*, Syracuse, NY: Syracuse University Press.

Docker, J. 1974, *Australian Cultural Elites: Intellectual Traditions in Sydney and Melbourne*, Sydney: Angus and Robertson.

Drinkwater, R. 1995, 'First-class travels with Auntie', *The Times*, 1 March, p.35.

Driscoll, G. 1994, 'Here's an idea I stole earlier', *Evening Standard*, (UK) 21 September, p.56.

Drummond, P., R. Patterson and J. Wills (eds.) 1993, *National Identity and Europe: The Television Revolution*, London: BFI Publishing.

Dyer, R. 1974, *Light Entertainment*, London: British Film Institute.

Dyer, R. 1977, 'Entertainment and Utopia', *Movie* No. 24, pp2-13.

Edmunds, M. 1994, 'The urge to merge', *TV World*, June, p.15.

Elliott, B. (ed.) 1988, *Technology and Social Process*, Edinburgh: Edinburgh University Press.

Elsaesser, T. 1975, 'The pathos of failure: American films in the '70s', *Monogram*, No.6, October, pp11-4.

Emmanuel, Susan 1997, 'France', in Newcomb, *Encyclopedia*, pp631-3.

Erler, R. and B. Tinburg 1997, 'Talk shows', in Newcomb, *Encyclopedia*, pp1617-23.

Fadul, A. (ed.) 1993, *Serial Fiction In TV: The Latin American Telenovelas*, São Paulo: School of Communications and Arts, University of São Paulo.

Featherstone, M. (ed.) 1990, *Global Culture: Nationalism, Globalization and Modernity*, London: Sage.

Febvre, L. and H.J. Martin 1976, *The Coming of the Book: The Impact of Printing, 1450–1800*, London: New Left Books.

Ferguson, M. 1993, 'The mythology about globalization', *European Journal of Communications*, Vol.7, No.1, pp69-93.

Fiddy, D. 1997, 'Format sales, international', in Newcomb, *Encyclopedia*, pp623-4.

Fine, F.L. 1988, 'A case for the Federal Protection of Television Formats: Teasing the limits of "expression"', *Pacific Law Journal*, Vol.17, pp49-75.

Fiske, J. 1983, 'TV quiz shows and the purchase of cultural power', *Australian Journal of Screen Theory*, Nos.13/4, pp1-18.

Fiske, J. 1987, *Television Culture*, London: Metheun.

Fiske, J. 1988, 'Everyday quizzes, everyday life', in Tulloch and Turner, *Australian Television*, pp72-87.

Fiske, J., B. Hodge and G. Turner 1987, *Myths of Oz: Reading Australian Popular Culture*, Sydney: Allen and Unwin.

Fox, E. (ed.) 1988, *Media and Politics in Latin America*, London: Sage.

Franco, J. 1986, 'The incorporation of women: A comparison of North American and Mexican narratives', in T. Modleski (ed.), *Studies in Entertainment: Critical Approaches To Popular Culture*, Bloomington: Indiana University Press, pp119-38.

Frayling, C. 1981, *Spaghetti Westerns: Cowboys and Europeans from Karl May to Sergio Leone*, London: Routledge and Kegan Paul.

Frean A. 1994, 'Have I got a show for you!', *The Times*, 12 October, p.23.

Freedman, R.I. and R.C. Harris 1990, 'Game show contracts: Winners and losers', *Entertainment Law Review*, pp209-14.

Freedman, S. 1996, Interview with Albert Moran, Los Angeles.

Frenz Norton, S. 1985, 'Tea time on the "telly"', *Journal of Popular Culture*, Vol.18, pp3-19.

Fry, A. 1995, 'Action man', *Broadcast - TV Supplement*, 7 April, p.30.

Fuller, C. 1992a, 'Different voices, still lives,' *Broadcast*, April pp30-1.

Fuller, C. 1992b, 'Look at what the wheel set in motion', *Variety*, 27 January, p.7.

Fuller, C. 1993a, 'Copycat riot', *TV World*, January, p.15.

Fuller, C. 1993b, 'Top Dutch Indies join', *Variety* 27, 5 December, pp22-24.

Fuller, C 1994a, 'Soaps success shows no signs of fading', *Broadcast*, 19 February pp136-8.

Fuller, C. 1994b, 'Dutch double', *Broadcast*, 28 October, p.13.

Galtung, J. 1993, 'The role of communication in rethinking European identity', *Media Development: Journal of the World Association for Christian Communication*, Vol.XL, No.4, pp3-7.

Gellner, E. 1983, *Nations and Nationalism*, Oxford: Basil Blackwell.

Geraghty, C. 1995, 'Social issues and realist soap: A study of British soaps in the 1980s/90s', in Allen, *To Be Continued*, pp66-80.

Gerard, J. 1990, 'Syndicators find a winner: The successful game show', *New York Times*, 23 January, p.102.

Gerric, A. 1992, 'Teaching the US to suck soap', *The Bulletin*, 9 June, pp98-100.

Giblin, S. 1996, Interview with Albert Moran, London.

Gillespie, M. 1995 'Sacred serials, devotional viewing and domestic worship: A case study in the interpretation of two TV versions of *The Mahabharata* in a Hindu family in South London', in Allen, *To Be Continued*, pp354-80.

Gillespie, M. 1995, *Television, Ethnicity and Cultural Change*, London and New York: Routledge.

Gitlin, T. 1985, *Inside Prime Time*, New York: Pantheon books.

Gledhill, C. 1992, 'Speculations on the relationship between soap opera and melodrama', *Quarterly Review of Film and Video*, Vol.14, pp103-24.

Globo TV n.d., *You Decide*, London: Globo TV.

Globo TV 1994, *You Decide: News Update*, Rio de Janeiro: Globo TV.

Goldberg, A. 1991, 'Beyond the corner shop', *New Statesman and Society*, 28 June, pp28-9.

Goodwin, P. 1992, 'Playing the percentages', *Broadcast*, 25 March, p.11.

Gordon, N. 1975, *My Life at Crossroads*, London: W.H. Allen.

Gordon P. 1991, 'The winning formula', *TV World*, November pp57-8.

Graham, J. 1988, *Come On Down!!! The TV Game Show Book*, New York: Abbeville Press.

Grantham, B. 1992, 'Far Eastern promise', *Television Business International*, October, pp48-54.

Gray, D. 1995, Interview with Emma Sandon, London.

Griffiths, A. 1993 '*Pobol y Cwm*: The construction of national identity and cultural identity in a Welsh-language soap opera', in Drummond et al, *National Identities*, pp9-24.

Griffiths, A. 1995, 'National identity and cultural identity in a Welsh-language soap opera', in Allen *To Be Continued*, pp81-97.

Gripsrud, J. 1992, 'French-American connection: *A bout de souffle*, *Breathless*, and the melancholy macho', in Skovmand and Schroeder, *Media Cultures*, pp104-23.

Grundy World Wide 1992-6, *Press Releases*, London.

Guback, T. 1969, *The International Film Industry: Western Europe and America Since 1945*, Bloomington: Indiana University Press.

Guback, T. 1984, 'International circulation of US films and television programs', in G. Gerbner and M. Siefert (eds.), *World Communications: A Handbook*, New York: Longman, pp79-103.

Guider, E. 1994, 'Grundy ups presence in Euro TV markets', *Variety*, 2 August, p.11.

Haagmans, J. 1996, Interview with Albert Moran, Amsterdam.

Hall, S. 1976, *Supertoy: 20 Years of Australian Television*, Melbourne: Sun Books.

Hamilton, A. 1992, 'The mediascape of modern Southeast Asia', *Screen*, Vol.33, No.1, Spring, pp81-92.

Hancock, R. 1995, Interview with Albert Moran, London.

Harcourt, P. 1980, *Self-Portrait*, Ottawa: Canadian Film Institute.

Harris, M. 1987, 'Oz-based Grundy organisation eyes gameshows for the BBC', *Variety*, 15 July, p.17.

Head, S. and C. Sterling 1987, *Broadcasting in America: A Survey of Electronic Media*, Boston: Houghton Miffin Company (Fourth Edition).

Hein Bakke, P. 1996, Interview with Albert Moran, Lisbon.

Heinderyckx, F. 1993, 'Television news programmes in Western Europe', *European Journal of Communication*, Vol.8, No.4, December, pp425-50.

Heinderyckx, F. 1994, 'Language as the irreducible impediment to transnational television programmes', paper presented at the *Turbulent Europe* conference, London.

Held, D. 1989, 'The decline of the nation state', in Hall, S. and Jacques, M. (eds.), *New Times: The Changing Face of Politics in the 1990s*, London: Lawrence and Wishart.

Henry, J. 1995, Interview with Albert Moran, London.

Hill, J. 1986, *Sex, Class and Realism: British Cinema, 1956–63*, London: British Film Institute.

Hill, S. and R. Johnston (eds) 1985, *Future Tense? Technology in Australia*, Brisbane: University of Queensland Press.

Hirst, P. and G. Thompson 1995, *Globalisation in Question: The International Economy and the Possibilities of Governance*, Cambridge: Polity Press.

Hobson, D. 1982, *Crossroads: The Drama of a Soap Opera*, London: Methuen.

Hofmann, M. 1988, 'The Federal Republic of Germany', in Silj, *East of Dallas*, pp141-64.

Hofmann, M. 1992, 'Germany', in Silj, *The New Television in Europe*, pp525-96.

Hogg, I. 1995, Interview with Albert Moran, Sydney.

Holbrook, M. 1993, *Daytime Television Game Shows and the Celebration of Merchandising: The Price is Right*, Bowling Green, Ohio: Popular Culture Press.

Holmes, I. 1992, Interview with Stuart Cunningham, Marie Delofski and Albert Moran, Sydney.

Horsman, M. and A. Marshall 1994, *After the Nation State*, London: Harper Collins.

Inglis, K.S. 1983, *This is the ABC: The Australian Broadcasting Commission 1932–1983*, Melbourne: Melbourne University Press.

Ivanov, V.V. 1984, 'The inversion of bi-polar opposites', in T. Sebeok (ed.), *Carnival*, Berlin and New York: Mouton, pp22-47.

Jackel A. 1995, 'European co-production strategies: The case of France and Britain', in Moran, *Film Policy*, pp85-99.

Jameson, F. 1984, 'Postmodernism, or the cultural logic of late capitalism' *New Left Review*, Vol.146, pp53-92.

Jameson, F. 1986, 'Third World literature in the era of multi-national capitalism', *Social Text*, 15 (Fall), pp65-88.

Jarvis, C. 1995, Interview with Albert Moran, London.

JE 1995, *Press Release*, Aalsmeer.

Jenkins, H. 1992, *Cultural Poachers: Television Fans and Contemporary Culture*, London: Routledge.

Jensen, K.B. 1996, 'Audiences uses of news in world cultures: Comparative findings from the *News of the World* Project', paper delivered at the 21st General Assembly and Conference of the International Association for Mass Communication Researchers, Sydney.

Jensen, K.B. and N. Jankowski (eds.) 1991, *A Handbook of Qualitative Methodologies for Mass Communication Research*, London: Routledge.

Jezequel, J.P. and G. Pineau 1992, 'French television', in Silj, *New Television*, pp429-524.

Julius, D. 1990, *Global Companies and Public Policy*, London: RIIA Printers.

Kahn, J.S. 1995, *Culture, Multiculture, Postculture*, London: Sage.

Katz, E. and G. Wedell 1977, *Broadcasting in the Third World: Promise and Performance*, Cambridge, MA: Harvard University Press.

Kean, C. 1991, 'Ideas in need of protection', *Television*, October, pp20-1.

Kibberd, D. 1996, *Inventing Ireland: The Literature of the Modern Nation*, London and New York: Vintage.

Kilborn, R. 1992, *Television Soaps*, London: Batsford.

Kilborn, R. 1993, 'Speak my language: current attitudes to television subtitling and dubbing', *Media, Culture and Society*, Vol.15, No.4, pp641-60.

Kilborn, R. 1994, 'All change! The new face of East German broadcasting', paper delivered to the *Turbulent Europe* conference, London.

Kingsley, H. 1989, *Soap Box: The Australian Guide to Television Soap Opera*, Melbourne: Sun Books.

Kolle, R. 1995, Interview with Albert Moran, Sydney.

Kreutzner, G. and E. Seite 1995, 'Not all "soaps" are created equal: Towards a cross-cultural criticism of television serials', in Allen, *To Be Continued*, pp234-55.

Kreyn, K. 1996, Interview with Albert Moran, Amsterdam.

Kurtz, L.A. 1990, 'The rocky road to character protection', *Entertainment Law Review*, Vol.1, pp63-7.

Lane, R. 1994, *The Golden Age of Australian Radio Drama, 1923–60: A History through Biography*, Canberra: National Film and Sound Archive and Melbourne University Press.

Lane, S. 1992, 'Format rights in television shows: Law and the legislative process', *Statue Law Review*, pp24-49.

Lane, S. and R.M. Bridge 1990, 'The protection of formats under English law - part II', *Entertainment Law Review*, pp131-42.

Lane, S. and R.McD. Bridge 1990, 'The protection of formats under English law - part I' *Entertainment Law Review*, pp96-102.

Larsen, P. 1990, *Import/Export: International Flow of Television Fiction*, report and papers on Mass communication, 104. Paris: UNESCO.

Lasch, S. and Usury, J. 1987, *The End of Organised Capitalism*, Cambridge: Polity.

Laswell, Harold 1948, 'The structure and function of communication in society', in B. Berelson and M. Janowitz(eds.), *Reader in Public Opinion and Communication*, Glencoe, IL: The Free Press.

Levine, D.A. 1989, 'The Cosby Show: Just Another Sitcom?' *Loyola Entertainment Law Journal*, Vol.9, pp137-51.

Levy, J. 1995, 'Evolution and competition in the American video marketplace', in Moran, *Film Policy*, pp39-61.

Lewis, D. 1994, 'Europeans *troppo* over Grundy soap', *Sydney Morning Herald*, 13 August, p.18.

Libbert, R.Y. 1968, 'Round the prickly pear: The idea-expression fallacy in a mass communication world', *Copyright Law Symposium Number Sixteen*, New York: Columbia University Press, pp30-80.

Liebes, T. and E. Katz 1993, *The Export of Meaning: Cross-Cultural Readings of Dallas*, Oxford. Polity Press.

Life, R. 1997, Battle – Hungary enters a new broadcasting era, *Television Europe* MIP Com edition p 24.

Lindsay, M.J. Milichip 1994, 'It takes two to tango', *TV World*, April, pp3-9.

Lopez, A.M. 1995, 'Our welcomed guests: Telenovelas in Latin America', in Allen, *To Be Continued*, pp256-75.

Lotman, Y. 1990, *Universe of the Mind: A Semiotic Theory of Culture*, London: I.B. Taurus and Co.

Luger, K. 1992, '*The Sound of Music* country: Austria's cultural identity', *Media, Culture and Society*, Vol.14, pp185-92.

Luger, K. 1996, 'The entertaining city: Salzburg as stage and scene', paper delivered at the 21st General Assembly and Conference of the International Association for Mass Communication Research, Sydney.

Lull, J. 1995, *Media, Communication, Culture: A Global Approach*, Cambridge: Polity Press.

Luthar, B. 1993, 'Identity management and popular representational forms', in Drummond et al, *National Identity*, pp43-50.

Macken, D. 1989, 'Invasion of the Aussie soaps', *Sydney Morning Herald Good Weekend Supplement*, 8 April, p.9.

MacKenzie, D. and J. Wacjman 1985, *The Social Shaping of Technology: How the Refrigerator got its Hum*, Milton Keynes: Open University Press.

Madsen, O. 1994, 'On the quality of soap', in T. Elsaesser, J. Simons and L. Bronk (eds.), *Writing For The Medium: Television In Transition*, Amsterdam: Amsterdam University Press, pp49-53.

Mancisidor, A.D. and K.M. Ayyerdi 1994, 'The news types of television in Spain: Satellite, cable and Hertz television', paper presented to the *Turbulent Europe* Conference, London.

Martino, T. and C. Miskin 1991, 'Format rights: The price is not right', *Entertainment Law Review*, pp31-2.

Mason, B. 1996, Interview with Albert Moran, Sydney.

Mattelart, A., X. Delacourt and M. Mattelart, 1984, *International Image Markets: In Search Of An Alternative Perspective*, London: Comedia Publishing Group.

Mattelart, M. and A. Mattelart 1990, *The Carnival of Images: Brazilian Television Fiction*, New York: Bergin and Garvey.

Maxwell, R. 1997, 'Spain', in Newcomb, *Encyclopedia*, pp1356-9.

McAnany, E.G. 1984, ' The logic of culture industries in Latin America: The television industry in Brazil', in V. Mosco and J. Wasko (eds.), *Critical Communications Review*, Norwood, NJ: Ablex, pp126-54.

McArthur, C. (ed.) 1982, *Scotch Reels: Scotland in Film and Television*, London: British Film Institute.

McDermott, M. R. 1997, 'Goodson, Mark and Bill Todman', in Newcomb, *Encyclopedia*, pp707-10.

McLuhan, M. 1962, *The Gutenberg Galaxy*, New York: McGraw-Hill.

McLuhan, M. and Q. Fiore 1968, *War and Peace in the Global Village*, New York: Bantam Books.

McQuail, D. 1991, 'Broadcasting structure and finance: The Netherlands', in Blumler and Nossiter, *Broadcasting Finance*, pp144-57.

Merton, R. and P. Kendall 1955, 'The focussed interview', in P. Lazarsfeld and M. Rosenberg (eds.), *The Language of Social Research*, New York: Free Press, pp91-130.

Milichip, J. 1996, 'It just won't wash', *TV World*, February p.7.

Miller, T. 1993, 'National identity and traded images', in Drummond, Patterson and Willis (eds), *National Identity*, pp95-109.

Mills, A. and P. Rice 1982, 'Quizzing the popular', *Screen Education*, No.41, Winter/Spring, pp21-32.

Monteith, P. 1987, 'Sound and pictures', *Broadcast*, 16 October, pp32-3.

Moore, L. 1991, 'Spanish TV growing in the red', *Variety*, 23 September, p.59.

Moran, A. 1982, 'Localism and Australian television', in S. Dermody, J. Docker and D. Modjeska (eds.), *Nellie Melba, Ginger Meggs and Friends: Essays in Australian Cultural History*, Malmsbury, Victoria: Kibble Books, pp89-103.

Moran, A. 1985, *Image and Industry: Australian Television Drama Production*, Sydney: Currency Press.

Moran, A. 1989, 'Three stages of Australian television', in Tulloch and Turner, *Australian Television*, pp1-14.

Moran, A. 1993, *Moran's Guide to Australian TV Series*, Sydney: Australian Film, Television and Radio School, in conjunction with Allen and Unwin.

Moran, A. 1996a, 'National broadcasting and cultural identity: New Zealand television and *Shortland Street*', *Continuum: The Australian Journal of Media and Culture*, Vol.10, No.1, pp168-86.

Moran, A. 1996b, 'National identity and the television comedy game show: The case of *Man O Man*', *Continuum: The Australian Journal of Media and Culture*, Vol.10, No.2 pp78-96.

Moran, A. 1997, 'Australia', in Newcomb, *Encyclopedia*, pp114 21.

Moran, A. 1997a, 'Foreign exchange: Reflections on the Grundy buy-out', *Media International Australia*, No.83, February, pp123-34.

Moran, A. 1997b, '*Sale of the Century*', in Newcomb, *Encyclopedia*, pp1427–8.

Morley, D. 1992, 'Electronic communications and domestic rituals: Cultural consumption and the production of European cultural identities', in Skovmand and Schroeder, *Media Cultures*, pp48-69.

Morley, D. 1992a, *Television, Audiences and Cultural Studies*, London and New York: Routledge.

Moyal, A. 1984, *Clear across Australia: A History of Telecommunications*, Melbourne: Nelson.

Mummery, J. 1966a, 'The protection of ideas - I', *The New Law Journal*, 27 October, pp1455-6.

Mummery, J. 1966b 'The protection of ideas - II', *The New Law Journal*, 3 November, pp1481-2.

Munson, W. 1993, *All Talk: The Talkshow in Media Culture*, Philadelphia: Temple University Press.

Murdock, G. 1997, 'New Zealand', in Newcomb, *Encyclopedia*, pp1154-6.

Murphy, M. 1995, Interview with Albert Moran, London.

Murphy, R. 1989, *Realism and Tinsel: Cinema and Society in Britain, 1939 1948*, London and New York: Routledge.

Murray, J.C. 1973, 'Defending the defenders', *Lumiere*, April, pp16-9.

Negrine, R. 1990, 'British television in an age of change', in K. Dyson and P. Humphreys (eds), *The Political Economy of Communications: International and European Dimensions*, London: Routledge, pp148-70.

Newcomb, H. 1987, 'Texas: A giant state of mind', in H. Newcomb (ed.), *Television: The Critical View*, New York: Oxford University Press (Fourth Edition), pp281-98.

Newcomb, H. (ed.) 1997, *Museum of Broadcasting Communications Encyclopedia of Television*, Chicago and London: Fitzroy Dearborn Publishers.

Nieuwenhuis, A.J. 1992, 'Media policy in the Netherlands: beyond the market', *European Journal of Communications*, Vol.7, No.2, pp195-218.

Noam, E. 1991, *Telecommunications in Europe*, New York: Oxford University Press.

Noam, E. 1992, *Television in Europe*, New York: Oxford University Press.

Nordenstreng, K. and T. Varis 1974, *Television Traffic - a One-Way Street? UNESCO Report and Papers on Mass Communications* No.70, Paris: United Nations Educational Scientific and Cultural Organisation.

Notermans, T. 1996, Interview with Albert Moran, Aalsmeer.

Nowell-Smith, G. 1991, 'Broadcasting : National culture, international business', *New Formations: Journal of Cultural History/Memory*, No.13, Spring, pp39-45.

O'Grady, J. 1980, Interview with Albert Moran, Sydney.

O'Regan, T. 1988, 'Fair dinkum fillums: *The Crocodile Dundee* phenomenon', in S. Dermody and E. Jacka (eds.), *The Imaginary Industry: Australian Film and Television in the 1980s*, Sydney: Australian Film, Television and Radio School, pp155-76.

O'Regan, T. 1991, 'The rise and fall of entrepreneurial TV: Australian TV 1986-90', *Screen* Vol.32, No.1, pp51-67.

O'Regan, T. 1993, ' The regional, the national and the local: Hollywood's new and declining audiences', in E. Jacka (ed.), *Continental Shift: Culture and Globalisation*, Sydney: Local Consumption Publication, pp74-97.

Oakley, B. 1985, 'Great rivalries: Sydney, Melbourne, and Pina Wima', in T. Thompson (ed.), *The View From Tinsel Town: Sydney Cross Currents In Australian Writing*, Ringwood, Victoria: Penguin Books, pp91-4.

Ohmae, K. 1990, *The Borderless World*, London and New York: Collins.

Oxley, H. 1979, 'Ockerism: the cultural rabbit', in P. Spearritt and D. Walker (eds), *Australian Popular Culture*, Sydney: George Allen and Unwin, pp105-130.

Paulu, B. 1970, *Radio and Television Broadcasting on the European Continent*, Minneapolis: University of Minnesota Press.

Petersen, V. 1992, 'Commercial television in Scandinavia', in Silj, *The New Television in Europe*, pp619-20.

Pfeffer, W. 1989, 'Intellectuals are more popular in France: The case of French and American game shows', in R. Rollin (ed.), *The Americanization of the Global Village*, Bowling Green, Ohio: Bowling Green State University Popular Press, pp24-32.

Pike, A. and R. Cooper 1980, *Australian Film, 1900–1977*, Melbourne: Oxford University Press.

Pinne, P. 1996, Interview with Albert Moran, Santiago.

Pollard, S. 1981, *Peaceful Conquest: The Industrialization of Europe, 1760–1970*, London: Oxford University Press.

Porter, D. 1981, *The Pursuit of Crime: Art and Ideology in Detective Fiction*, New Haven: Yale University Press.

Porter, V. 1984, 'European co-productions: aesthetic and cultural implications', *Journal of Area Studies*, No.12 (1995), pp6-10.

Potts, J. 1989, *Radio in Australia*, Sydney: University of New South Wales Press.

Powell, D. 1993, *Out West: Perceptions of Sydney's Western Suburbs*, Sydney: Allen and Unwin.

Pross, H. 1991, 'On German identity', *Media, Culture and Society*, Vol.13, No.1, pp346-57.

Ray, K. 1997, Grundy Public Relations office. Telephone conversation with Albert Moran.

Richeri, G. 1985, 'Television from service to business: European tendencies and the Italian case', in P. Drummond (ed.), *Television in Transition: Papers From The First International Television Studies Conference*, London: British Film Institute, pp21-35.

Rinke, A. 1994, 'Wessi + Ossi = Wossi? Representation of East and West German cultural identities on German television after unification', paper presented to the *Turbulent Europe* conference, London.

Robertson, R. 1992, *Globalisation: Social Theory and Global Culture*, London: Sage.

Robinson, H. 1986, 'Grundy: The global gamester', *Sydney Morning Herald*, *The Guide*, 20 October, pp1-7.

Roe, J. 1974, *Marvellous Melbourne: The emergence of an Australian City*, Sydney: Hicks, Smith and Sons.

Rubinstein, S. 1957, 'Copyright in the past and in the present', *Revue Internationale du droit d'auteur*, n.XV, pp75-107.

Saenz, M. 1997, 'Programming', in Newcomb, *Encyclopedia*, pp1301-8.

Schiller, H. 1969, *Mass Communications and American Empire*, New York M.E. Sharpe.

Schiller, H. 1976, *Communication and Cultural Domination*, New York: M.E. Sharpe.

Schlesinger, P. 1987, 'On national identity: some conceptions and misconceptions criticised', *Social Science Information*, Vol.26, No.2, pp219-64.

Schlesinger, P. 1991a, 'Media, the political order and national identity', *Media, Culture and Society*, Vol.13, No.3, pp297-308.

Schlesinger, P. 1991b, *Media, State and Nation: Political Violence and Collective Identities*, London: Sage.

Schlesinger, P. 1992, 'Wishful thinking: Cultural politics, media and collective identity in Europe', *Journal of Communications*, Vol.43, No.2, Spring, pp6-17.

Schlesinger, P. 1993, 'Islam, postmodernity and the media: An interview with Akbar S. Ahmed', *Media, Culture and Society*, Vol.15, No.1, pp29-42.

Schlieir, C. 1986, 'King World on top of the game show hill', *Advertising Age*, 16 January, pp16-9.

Scrivanor 1987, 'The economic nexus', in J.D.B. Miller (ed.), *Australia and Britain: Social and Political Connections*, Sydney: Metheun, 198-213.

Servaes, J. 1995, 'Dutch Broadcasting Media: Privatisation and commercialisation in view of European regulation', *Journal of International Communication*, Vol.2, No.2 pp40-551.

Shaw, P. 1987, 'Generic refinement on the fringe: The game show', *Southern Speech Communication Journal*, Vol.52, Summer, pp481-501.

Silj, A. (ed.) 1988, *East of Dallas: The European Challenge to American Television*, London: British Film Institute.

Silj, A. (ed.) 1992, *The New Television in Europe*, London: John Libbey.

Silverman, M. 1987, 'Licensing US game shows to UK: Jeremy Fox is Taffner in reverse', *Variety*, 14 February, p.24.

Sinclair, J. 1996, 'Mexico, Brazil and the Latin World', in J. Sinclair, E. Jacka and S. Cunningham, (eds.), *New Patterns in Global Television: Peripheral Visions*, New York: Oxford University Press, pp35-66.

Skinner, T. 1996, Interview with Albert Moran, Singapore.

Skovmand, M. 1992, 'Barbarous TV international: Syndicated *Wheels of Fortune*', in Skovmand and Schroeder, *Media Cultures*, pp84-103.

Skovmand, M. and K.C. Schroeder (eds.) 1992, *Media Cultures: Reappraising Transnational Media*, London: Routledge.

Smith, A. 1990, 'Towards a global culture?', *Theory, Culture and Society*, Vol.7, No.2/3, pp171-91.

Smith, P. 1991, 'Format rights: Opportunity knocks', *Entertainment Law Review*, pp63-5.

Smith, R. 1992, 'I am 68. I live in the Bahamas. I am Australia's biggest TV star. Who am I?', *Sunday Age*, 26 July, p.98.

Smythe, D. 1981, *Dependency Road: Communication, Capitalism, Consciousness and Canada*, Norwood, NJ: Ablex Publications.

Solomon, L. 1994 'The Oz invasion' *The Age Green Guide*, 24 March, p.1.

Sommer, D. 1991, *Foundational Fiction: The National Romances of Latin America*, Berkeley, Calif.: University of California Press.

Sreberny-Mohammedi, A. n.d., 'Whither national sovereignty: cultural identities in a global context', unpublished paper, Centre for Communications Research, University of Leicester.

Staubhaar, J. 1997, 'Brazil', in Newcomb, *Encyclopedia*, pp216-8.

Stiles, P. 1995, Interview with Albert Moran, London.

Stern, L. 1978, 'Oedipal opera: *The Restless Years*', *Australian Journal of Screen Theory*, No.4, pp39-48.

Stern, L. 1982, 'The Australian cereal: Home grown television', in S. Dermody, J. Docker and D. Modjeska (eds.), *Nellie Melba, Ginger Meggs and Friends: Essays in Australian Cultural History*, Malmsbury, Victoria: Kibble Books, pp103-24.

Strover, S. 1994, 'Institutional adjustment to trade: The case of US-European

coproductions', paper delivered at the *Turbulent Europe* conference London, July.

Strover, S. 1997, 'United States: Cable television', in Newcomb, *Encyclopedia*, pp1721-7.

Struss, P. 1995, Interview with Albert Moran, Cologne.

Summers, A. 1975, *Dammed Whores and God's Police: The Colonization of Women in Australia*, Ringwood, Victoria: Penguin Books.

Swoch, J. 1993, 'Cold War, hegemony, postmodernism: American television and the world system, 1945–1992', *Quarterly Review of Film and Video*, Vol.14, No.3, pp9-24.

Thompson, K. 1985, *Exporting Entertainment: America in the World Film Market 1907–1934*, London: British Film Institute.

Todd, J. 1995, *Colonial Technology: Science and the Transfer of Innovation to Australia*, New York: Cambridge University Press.

Tomlinson, J. 1991, *Cultural Imperialism: A Critical Introduction*, Baltimore: John Hopkins University Press.

Toohey, B. 1973, 'TV Packagers Stand To Gain Most From Points System', *Australian Financial Review* July 2, pp24-25.

Tulloch, J. 1976, 'Gradgrind's heirs: The quiz show and the presentation of "knowledge" by British television', *Screen Education*, No.19, Summer, pp11-18.

Tulloch, J. 1989, 'Soaps and ads: Flow and segmentation', in J. Tulloch and G. Turner (eds.), *Australian Television: Programs, Pleasures and Politics*, Sydney: Allen and Unwin, pp120-38.

Tulloch, J. and A. Moran 1986, *A Country Practice: 'Quality Soap'*, Sydney: Currency Press.

Tunstall, J. 1970, *Media Sociology: A Reader*, London: Constable.

Turner, G. 1994, *Making It National: National Identity and Australian Popular Culture*, Sydney: Allen and Unwin.

Twopenny, R.E.N. 1973, *Town Life in Australia* (1883), Sydney: Sydney University Press.

van der Meer, K.K. 1996, Interview with Albert Moran, Hilversum.

van Manen, J. 1994, *Televisie formats: en-iden nar Nederlands recht*, Amsterdam: Otto Cranwinckle Uitgever.

Villagrasa, J.M. 1992, 'Spain: The emergence of commercial television', in Silj, *New Television*, pp337-52.

Wells, A. 1972, *Picture-tube Imperialism?: The Impact of US Television on Latin America*, New York: Orbis Books.

Westcott, T. 1995, 'A family affair', *Television Business International*, February, pp22.

Whannel, G. 1982, '*It's a Knockout*: Constructing communities', *Block*, No.6, pp37-45.

Whannel, G. 1989, 'Winner takes all: Competition', in A. Goodwin and G. Whannel (eds.), *Understanding Television*, London: Routledge, pp103-112.

Whannel, G. 1992, 'The price is right but the moments are sticky: Television, quiz and game shows, and popular culture', in D. Strinati and S. Wagg (eds.), *Come on Down? Popular Media Culture in Post-War Britain*, London and New York: Routledge, pp179-201.

Wheelwright, E.L. and Crough, G. 1988, 'The political economy of technology', in R. MacLeod (ed.), *The Commonwealth of Science: ANZAS and the Scientific Enterprise in Australia, 1888–1988*, Melbourne: Oxford University Press, pp107-38.

Whitington, R.P. 1971, *Sir Frank: The Frank Packer Story*, Melbourne: Cassells Australia.

Widdicombe, R. 1994, 'A clan for all regions', *TV World Guide to Spain and Portugal*, March, pp18-21.

Williams, R. 1974, *Television: Technology and Cultural Form*, London: Fontana.

Wilson, H. 1991, 'New Zealand deregulation and the spectrum', *Media Information Australia*, No.62, November, pp60-8.

Windshuttle, K. 1979, *Unemployment: A Social and Economic Analysis of the Economic Crisis in Australia*, Ringwood, Victoria: Penguin Books.

Wood, D. 1994, 'Life in the old dat yet', *Broadcast*, 11 November, p.29.

Youngson, A.J. (ed.) 1972, *Economic Development in the Long Run*, London: Allen and Unwin.

Zalcock, B. and J. Robinson 1996, '*Inside Cell Block H*: Hard steel and soft soap', *Continuum: The Australian Journal of Media and Culture*, Vol.9, No.1, pp88-97.

Abbreviations

AAFI: All American Fremantle International
ABC: American Broadcasting Company
ABC: Australian Broadcasting Corporation
ARD: Arbeitgemeinshaft der Offentlich-Rundfunkenstalen der Bundesrepublik Deutschland
AVRO: Algemene Omroep Vereniging
BBC: British Broadcasting Corporation
BCNZ: Broadcasting Corporation of New Zealand
BRITE: British Independent Television Enterprises
CBS: Columbia Broadcasting System
CTL: Compagnie Luxembourgeoise de Télédiffusion
EBU: European Broadcasting Union
EC: European Community
EO: Evangelische Omroep
FCC: Federal Communications Commission
ITV: Independent Television
ITU: International Telecommunications Union
JE: Joop van den Ende
KPN: Dutch telecommunications carrier, now privatised.
KRO: Katholieke Radio Omroep
LWT: London Weekend Television
NBC: National Broadcasting Company
NCRV: Nederlandse ChrystelijkeVereniging
NHK: Nippon Hoso Kyokai
NTSC: National Television Standards Committee
PAL: Phase Alternation by Line
RAI: Radio-televisione Italia (formerly Radio Audione Italia)

RTL: Radio Tele Luxembourg
RTVE: Radio Television Española
SBS: Special Broadcasting Service (Australia)
SBS: Scandinavian Broadcasting System
SECAM: Sequential a Mémoire
SIC: Portugese private broadcaster
STD: Switched Trunk Dialling
SVT: Sveriges Radio Ab
TF: Tele France
TMC: Tele Monte Carlo
TPI: Televisi Pendidikan Indonesia
TROS: Televise Radio Omroep Stichting
TVNZ: Television New Zealand
TVV: Television Valencia
UK: United Kingdom
US: United States of America AAFI
VPRO: Vrijzinning Protestantse Radio Omroep
VARA: Vereniging Arbeiders Radio Amateurs
VOO: Veronica Omroep Organisatie
ZDF: Zweites Deutsches Fernsehen

Index

INDEX OF TITLES